KT-225-021

CATS in ART

Desmond Morris

REAKTION BOOKS

Published by Reaktion Books Ltd
Unit 32, Waterside
44–48 Wharf Road
London N1 7UX, UK
www.reaktionbooks.co.uk

First published 2017
Copyright © Desmond Morris 2017

All rights reserved

No part of this publication may be reproduced, stored in a retrieval system,
or transmitted, in any form or by any means, electronic, mechanical,
photocopying, recording or otherwise, without the prior permission
of the publishers

Printed and bound in China
A catalogue record for this book is available from the British Library

ISBN 978 1 78023 833 3

Contents

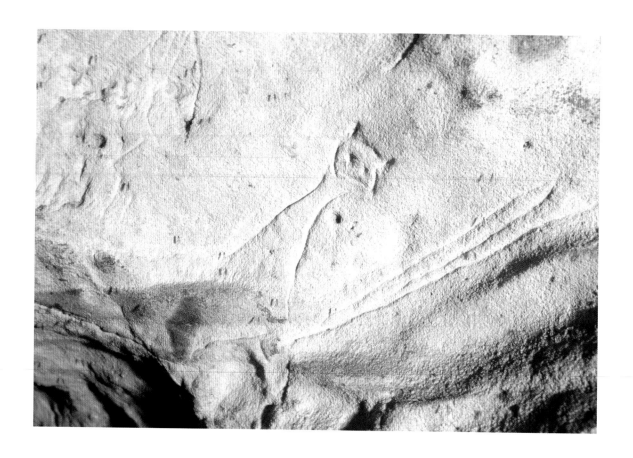

Palaeolithic image of a long-necked cat from the Gabillou Cave
in the Dordogne, central France.

Introduction

Before it was domesticated, the cat had little importance for prehistoric humans. Stealthy and cunning, it would rarely have come into contact with our ancestors when they were living as tribal hunter-gatherers. As a result, its image is extremely rare in the cave art of the Palaeolithic period, or in the later rock art. Lions appear from time to time, but small cats are almost entirely absent from the cave walls or rocky surfaces where so many other animals are portrayed. Even the few cases where small cats have been identified are dubious and open to other interpretations. There are only about half a dozen examples that are worth considering.

In the Gabillou cave in France, there is an engraving on the wall that is the closest we can come in a search for a small cat image in the Palaeolithic era. Henri Breuil, the famous pioneer of cave-art studies, considered that it portrayed a cat, and he seems to have been right, although some later authors doubted his identification. Its long, tapering neck, its rounded face and the shape and position of its ears all point to it being a small cat. If it is indeed a small cat, it can only be an image of the species *Felis silvestris*, the wildcat, because that was the only species of small feline that inhabited Europe at the time. It was the North African race of this species, *Felis silvestris lybica*, that was the direct ancestor of the domestic cat.

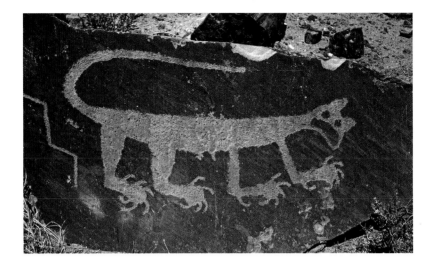

This simple engraving is practically all we have from the time of the cave artists. There is also a little piece of carved bone from the Saint-Michel cave in the Pyrenees that has been identified as a cat, but again doubts have been expressed. We should not be surprised at this rarity of prehistoric cat images. Almost all the animal images on the Palaeolithic cave walls are commemorations of the large prey animals that the hunters had killed. The smaller species do not seem to have impressed the people enough for them to make lasting records. The same is true of cave art everywhere in the world; there are one or two isolated examples, but we do not know exactly which felines are involved.

A few years ago cave art dating from as early as 8,000 BC was accidentally discovered in the Mato Grosso do Sul region of south-western Brazil. An image in the Taboco cave was certainly that of a cat, but again this must have been a wild cat, one of the nine species that inhabit South America. Its outline is so crude that it is impossible to identify it with any accuracy, although its proportions would seem to indicate that it was one of the smaller cats.

A savage cat with huge claws and a gaping mouth, from the
Painted Desert in Arizona, 10th–14th century.

Further north, in the Painted Desert of Arizona, there is a wonderfully savage cat, with huge claws and a brutal expression, created by a member of one of the early Native American tribes. Clearly the artist was impressed by the hunting weapons of this cat, but there is no clue to its size. It is likely to have been based on something the size of a puma, rather than on one of the smaller New World cats.

Perhaps the most spectacular prehistoric carving of cats is to be found in Libya, where a large, 7,000-year-old rock engraving shows us two felines rearing and striking out at each other: the oldest catfight in feline art. Here, obviously, the cat is presented as a symbol of violent aggression, rather than of hunting skill.

These few images sum up the cat in art before it became a domesticated animal. Everything changed once that process had occurred, and it has since become the subject of literally millions of paintings and drawings all over the world.

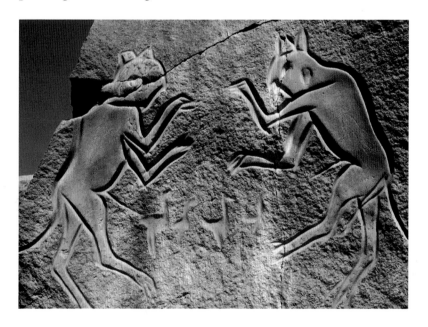

9

Two cats rearing up in a fight, clawing at one another. A rock carving in Libya, at the Wadi Mathendous Archaeological Site, 5000 BC.

TODAY, IN NUMBERS, the cat is by far the most popular domestic pet on the planet. When wild cats gave up their freedom and attached themselves to human families, first as pest-controllers but eventually simply as companions, their populations grew and grew. Today there are hundreds of millions in existence, making them by far the most successful carnivore in the world. The United States, with roughly 87 million, has more domestic cats than any other country. Indonesia has 30 million and Brazil 15 million. The United Kingdom, Canada, Germany, France, Japan and China each have between 8 and 11 million. With this level of popularity, it is not surprising that feline art has been a major theme in many cultures. As we will see, there has been a rich variety of cat images, from ancient Egypt right through to the modern art of the present day.

It is usually said that the domestication of the Middle Eastern subspecies of the wild cat began in Egypt about 4,000 years ago, when wild cats, attracted to the rodents that infested the grain stores of that ancient civilization, were seen as efficient pest-controllers and worthy of human assistance and cooperation. Many were taken into early Egyptian homes and protected, increasing their efficiency as rodent-killers. In fact, we now know that feline domestication began much earlier, in Mesopotamia and elsewhere, probably as far back as 12,000 years ago. The reason these earlier cases have been overlooked is simple enough: unlike the Egyptians, the people of these civilizations did not leave a legacy of feline images. Those early cats may have become efficient at killing rats, but they had not yet become friendly house companions. As small, working animals they would have been largely ignored by the artists of the day.

There is one possible exception, a beautifully shaped clay cat's head from ancient Babylonia, but it cannot be said beyond any

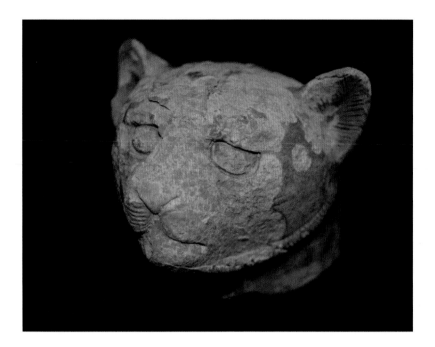

doubt that this is a domestic cat rather than the stylized head of a lioness. Supporting the idea that it may be a domestic cat is the fact that the Babylonians believed that the souls of priests were escorted to paradise by a helpful cat. There is also some evidence that the Babylonians were already employing cats as pest-controllers, to hunt the rodents that were attracted to human habitation. But to start the story of cats in art in earnest, we must turn straight away to that extraordinary civilization that flourished along the banks of the Nile in northeast Africa, and which has left us such a rich legacy of spectacular ancient art: the world of the pharaohs.

Cat's head, Babylonian, 2nd millennium BC. A rare example of a pre-Egyptian feline artefact.

1

Sacred Cats

It was in ancient Egypt that the cat truly came into its own as a subject for works of art. It may have been domesticated much earlier, but it was not until the Egyptian civilization had established itself along the River Nile that the cat became an important cultural icon. It is crucial to realize that it did not have a single significance for the early Egyptians, but in fact occupied as many as five distinct roles.

In its first role, it was a much-loved household companion, and in this capacity it is often depicted sitting quietly beneath its owner's chair. Works of art showing the cat in this way span nearly eight hundred years and nine dynasties. Interestingly, the chair under which the cat sits is always that of its female owner. This suggests either that these household cats were traditionally the pets of the lady of the house, or that they somehow symbolize female sexuality. Some authorities have favoured the symbolic explanation, saying that there is an erotic implication in the repeated placing of the cat beneath the chair of its mistress, but the way in which the animal itself is portrayed goes against this. Instead of sitting always in identical, symbolic poses, cats are depicted in a variety of mundane situations. One is shown tethered to one of the legs of the chair by a heavy collar and a lead. Its left forepaw is tugging at the lead, in an attempt to

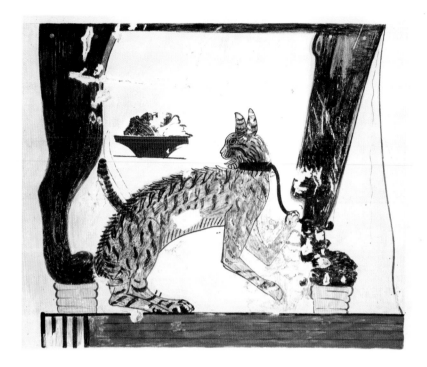

break free. The animal has a special reason for wanting to escape from its tether, because nearby – but just out of reach – a bowl piled high with food has been set on the ground. The cat's head is twisted towards the bowl, and it is clear from its rather slender body that it is hungry and desperate to reach the food. This scene does not have the air of a stylized, symbolic statement, and clearly lacks any sort of erotic or sexual message. Instead, it has an everyday atmosphere – a hungry cat wanting its dinner.

Another example shows the cat under the chair, bent over and busily consuming a fish that is lying on the floor. Another depicts a pregnant cat with swollen teats, and yet another shows a cat squatting nervously beneath the chair of a queen who is seated in a papyrus canoe, floating on a marsh. Another has the cat striking out at a bird. Other examples show the cat under the chair chewing what

A rather thin house cat, attached to the leg of a table by a collar and lead, looks hungrily at a bowl of food beyond its reach. From the tomb of May, 18th dynasty, *c.* 1500 BC.

looks like a bone, spitting at a goose that is threatening it, or in the company of a pet monkey.

The only consistent element in these portrayals is the fact that the cat is always positioned under a woman's chair, and it is remarkable that this visual tradition survived for nearly eight hundred years. However, the actions of the cats are highly individualistic and natural, suggesting that the artists wanted to make it clear that these animals are personal to the particular scenes in which they appear. They are real, living cats, not stiffly posed symbolic ones. We may have only a dozen or so examples of this genre, but they are enough to confirm that in ancient Egypt, in addition to its more sacred roles, the cat was also kept as an ordinary household pet.

In its second role, the cat is depicted as a hunting companion. In four separate scenes a cat is shown in the wilds with its owner, who is in the act of spearing fish or flushing out wildfowl in the marshlands of the Nile. A Twelfth Dynasty tomb wall dating from

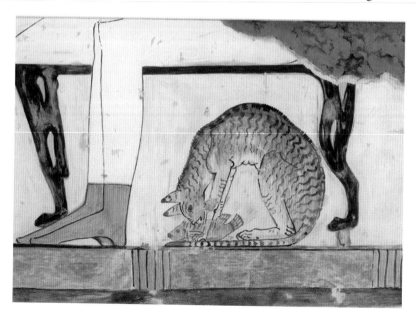

14

Copy by Nina de Garis Davies of a tomb painting in Thebes, tomb of Nakhts, 1400 BC, showing a cat eating a fish.

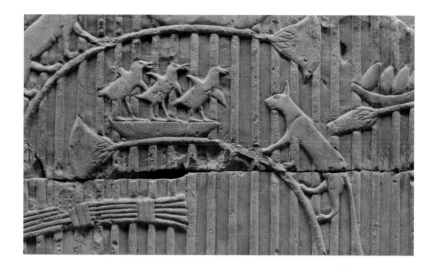

about 1880 BC shows a scene in which the human hunter is perched on his papyrus boat, spearing fish, while his cat, along with a genet and a mongoose, are hunting birds in a papyrus thicket. The presence of these three small carnivores reminds us that the Egyptians were great experimenters in the process of domestication, trying out all kinds of new species as possible companions. As domesticated livestock, the genet and the mongoose ultimately proved to be failures, but the cat was a great success. In a second, similar hunting scene, the human hunter is in the act of hurling a throwing stick at a cluster of birds while his pet cat paws at the hem of his garment, trying to attract his attention. Again, the cat and its master are standing on a papyrus boat, a style of hunting in which a cat could be kept under control; on dry land it would prove more difficult to restrict the animal's movements.

In a third hunting scene, dating from the Eighteenth Dynasty, the cat is shown climbing carefully through a papyrus thicket in search of birds. It would seem that its master is using it to flush out game, so that he can kill them with his throwing stick. Only the

Cat caught in the act of hunting some small birds, 18th dynasty, 1570–1293 BC.

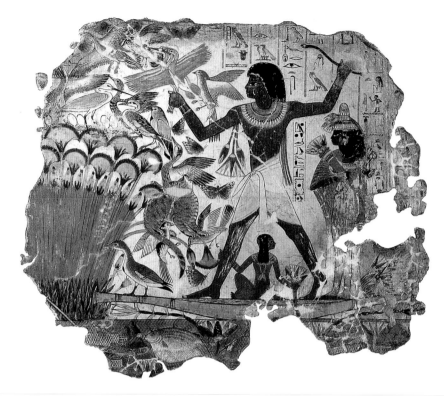

Egyptians used cats in this particular role; all other cultures have employed dogs for flushing out game.

The most famous and skilful of the hunting scenes is also from the Eighteenth Dynasty, and is now in the British Museum. It is unusual in depicting a family outing rather than a serious hunting expedition: the hunter's wife and daughter and even his tame goose are with him in the boat. He is caught in the act of hurling his throwing stick, sending a confusion of birds up into the air. In the midst of these birds is his pet cat, clawing at one of them with its front legs and at another with its hind legs, and grabbing yet another in its jaws.

In its third role, the Egyptian cat plays a part in light-hearted social satires, presented rather in the manner of present-day strip

A man (Nebamun) and his family out hunting in their boat on the marshes, aided by a cat that holds one bird in its front paws, one in its rear paws and one in its mouth, 18th Dynasty, *c.* 1350 BC.

cartoons. These are extremely rare in Egyptian art, and only ten examples that feature cats are known. A typical device employed in these satires is a role reversal in which mice dominate cats. In one, a cat brings gifts to a royal mouse; in another, a cat waits on an enthroned mouse; in a third, cats assist in the toilet of a mouse queen. Other satirical compositions present the cat as a hard-working driver of a flock of birds – either geese or ducks.

In its fourth role, the cat is depicted as a slayer of serpents. This is not as fanciful as it may sound. Even today, the Tuareg people of North Africa employ cats to kill poisonous snakes. In ancient times this role was so well known that a Roman writer commented in the first century BC: 'The cat is useful against asps with their deadly bite and other reptiles that sting.'

The dramatic battle between cat and snake led to their being cast as the legendary opponents in the constant feud between day and night. The cat became identified with the sun god, Ra, and the snake with the evil serpent of darkness, Apophis. In depictions of this antagonism, the cat was shown decapitating the serpent with a sharp knife. The scene became a formula, and was used over a period

17

New Kingdom satirical scene, *c.* 1295–1075 BC, in which a scrawny cat
is acting as the servant of a plump mouse.

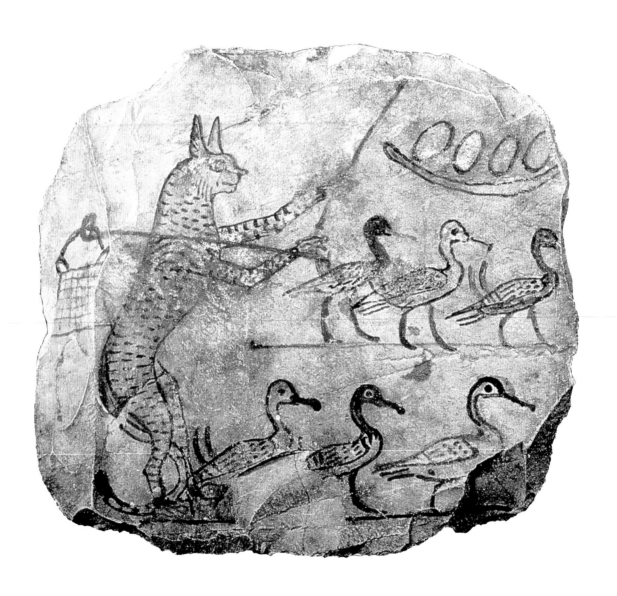

Cat herding geese, on a limestone ostracon of the 19th–20th dynasty, 1150 BC.

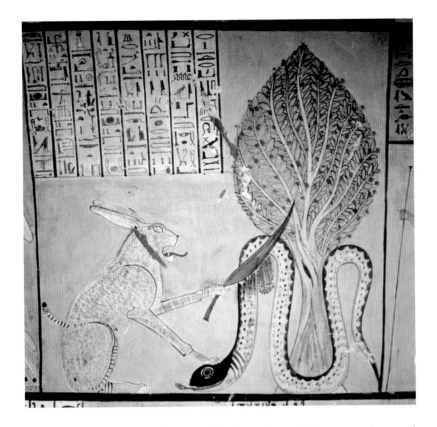

of five hundred years, always with a long-legged, long-eared, seated cat decapitating a vertically coiled serpent with a sharp-pointed, tapering knife, with a tree in the background. Unfortunately for the cat, the beheaded serpent keeps recovering, and the sinister darkness of night once again follows the joyful light of day.

Finally, the fifth role of the cat in ancient Egypt – and the most important – is that of goddess. The earliest feline deity was the fierce lion-headed goddess of war, Sekhmet. As the centuries passed she was gradually eclipsed by the more friendly cat-headed goddess Bastet. Both represented the sun, but Sekhmet was the cruel, searing heat of the destructive sun, while Bastet was the warming, life-giving sun. There seem to have been two reasons why Bastet finally won out: the

Cat decapitating the evil serpent Apophis, painting from the tomb of Inherkha, Egypt, 20th dynasty, *c.* 1186–1070 BC.

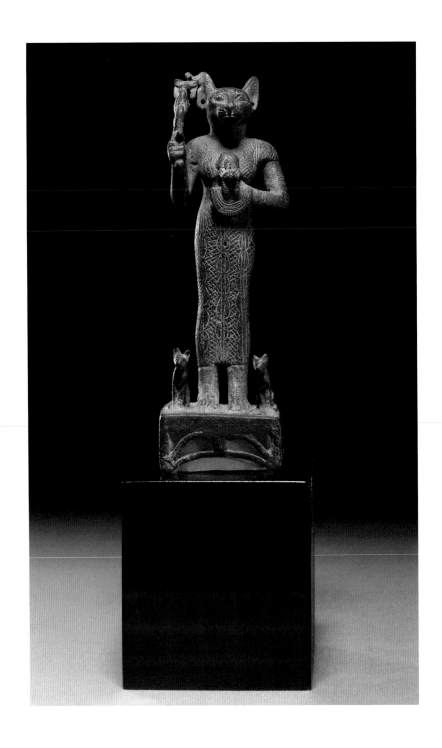

Bastet in the form of a cat-headed woman. Ptolemaic, Late Period, Egypt,
7th–4th century BC.

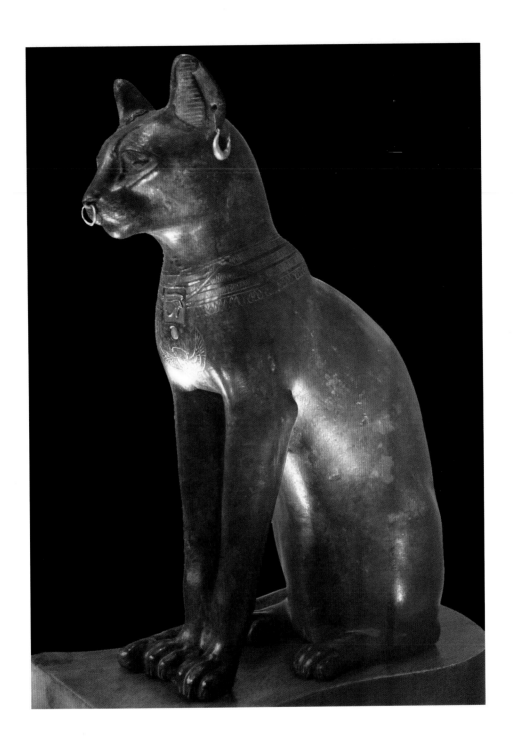

The goddess Bastet in the form of a squatting cat, with gold earrings
and nose-ring. Late Period, *c.* 664–332 BC.

wild lions that plagued the early Egyptians were being exterminated, and the small, domestic cat was becoming increasingly important as a pest-controller around the vast food stores as the civilization grew larger.

Bastet became a local cult figure at her religious centre, Bubastis, in the Delta region in the north of Egypt. She rose to become the dominant deity of her time, and her festivals attracted vast crowds. The Greek historian Herodotus tells us something about these events, describing them as noisy and bawdy. He says that barges carrying the crowds to the ceremonies were full of music, singing and dancing, and that they would stop at riverside towns, where the women would shout, dance, sing and 'pull up their clothes'. Once the rowdy mob had arrived at Bubastis, he reports that there was a great feast, 'and more wine is consumed at this festival than in all the rest of the year.'

There was a useful excuse for this drunkenness, because an old myth about Sekhmet gave it religious significance. The legend tells how the fearsome goddess of war was tricked when beer was dyed red and spilled on the battlefield by Ra. Thinking it was blood, Sekhmet lapped it up greedily; she became so drunk that she fell asleep, and mankind was saved from her savagery. Getting drunk at Bubastis' festival, then, was a way of re-enacting the defeat of Sekhmet and celebrating the rise of the friendly Bastet.

It is easy to see how the cult of Bastet became so popular that it lasted a thousand years. Sadly, her great temple and festival hall at Bubastis were later reduced to rubble, and they remain in that condition today. Among the ruins, over the years, diggers have found thousands of bronze figures of the goddess in the form of a squatting cat. Many of the larger, life-sized examples are beautifully

formed, and are today considered great works of art. The best have gold attachments on the head, including gold earrings. Sometimes the goddess was shown in the shape of a standing woman with the head of a cat.

Cat-worship in Egypt came to an end in about 30 BC. The fact that the goddess had been associated with fertility, pleasure, music and dance did not help the cat in later periods, when the fun was removed from religious activities and replaced with a solemn, puritanical approach that saw itself in opposition to the pleasures of the flesh.

2

Early Urban Cats

T he cat's sacred status did not survive when the civilization of ancient Egypt gave way to the dominance of ancient Greece. Cats hardly appear in the spectacular art of the early Greeks, and in the few instances in which they do surface, their role is completely changed. They are now lowly creatures of little importance.

The Greek cat's worst moment comes in a marble relief from around 500 BC, found near Athens. A terrified cat, so emaciated that its ribs are showing, is being pitted against a large dog in what appears to be a cruel sporting contest. The owners of the two animals face each other in eager anticipation of the unfolding savagery. The one on the left, behind whom an enthusiastic supporter stands, is obviously hoping that his dog will tear the cat to pieces. The man on the right, also with a watching supporter, presumably hopes that his starving cat will be so desperate that it will claw out the eyes of its rival before it has been crushed in the dog's jaws. The contrast with the dignified portrayal of the cat in the art of ancient Egypt could not be greater.

A cat also appears to be in serious trouble in the decoration on a red-figure amphora. A naked young man is shown as he is about to place a cat in what appears to be a large bowl of water on a pedestal.

If this were a modern scene, the implication would probably be that the man is about to wash the cat to rid it of fleas. But this ancient bowl on a pedestal has a ritual feel, and is more likely to represent a sacred font in which the cat will undergo water purification before it is sacrificed in some religious ceremony. Another possibility is that the man is about to drown the cat, which he sees as a nuisance that must be disposed of as quickly as possible. Alternatively, perhaps he wants to kill it and use its pelt to help clothe his naked body, or because he is hungry and wants to cook and eat it. If this last suggestion seems improbable, it is worth remembering that in a comedy by the playwright Aristophanes, a pedlar arrives in Athens from the countryside selling various animals as food, and his list of edibles includes cats.

On another red-figure vase, dating from about 380 BC, the cat's role is less hazardous. This time it appears to be a pet, adorned with a strap of some kind around its chest. It is shown pawing the air as it waits to be thrown a ball that is being offered to its owner by a naked young man. The scene suggests that, in some households at least, cats were kept as family pets.

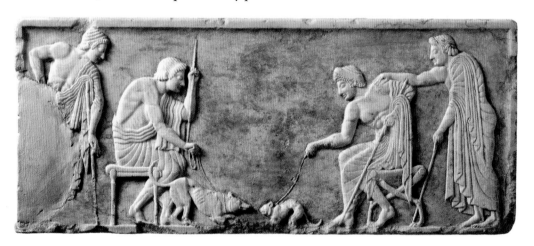

25

On an ancient Greek relief from *c.* 500 BC, two youths are preparing to stage a cruel fight between a dog and an emaciated cat.

Apart from these three cases – the fight, the font and the ball – there are only a few examples of feline images in ancient Greek works of art. There are three, for instance, in the British Museum. One, a vase dating from the fourth century BC, shows a naked youth holding a small bird in his raised hand; his pet cat clings to his body, trying to swipe at the bird with its paw. On another vase from about the same time, two women face each other with a tabby cat between them. One of the women stands, holding up a ball in her left hand. This ball would normally have attracted the cat's attention, but in this scene its gaze is focused instead on a bird that the woman's seated companion is dangling tantalizingly just above the animal's head. The cat's reaction is to rear on its hind legs and reach for the bird with its front paws. Finally in the British Museum, a fourth-century BC Apulian vase shows a cat confronting a white goose.

To find more feline examples in the art of ancient Greece one must turn from decorated ceramics to silver coins of the fifth century BC. Some show a naked youth sitting on a chair, playing with his cat, which jumps up to strike out at a bird or other object in the young man's raised hand. In a variant, the cat plays with a ball beneath the chair.

In ancient Babylonia and Egypt, as well as in modern times, domestic cats were employed to keep down the numbers of rodent pests in villages, towns and cities. Because this function is so obvious to us today, we tend to think that they have always been used in this way, but surprisingly this is not the case. In ancient Greece and in Europe generally for many centuries, the most common pest-controller was not the cat, but a mustelid – the polecat or ferret (sometimes inaccurately referred to as a weasel).

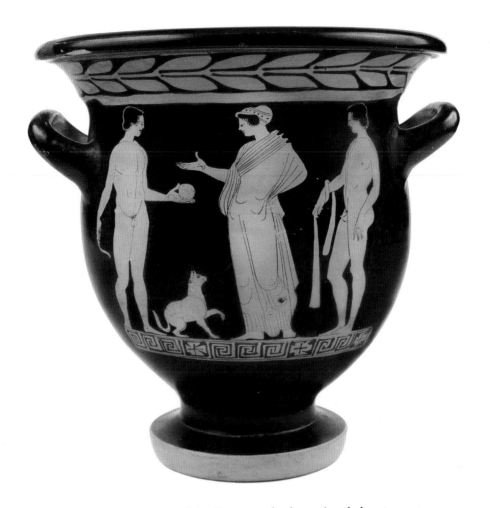

The popularity of the ferret made the cat's role less important in Greek society, and there was another reason it became less popular. According to Greek legend, the cat was associated with Hecate, the goddess of darkness and witches. We see in this unfortunate connection the very start of a long history of persecution for the cat, perceived as a familiar of witches and the personification of evil.

Fortunately for the cat, myths and legends can change over the years, and, later in Greek history, the cat became linked instead

Pet cat begging to play with a ball, on red-figure vase
from ancient Greece, 380 BC.

to a benign, helpful role that allowed it to enjoy a more comfortable existence. In its new legendary status it was seen not as the embodiment of the Devil, but as the precious guardian of the baby Jesus, the brave feline hunter who protected the infant Christ from rats and snakes. This may have led to a more favourable treatment of the cat as a dwelling-companion when Christianity arrived in Greece, but sadly that did not last: as the centuries passed perception of the cat reverted to its wicked persona, as the companion of malevolent witches.

ROME

The cat fares a little better in the art of ancient Rome than in that of ancient Greece. It is still not a common subject, being largely restricted to mosaics, but at least the cats are portrayed more sympathetically.

The most accurate Roman representation of a domestic cat, dating from the first century AD, appears in a skilful mosaic panel found in Pompeii and now in the Naples National Archaeological Museum. Unlike its Greek predecessors, this cat has lifelike details and an attractively striped tabby coat. It is holding down a live partridge with its left forepaw, and the mosaic artist has frozen the action at the instant before the feline hunter sinks its jaws into the back of the doomed bird's neck. This is a healthy, well-fed, well-groomed feline, suggesting that the Romans had more respect for their cats than did the Greeks. There are three versions of this panel, revealing that it must have been done from a copy-book. One of these mosaics, found on the Via Ardeatina south of Rome and now in the capital's Roman National Museum, Palazzo Massimo alle Terme, is very similar, but less skilful in its detail. The third version, in the collection of the Vatican, was found at Tor Marancia, now a suburb of Rome.

It is the least expertly executed of the three, and shows the cat attacking a cockerel rather than a partridge.

A different scene depicting a hunting tabby cat was also found at Pompeii and is now housed in the Naples Museum. In this mosaic panel the cat – which has unusually long, erect ears and claws the air with its right forepaw – crouches on the ground, staring longingly up at three birds perched on the rim of an ornamental pedestal bowl. The birds, two long-tailed parrots and a dove, are clearly out of the cat's reach, and should it try leaping up at them, they would have an easy escape. The angry frustration of the cat is portrayed well by the artist.

Several other cat images appear on ancient mosaics, but they are of little importance. Clearly the cat was not considered significant enough to merit frequent commemoration on Roman mosaics. It

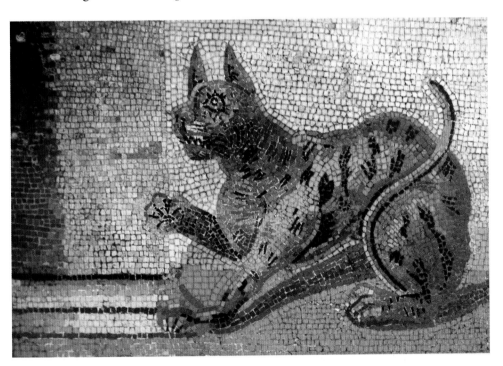

29

Detail of cat with a raised paw, from a mosaic in the
House of the Faun in Pompeii, 2nd century BC.

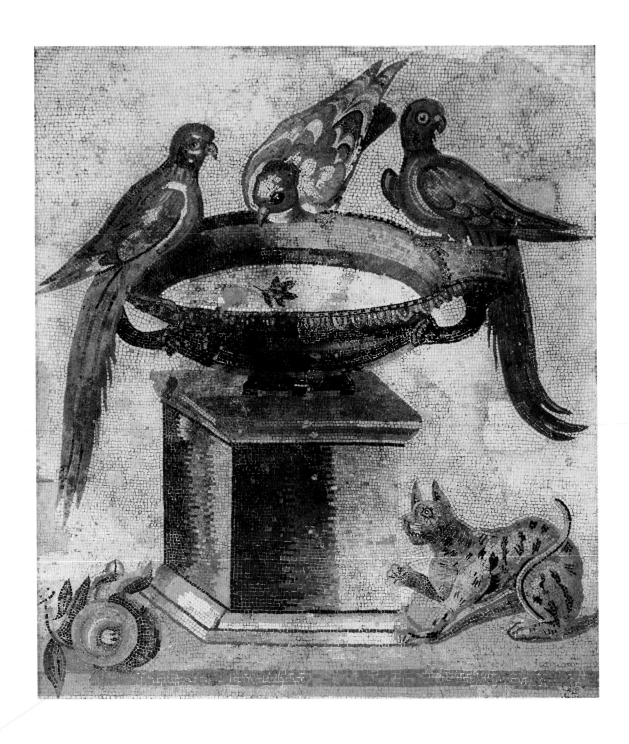

Cat with a raised paw, from a mosaic in the House of the Faun in Pompeii,
2nd century BC.

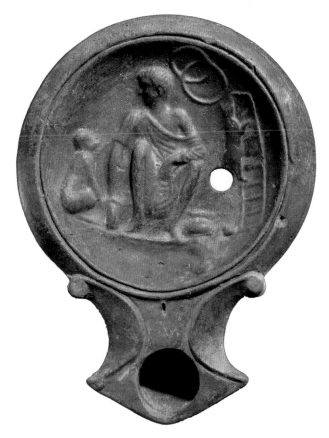

was essentially a working animal, employed to control the growing population of rodents. In this role cats were apparently favoured over ferrets: as early as the fourth century BC, the writer Palladius advised that cats were better than ferrets at stopping moles from eating up the artichoke beds. This confirms that both kinds of predator were used, but that the cat was gaining in popularity. Pliny the Elder was impressed by the cat's hunting technique: 'How silently and with how light a tread do cats creep up to birds, how stealthily they watch their chance to pounce on tiny mice.'

Sadly for the Roman cat, despite its improved status as a pest-controller, it suffered from the quack medicine of the day. Pliny the

31

Roman oil lamp showing a street performer with a cat climbing a ladder.

Elder commented, in the first century AD, that fevers could be cured by drinking a mixture of wine and the liver of a cat that had been killed when the moon was on the wane.

Finally, away from the mosaics, there is a curious scene on a first-century AD Roman oil lamp in which a street performer squats next to his pet monkey, while his acrobatic cat climbs a vertical ladder. Two hoops are shown above the cat, and the implication is that, once it has reached the top of the ladder, it will have to leap through the hoops to conclude its act.

In all the records of small Roman felines that have come down to us, only one cat is known to have been given a name. Depicted on a mosaic found in Volubilis (an ancient city between Fez and Rabat in Morocco, on the southwestern border of the Roman Empire) is a household cat wearing a red collar with a small bell attached to it and shown in the act of killing a rodent. This cat was given the rather lofty name Vincentius.

3
Medieval Cats

The arts went into decline during the period following the downfall of the Romans, roughly from the fifth to the tenth century AD, and few images of cats have survived from this time. They are not entirely absent, however. During their widespread expansion abroad, soldiers of the Roman army had often taken cats with them as mascots, and they left them behind when they departed. Apart from feral cats, thriving on the generous supply of rats and mice that were available to them, a number were kept as pets, especially in nunneries and monasteries.

In the sixth century even the Pope had a pet cat. In the year AD 590, Pope Gregory the Great was so fond of his cat that the theologian John the Deacon commented: 'He liked stroking his cat better than anything else.' This was a good time to be a cat, and the Pope was not the only important cat-lover at this time. The prophet Mohammed, who was then twenty years old, was also devoted to his feline companion – so much so, the story goes, that he cut off the sleeve of his garment when he had to go to pray, rather than wake his cat who was sleeping on it. It is significant that the cat is described in the Qur'an as a pure animal while the dog is impure. Cairo was the first city in the world to boast a hospital for sick cats and a garden for the feeding of homeless cats. This early

attachment to the cat in the Muslim world may have been a hidden factor in the rise of the hatred of cats on the part of the Christian Church in later centuries.

One cat-loving monastery was at Nivelles in Belgium, just south of Brussels. In the seventh century AD it was overrun with rodents, and cats were used to eliminate them. So successful was this campaign that legends grew up around the monastery, suggesting

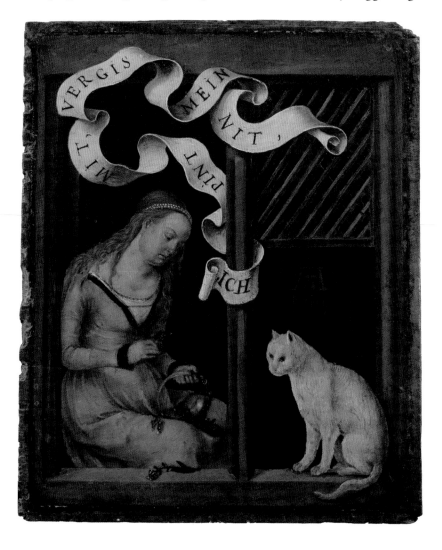

34

This painting, from a later period, was thought to show the 7th-century St Gertrude of Nivelles with one of her cats.

that the water drawn from its well, or the bread baked in its oven, could repel rodents or that the prayers being said by the abbess were sufficient to drive the pests away.

The figure credited with defeating the rodent pests was St Gertrude of Nivelles, who lived from AD 621 to 659 and whose mother had founded the monastery. On her mother's death Gertrude became the abbess, and she was later identified as 'the protector from rodent pests'. Centuries later, she became known – inaccurately – as the patron saint of cats, and was soon widely adopted by cat-lovers as their special saint. The error arose because in 1981 a picture of a young girl sitting next to her white cat, painted in 1503, had been published in a book with a confusing caption that included the statement 'Saint Gertrude of Nivelles was the patroness of cats.' It was assumed that the girl in the painting was St Gertrude, and a cult rapidly grew up around her, with hundreds of modern images being created showing her holding a cat. In reality, the girl in the painting is no nun. The scroll above her reads 'I am here, do not forget me', and on the reverse of the panel is a picture of a young man. The painting is signed 'AD', implying that the painting is by Albrecht Dürer, but it is not. It is by a little-known contemporary of his, pretending to be him.

A famous eighth-century poem by a scholarly Irish monk is devoted entirely to his pet cat, who was called Pangur Bán, or Pangur the Fair. It reveals that, during this period – before the unfortunate link between cats and witches had developed – the Church and the cat could have a pleasant relationship. The poem begins: 'I and Pangur Ban my cat,/ 'Tis a like task we are at:/ Hunting mice is his delight,/ Hunting words I sit all night.' And it ends: 'Practice every day has made/ Pangur perfect in his trade;/ I get wisdom day and

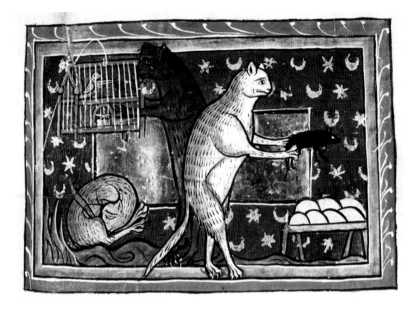

night/ Turning darkness into light.' The Benedictine monk writes lovingly of his pet cat, referring to him at one point as 'the hero Pangur', and it is amusing to think that, today, although we know the name of his cat, his own name is lost for ever.

A few centuries later, in the twelfth and thirteenth centuries, bestiaries – collections of beautifully illustrated and briefly described animals – were flourishing in England and France. One of their special features was that the animals depicted were usually associated with a moral tale of some kind. Bestiaries are not very kind to cats, treating them essentially as mouse-killers and ignoring their role as companion animals. A twelfth-century bestiary, when translated from the Latin, has this to say: 'She is called mouser because she is fatal to mice . . . So acutely does she glare that her eye penetrates the shades of darkness with a gleam of light.' The illustration shows three cats sitting up on their haunches, one of them holding a rodent in its paws. In another bestiary scene we see three cats in a domestic

Three cats at home, as pictured in a 13th-century bestiary. One is licking itself, another takes a bird from a cage and a third is holding a rat.

setting. The first is licking itself; the second is reaching inside a cage to grab a terrified bird; and the third is standing on its hind legs, holding a black rat.

There are variations on this 'three cat' set piece in other bestiaries. In one, the cat on the left is licking itself, the one in the centre is holding a rat and watching the one on the right, who is trying to catch a rat that has escaped upwards. In another, one cat is licking itself while the other two stare up at an unseen rat. Finally, in a bestiary of the twelfth century, the three cats sit together, all looking forwards; the front one is holding a rat.

In one of the bestiaries an illustration shows only one cat, and this is the one that is licking itself. The repeated use of this motif is related to a popular superstition of the day: that a cat licking itself is a sign of coming rain. Surprisingly, there is an element of truth in this. Thunderstorms disturb the cat's electromagnetic sensitivity, causing it to become nervous and start cleaning itself. This can

37

Illustration of a cat licking itself, 13th century.

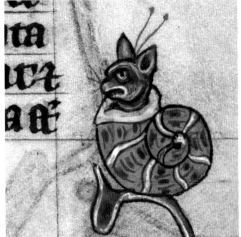

happen even before its human companions are aware that there is a storm approaching, so it can, indeed, predict rain.

In the thirteenth century the scholarly Franciscan monk Bartholomaeus Anglicus, writing in his compendium *De proprietatibus rerum* (On the Properties of Things) – an early form of encyclopaedia – describes the cat in some detail. According to him, the cat is

> a lecherous beast in youth, swift, pliant and merry, and leaps and rests on everything that is in front of him; and is led by a straw, and plays with it . . . and lies in wait for mice . . . and when he takes a mouse, he plays with it, and eats it after playing. In time of love is hard fighting for wives, and one scratches and rends the other grievously with biting and with claws. And he makes a ghastly noise when one proffers to fight with another.

Although not hostile towards the cat, this early text shows that the animal is already being characterized as a hunter with an active, even

Nun's cat playing with a spindle from a 14th-century manuscript.
Cat in a snail shell from the *Maastricht Hours*, c. 1320.

violent sex life. This is no docile pet, but a full-blown carnivore that retains its wild behaviour, even though it is now living alongside humans.

Also in the thirteenth century, the philosopher Albertus Magnus wrote a treatise on animals in which he observed that the cat 'loves to be lightly stroked by human hands and is playful, especially when it is young'. This suggests a more friendly relationship with the cat, but Magnus then spoils it by adding that 'it especially likes warm places and can be kept home more easily if its ears are clipped since it cannot tolerate the night dew dripping into its ears ... They have whiskers around their mouth and if these are cut off they lose their boldness.'

In the thirteenth century nuns were often in trouble for keeping too many pets in their nunneries, including dogs, rabbits and even monkeys. A nuns' rule book introduced in 1300 stipulates: 'You shall not possess any beast, my dear sisters, except only a cat,' and there is an illustration in a manuscript from this period that shows a nun working at spinning, with a cat playing with one of her spindles.

The permission to keep cats was accompanied by stern warnings:

> Now if someone needs to keep one, let her see to it that it does not annoy anyone or do harm to anybody, and that her thoughts are not taken up with it. An anchoress [a woman who has taken the veil] ought not to have anything which draws her heart outward.

In the Book of Hours known as the *Maastricht Hours*, produced in the Netherlands in the early fourteenth century, there is a curious little illustration that shows a cat living in a spiral snail shell. Why the monk who drew this strange picture should have wanted to treat

a cat in this way has been much debated. Was he being hostile to the cat, or sympathetic? One suggestion was that the cat represents the accepted companion of nuns, while the snail symbolizes the virtue of humility, for which nuns strove. Another interpretation is that the artist was feeling sorry for the way in which cats were being treated, and thoughtfully provided one with a hard shell into which it could retreat for safety. An alternative view, which seems to make more sense, is that this was simply a visual joke inserted in the margins of the book by a bored illuminator to relieve the tedium of the many long hours spent copying the lengthy manuscripts.

Towards the end of the medieval period, attitudes to cats began to change. From being the friendly, useful companions of devout, God-fearing nuns, they now found themselves labelled as the evil familiars of Devil-worshippers. This attitude would spread and harden in the centuries to come. A terrible period of persecution was on the horizon for the domestic cat.

4

Satanic Cats

From the twelfth century onwards there were two distinct
attitudes to cats. For many people the cat population continued
to operate as important rodent-controllers, and every so often a
cat would go beyond being a mere working animal and become a
welcome pet inside the house. Working cats and house cats were
always popular, but now a negative attitude began to run alongside
the friendly one. For some people, the cat was now seen as an evil
animal, in league with the Devil. For them, the cat needed to be
persecuted if Satan and his followers were to be defeated.

As early as 1180 the warning bells were sounding. The gullible
were told – and believed – that during satanic rituals, 'the Devil
descends as a black cat before his devotees. The worshippers put out
the light and draw near to the place where they saw their master.
They feel after him and when they have found him they kiss him
under the tail.'

In the following century Pope Gregory IX added his voice to
the campaign against the evil cat. He was intent on stamping out a
sect of Devil-worshippers in Germany who involved black cats in
their rituals. This sect had taken its inspiration from the legend of
the Nordic goddess of sexuality, Freya, written down in 1220. She
was said to be drawn through the heavens by a pair of magnificent

cats. Sometimes she was depicted in a chariot and sometimes she was shown riding on the back of one of the animals. The cats symbolized the twin qualities of their Scandinavian mistress, fecundity and ferocity. They were very loving until they were angered, when they became terrifyingly ferocious.

Freya wept golden tears as she roamed the night skies, and soon became the patroness of a witchcraft cult that involved trance-like states and orgiastic rites. This cult had taken a hold in Germany, and it was news from there that had alarmed the pontiff in Rome. He had been told that members of the sects that made up this satanic cult would gather for a ceremonial meal and, when the meal had ended, they would rise and a statue of a black cat would come to life, walking backwards with its tail erect. First a new initiate and

The Devil's cat. The horned Devil is telling the reluctant Satan-worshippers to kiss the cat's behind. Bruges, *c.* 1470–80.

then the master of the sect would kiss the cat on its rump. A wild orgy would follow.

How much of this is true is irrelevant. The fact is that people believed it, and an Inquisitor was sent to stamp out the practices of the cult, using torture to gain confessions. Clearly, as far as the Catholic Church was concerned, the cat was in bad company, and it was inevitable that it would come under attack, along with the Devil-worshippers themselves.

It was the pure-black cat that was the focus of the campaign. Cats of other colours were spared, and if a black cat had even the smallest patch of white hair somewhere on its body, it too was safe. A small patch of white fur was called an angel's mark, and it is interesting that even today most black cats carry such a marking.

The attack on black cats spread all over Europe, and thousands were put to death by devout Christians who believed that the screams

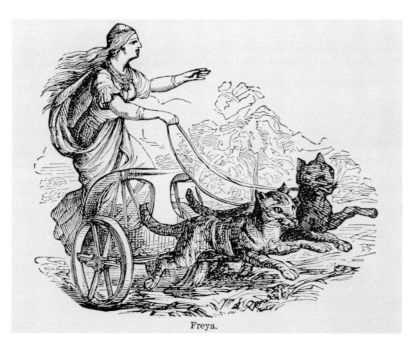

Freya.

43

The goddess Freya in her chariot, pulled by two powerful cats. Ludwig Pietsch, 1865, woodcut.

of the dying cats were in reality the cries of the Devil. The worst day of the year for black cats was 24 June, the feast of St John, when as many black cats as could be found were rounded up, put into sacks or large baskets hundreds at a time, and burned alive on bonfires. It was believed that on this day witches could turn themselves – by shape-shifting – into black cats to carry out evil deeds. So, to the faithful, it was witches who were suffering and being put to death, not cats. This is why onlookers – even pious Christians – could stand laughing at the cruel spectacle of writhing bodies, listening to the hideous screaming of the burning cats and taking pleasure in it. They truly believed that they were witnessing a spectacle in which the Devil was being defeated.

It goes without saying that if gangs were out rounding up cats to put into the sacks for these festivals, the men given this task would not be too concerned about the colour of the cats they were catching. Just as all cats are grey in the dark, so all cats are black in the sack. As a result, all cats were at risk on such occasions. The feline population as a whole was under threat.

The religious assault on the innocent cat spread beyond the Church. Writing between 1406 and 1413, Edward, Duke of York, felt obliged to add a comment on the cat's evil nature in his great work *The Master of Game*, the first major treatise on hunting in the English language: 'One thing I dare well say that if any beast has the devil's spirit in him without doubt it is the cat, both the wild and the tame.'

In some places, cruelty to cats became an accepted social event without any special religious link. In the city of Ypres in Belgium, for example, it became a popular custom to throw live cats from the top of the belfry tower of the Cloth Hall once a year. In years when the city had been prosperous, only a few cats were thrown;

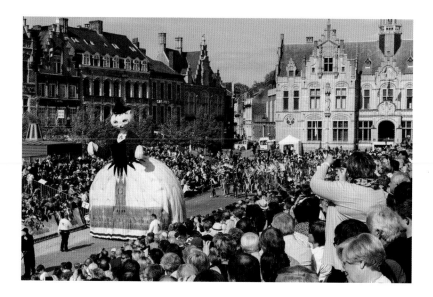

in bad years the number was increased, presumably because it was thought the Devil had been at work and his feline familiars must be dealt with more firmly as a punishment. The earliest descriptions of this cat-throwing have been found in the city chronicles for the years 1410–20, but it may have been taking place even earlier. It continued annually until 1817, when the final throwing took place. An eyewitness reported that the very last live cat to be thrown somehow managed to survive the fall and was seen scampering to safety. After that the custom died out, and the idea was not revived until the twentieth century, when it became a great cat parade and carnival with no cruelty involved. The cats that are thrown now are toy ones, to be caught by children standing below. In the twenty-first century the parade – called the *Kattenstoet* – continues, but it is staged only once every three years.

In sixteenth-century Holland an evil cat appeared in the company of a curious anti-saint known as 'Saint' Aelwaer. A satirical image meant to display attributes that were the exact opposite of

The modern *Kattenstoet* in Ypres, celebrating the throwing of cats from the belfry tower each year. Today, live cats have been replaced by toy cats.

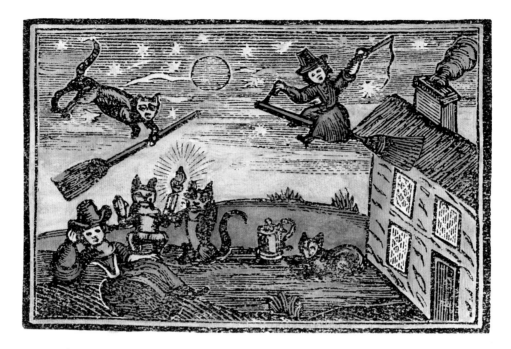

the qualities of the Virgin Mary, she was described as a 'demonic patroness of all tribulation'. In a Dutch woodcut of 1550 she is portrayed riding a donkey, with a magpie on her head symbolizing immorality, a pig under her left arm symbolizing gluttony and a cat held aloft on her right hand symbolizing the forces of evil. The cat is held high, like an emblem or ensign that is clearly meant to advertise the fact that this figure is in league with the Devil.

This widely diffused negative attitude to the cat heralded a period of about three centuries of brutal feline persecution, in which cats all over Europe were tortured and killed. Much of it was focused on witchcraft. The witch-hunting craze rose to a frenzy between 1580 and 1630, spreading rapidly and leading to the execution of as many as 60,000 unfortunate women. It took the form of a kind of moral panic, with the victims being portrayed as arch-enemies of the Christian Church. They were said to be Satanists, who worshipped

The cat as the witch's familiar in the 17th century, woodcut.

Elck dient sinte aelwaer met grooter begheert die van veel menschen wordt gheeert.

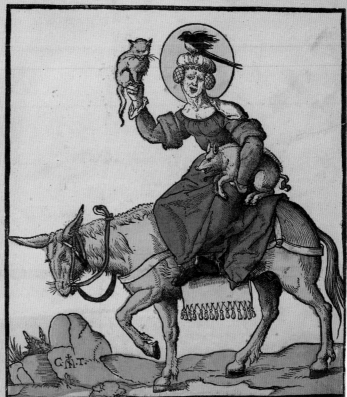

'Saint' Aelwaer, the demonic anti-saint with her evil cat, by Cornelis Anthonisz.,
c. 1550, woodcut.

the Devil and engaged in unspeakable pagan rituals. In reality, most were no more than eccentric old women who lived alone and whose only companions were their cats. They were despised by superstitious villagers, who feared being cursed by them. Socially speaking, their executions served to rid local communities of awkward eccentrics who refused to join in with normal village activities. For the Church, they added a valuable fear factor that helped to stop people from straying from strict religious practices.

There are several reasons why cats – rather than dogs or horses, for example – became associated with Satanic powers. First, they had been sacred to an earlier, non-Christian religion – that of ancient Egypt. This gave them a pagan importance that worked against them. Second, they stubbornly kept their independence, even when they were tamed and domesticated. They never became the slaves of men in the way dogs, horses and cattle did. This made them the heretics of the animal world. Heretics challenged orthodox views, and cats challenged the rules that were laid down by their owners. They tolerated humans but kept their wild streak.

Third, many of them were jet-black and, as with crows, this caused them to be associated with death. Fourth, in pagan superstition cats, especially black ones, were thought to bring good luck. If something was good for pagans, it had to be bad for Christians – another feline fault. Fifth, cats are by nature nocturnal and therefore animals of the dark hours, when evil spirits are abroad. Furthermore, they could be heard at night yowling and caterwauling, making horrific noises that were thought to reflect demonic possession rather than testosterone.

Finally, cats were seen to play with their prey before killing it. This apparent cruelty was likened to that of Satan: 'The devyl playeth

ofte with the synnar, lyke as the catte doth with the mous,' as William Caxton wrote in the fifteenth century. In cats' defence, it is worth pointing out that they do not play cruelly with mice. Once they have caught a mouse, they want to be sure that it is incapacitated before they attempt to eat it. Failure would mean that, as they chew into the mouse, it might respond by biting the cat's face. This is something the cat cannot risk, so it lets go of the mouse to see how much life is left in it. It will repeat this process until the mouse is no longer a biting risk. This may give the impression of torture, but it is simply the cat being cautious.

With all this going against it, it was decided that the cat must have some kind of pact with the Devil. Towards the end of the fifteenth century Pope Innocent VIII issued a decree that put the Vatican's official stamp, yet again, on cat hatred, declaring it to be an unholy creature. He demanded that, whenever a witch was burned, her pet

49

The Devil appears to St Dominic of Calerueja in the form of a black cat climbing up his bell-rope, 1400–1410, illustration from a manuscript.

cat (if she had one) was to be burned with her. Worse than that, some witch-finders insisted that anyone owning a cat must automatically be a witch. For even the most ardent cat-lover, this was too much. When asked whether the pleasures of owning a cat could outweigh the nightmare of being burned alive, there was only one answer. As a result, the population of household cats began to decline rapidly.

When cat populations were decimated in this way, rats and mice flourished, and when flea-infested rats brought widespread epidemics to Europe it was seen by some as a case of the cats getting their revenge for the horrors to which they had been subjected. As one writer put it, if the murdered cats had ghosts they would have enjoyed a vindictive satisfaction in watching the mass suffering of the human population.

When he came to compile his encyclopaedia of natural history, *The History of Four-footed Beasts and Serpents*, in the middle of the seventeenth century, the English writer Edward Topsell was unable to ignore the cat's evil reputation, even in a serious scientific volume. He warned that 'the familiars of Witches do most ordinarily appear in the shape of Cats, which is an argument that this beast is dangerous to soul and body.' He recognized how useful they were in keeping down rodent pest populations, however, and reached a typical British compromise by suggesting that 'with a wary and discreet eye we must avoid their harms, making more account of their use than of their persons.' In other words, we should exploit their skill in the hunt, but not be friendly towards them.

Eventually, in the eighteenth century, sanity returned to Europe and cats were no longer persecuted. The days of the demonic, evil cat were finally over, and domesticated felines could return to their useful task of pest control. In 1727 the French writer François-Augustin

de Paradis de Moncrif devoted a whole book to their defence. Called simply *Histoire des chats* (The Story of Cats), it was the first cat book ever written. In earlier centuries it would have been unthinkable to devote a whole volume to this subject, and even in the early eighteenth century the book came in for much ridicule. This came to a head when Moncrif was admitted to the French Academy. One of his critics, a fellow academician, let a cat loose during the ceremony, and it meowed pitifully during Moncrif's maiden speech. All the other academicians started to mimic its cries, and Moncrif was so upset that he withdrew his cat book from circulation.

Moncrif should have been prepared for such scenes, having warned in his book of the surviving dislike of cats: 'It is true that

Cat playing the bagpipes, from a Book of Hours, Paris, *c.* 1460. Perhaps the wailing of satanic cats reminded the artist of the sound of the pipes.

the colour black does much harm to cats among vulgar minds; it augments the fire of their eyes; this is enough for them to be thought sorcerers at the least.' He adds: 'One has heard since the cradle that cats are treacherous by nature . . . Succeeding reason may cry out in vain against these calumnies . . . there is none among the animals who can bear more brilliant titles than those of the cat species.' Warming to his subject, he declares that 'one day we shall see the merit of cats generally recognized.' He was right, of course, but, as he discovered to his embarrassment, a little ahead of his time.

One surviving legacy of the brutal centuries of feline persecution is the popular superstition that if a black cat crosses your path, you will suffer bad luck. This is based on the fear that because the Devil – in the guise of a cat – has come close to you, you are in serious danger. This belief is common in mainland Europe and the United States, but not in the British Isles. There, the opposite is believed – that if a black cat crosses your path you will enjoy good luck – for the simple reason that the Devil has crossed your path but ignored you and done you no harm. For some reason, the county of Yorkshire differs from the rest of the British Isles and, like continental Europe, sees the appearance of a black cat as a sign of bad luck.

5

Old Master Cats

Cats feature in many paintings by the old masters, but hardly ever as the principal figure. They are usually tucked away in a corner of a scene, playing a very minor role. One great artist who did enjoy watching cats, however, and sketching their varying moods and postures, was Leonardo da Vinci.

Leonardo is quoted as saying: 'The smallest feline is a masterpiece', and cats appear in at least eleven of his drawings. Sadly, however, they never progress to become a feature of a painting. Perhaps this is not surprising when one considers that, although he produced many hundreds of drawings, he left us only about fifteen finished paintings. This is a staggeringly small output for an artist who gave us some of the world's greatest masterpieces. The reason for the great rarity of Leonardo's finished work is that he was one of the world's great procrastinators. He was always about to start something, but then put it off; or he actually got started but then never finished the work.

Leonardo's *Madonna with a Cat* is a case in point. He was planning to make a painting of the Madonna with an infant Jesus in her arms, and with the child hugging a cat. The subject of the painting was the legend that a cat gave birth at the very moment of the Nativity. He did no fewer than eight preparatory sketches

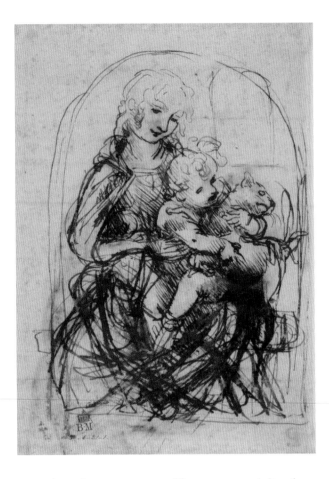

in the 1470s, but the painting itself never materialized, or at least has not survived. Apart from his general procrastination, there may have been an additional reason for him not to have completed this particular painting. It is clear from his sketches that he had live models sitting for the painting, including a real woman, a real infant and a real cat. It is also very clear that this combination was a troublesome one. In each of the sketches, the infant is obviously struggling to keep hold of the cat, and in one of them he appears to be nearly strangling it in his efforts to stop it from jumping down and stalking angrily out of the studio. The animal is drawn by Leonardo

54

Sketch made by Leonardo in the 1470s for a painting he was planning called
Madonna with a Cat.

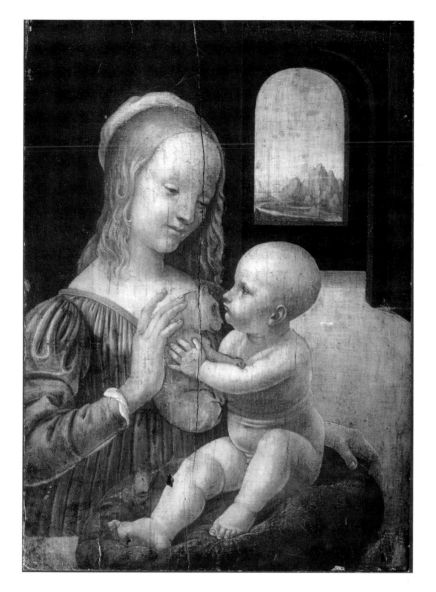

with great observational honesty, and is shown writing this way and that, trying desperately to escape.

Anyone who has ever been asked to hold a cat for any length of time to please a photographer will know how difficult this can become once the cat has decided that it has had enough. A dog might

Madonna with a Cat by Cesare Tubino, pretending to be Leonardo da Vinci, mid-20th century, oil on wood.

stay put for hours, but a cat has a much shorter fuse. Leonardo has brilliantly caught this struggle between infant and cat, but the sketches he made were obviously dashed off at high speed. It must have dawned on him that any attempt to keep the cat there for the many hours needed for a detailed portrait painting would be doomed to failure. As a result, we have been robbed of a finished painting of a cat by the grand master.

Amusingly, a painting entitled *Madonna with a Cat* did come to light, and was even exhibited as a newly discovered Leonardo at an exhibition of his work in Milan in 1938. It was said to have come from the collection of an Italian nobleman whose family had owned the work for many years. After the exhibition was over the painting disappeared, and nothing was heard of it for half a century. Then, when the Italian artist Cesare Tubino was on his deathbed in 1990, at the age of 92, he admitted that he had done it and that he had kept the painting hanging on his bedroom wall for the past fifty years. He had apparently painted the picture not for financial gain, but because Mussolini would not allow him to exhibit his own work – and this was his revenge.

Looking closely at the picture, it is surprising that anyone could have accepted it as a genuine Leonardo, if only because of the very poor depiction of the cat. The animal displays no movement at all and looks more like a dummy or stuffed cat than a living one. Its rounded rear end is particularly odd.

We must be content with Leonardo's sketches of cats, then, and although they are only very minor works, some do demonstrate his remarkable powers of observation. These are not pretty, cuddly pet cats; they are almost certainly working house cats kept to control rodents. The artist catches them engaged in typical feline activities:

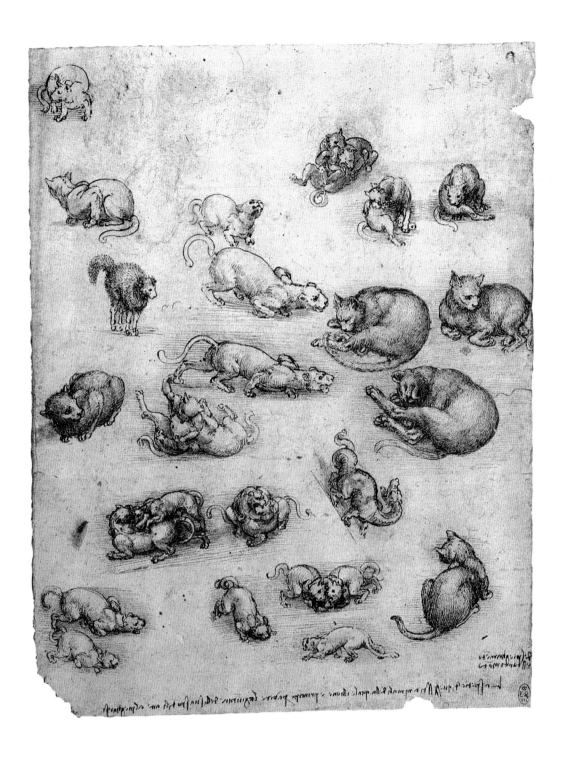

Page of sketches by Leonardo da Vinci, *c.* 1513–18, pen and ink with wash over black chalk, showing cats in well-observed, naturalistic postures.

cleaning themselves, rolling over, fighting, resting, crouching or bristling with fear. An odd feature of his cat images is that although they show highly characteristic feline postures, their faces are un-usually pointed – too long for a typical modern pet cat. Whether this was a Leonardo stylization or whether his cats really did have longer snouts, we will never know, but it does somehow reduce their feline appeal, at least to the modern eye.

Leonardo da Vinci was not only a brilliant artist but an extraordinary man, far ahead of his time in many ways. In one of his notebooks he writes: 'If you are as you have described yourself, the king of the animals – it would be better for you to call yourself king of the beasts since you are the greatest of them all! – why do you not help them . . .?' To refer to human beings as animals – even

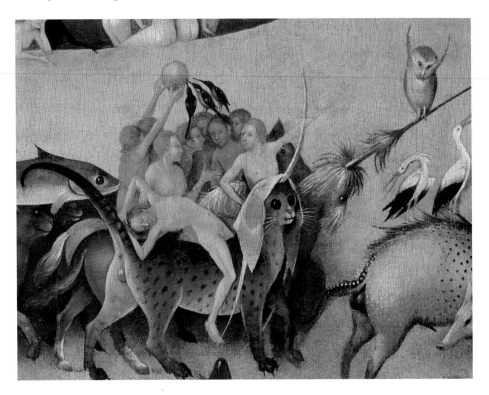

58

Hieronymus Bosch, cat with a naked man on its back. This animal appears in the centre panel of the triptych *The Garden of Earthly Delights*, 1490–1510, oil on wood, and is seen walking in a parade of strange beasts.

great ones – in this manner in the fifteenth century is truly amazing. When I did so myself as recently as 1967, I was soon under attack, and it is not surprising to read of Leonardo's caution in the sentence that follows, in which he grumbles: 'Even more I might say if to speak the whole truth were permitted me.' In 1519, a few years before his death, he did risk going a little further, when he left himself a memorandum reminding him to 'Write a separate treatise describing the movements of animals with four feet, among which is man, who likewise in his infancy crawls on all fours.'

With this exceptionally enlightened attitude towards other animal species, it is not surprising that in his time Leonardo was almost alone in taking the trouble to catch so perfectly the moods and movements, postures and actions of the humble house cats of his day. No other old master seems to have enjoyed the direct observation of feline behaviour in the way that Leonardo did.

Far to the north of Leonardo's Italy, working in the Netherlands, was a contemporary of his, Hieronymus Bosch. Both were born in the middle of the fifteenth century, and both died early in the sixteenth. Neither left us many paintings – Leonardo 15, Bosch 25 – but those they did leave were masterpieces. There was one big difference between them: Leonardo gave us reality, Bosch gave us fantasy. Where cats are concerned, Leonardo's are caught in moments of natural behaviour, while Bosch's are taking part in arcane ceremonies in some other world.

One of Bosch's cats is being ridden bareback by a naked man. This makes it as large as a horse, but all sense of natural proportion is lost once you are inside Bosch's dream world. It is a grey cat with black spots, black feet, a sharply pointed tail and a long, thin spike sprouting from its forehead. It also has prominent genitals, very large

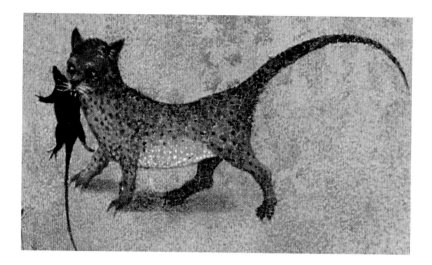

black eyes and a strange piece of cloth draped over its head. Walking behind it is another cat, also with a naked man on its back. This man is holding a large fish that he is pointing forwards, as if firing a gun; this cat is plain brown in colour.

Another of Bosch's cats, seen walking away from Adam and Eve with a fat lizard held in its jaws, also has a long, tapering, sharply pointed tail. This animal has a brown coat, again covered in black spots, but this time there is a separate patch of white spots on its belly and chest. This form of coloration is unknown among cats, and seems to have been invented randomly by the artist to make his cat look strange. The animal also has a pronounced downward arch to its back. In a horse, this hollowed back would be called a swayback or saddleback; the technical term for it is lordosis.

A fourth Bosch cat is reaching out from underneath a red curtain to grab a large dead fish. Watched by a naked woman, it turns its head towards her and threatens her with an open mouth. Its long, pointed ears curve slightly so that they start to look like horns. This is a devil-cat.

Hieronymus Bosch, cat with a lizard in its jaws. This animal appears in the left-hand panel of the triptych *The Garden of Earthly Delights* and is seen walking away from Adam and Eve.

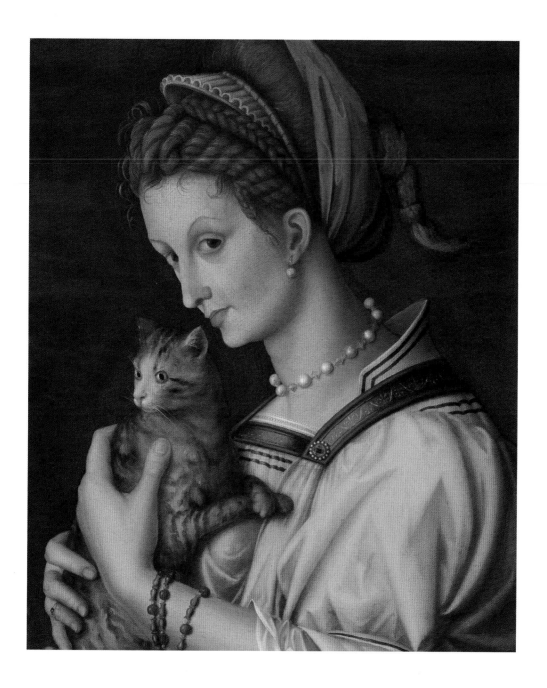

Francesco d'Ubertino Verdi, *Woman with a Cat*, 1525, oil on panel.

These Boschian cats are not loved, but neither are they hated. They are simply part of a bizarre fauna that swarms all over his major triptychs. Birds, mammals and reptiles of many different kinds interact with the human figures, and cats are just one of the species illustrated.

In the sixteenth century, after the time of Leonardo and Bosch, a number of artists added a cat to their portraits. This was nearly always done with portraits of ladies, presumably because, at that time, it would have been thought of as slightly effeminate to paint a portrait of a great man with a cat in his lap. One such artist was the Florentine Francesco d'Ubertino Verdi, known as Bacchiacca, a painter at the court of Duke Cosimo de' Medici. In the best-known of his 'woman-with-cat' portraits, the woman in question is wearing a striking golden-yellow dress and clasps her cat lightly in both hands. The alert cat has twisted its head to look at something in the distance. The woman leans her head towards the cat as if she is about to press the back of its head against her face. The cat is a striped, mackerel tabby, a breed that was especially rare and valuable at the time. In other words, a high-status lady is depicted with a high-status cat. This tabby breed was known in the West as a Syrian cat – in Italy, *soriano*.

Bacciaccha painted another portrait of this type, but it is less successful. In it, the woman, dressed drably in black, stares vacantly into space. She supports her cat in her left hand and strokes it absent-mindedly with the first two fingers of her right hand. The cat itself, which is pale brown with dark spots, looks ill at ease. This variant of the mackerel tabby, known as the spotted tabby, appealed to some owners because its spots made it look like some of the exotic, small wild cats. Its spots are, in reality, 'broken stripes' – stripes that have become broken up into rows of dots. This would also have been a

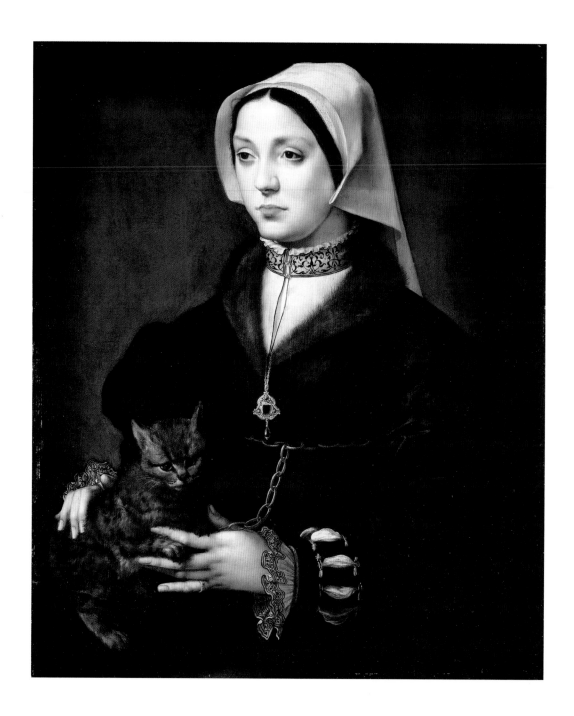

Ambrosius Benson, *Woman with a Kitten*, early 16th century, oil on canvas.

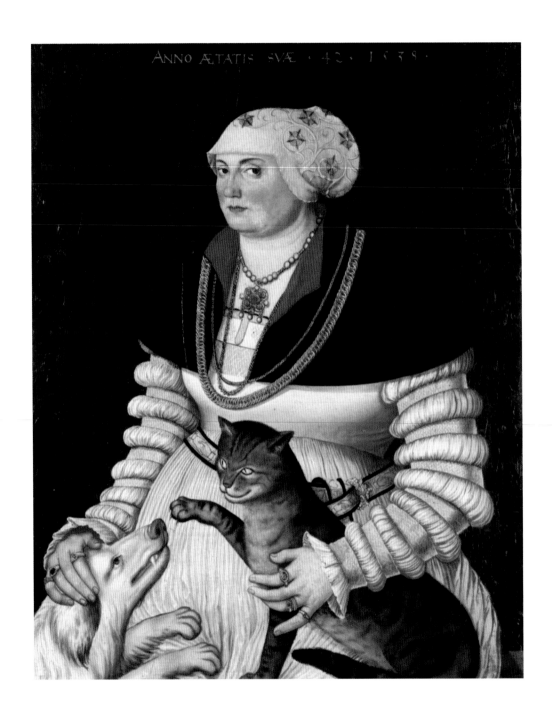

Hans Asper, *Cleophea Holzhalb*, 1538, oil on panel, with her cat about to scratch the delicate nose of her pet dog.

high-status breed for a pet-owner in the sixteenth century, and the animal would have been distinguished from the common mousers.

Another sombre lady is the one shown holding her pet kitten painted by Ambrosius Benson in Bruges in the first half of the sixteenth century. She, too, stares solemnly into the distance, balancing the kitten on her right knee, with her right hand lightly on its back and her left hand, rather curiously, holding its front right paw between her first and second fingers. The kitten is, once again, a high-status tabby cat imported from Syria. Benson was an Italian-born artist who moved to Bruges when he was about twenty and spent the rest of his life there. His trademark portraits were of women holding something in their hands. This was nearly always a book, but in this particular case, it was a cat.

A bolder portrait altogether is that created by Hans Asper in 1538. *Cleophea Holzhalb* shows that lady managing to hold both her pet cat and her pet dog. The dog looks submissive and cowed, while the irritated cat, restrained by the woman's left hand, is clawing out at the dog's sensitive snout. One cannot help feeling that this pleasant pet-loving scene is about to get ugly. The unusually large cat, which has the broad head of a dominant tom, is yet another mackerel tabby, but this time with a rather grey coat. Asper was a Swiss artist working in Zurich, where he spent his entire life. He is thought to have been one of the illustrators who worked on the animal figures in Conrad Gesner's great *Historia animalium* (Natural History), which was being created in the city at the time Asper was active.

Towards the end of the sixteenth century the Italian Baroque painter Annibale Carracci introduced a less formal composition in which two children are tormenting a cat. They have placed a live crayfish on the table in front of it, knowing that if it tries to attack

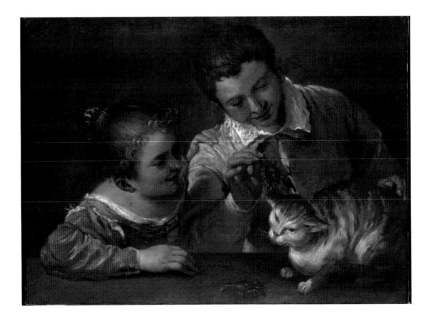

the crustacean it will be nipped by its sharp claws. Since the cat appears to be reluctant to do this, the boy is making sure that it suffers by lowering another crayfish on to its right ear. This crayfish has responded by clamping the ear painfully in one of its claws. The cat is trying to twist its head away to break free, but the boy holds it firm to prolong the torture. Today we see the sneering smiles of the two children as singularly unpleasant, but in 1590, when *Two Children Teasing a Cat* was made, the animal was still the subject of widespread religious persecution and the children would simply have been seen as playful.

At the very beginning of the seventeenth century the social rule suggesting that only women or children should be portrayed with their cats was broken and a portrait of a great man with his cat did at last appear. Even now, the cat was not shown held on his lap, but was instead depicted sitting on a windowsill next to him. The story behind the portrait is an unusual one.

Annibale Carracci, *Two Children Teasing a Cat*, 1590, oil on canvas.

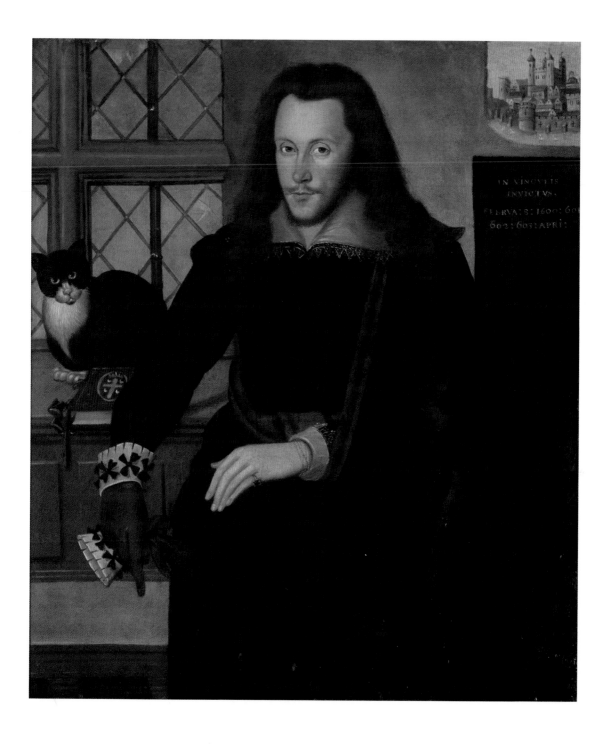

John de Critz the Elder, *Henry Wriothesley, 3rd Earl of Southampton*, 1603,
oil on panel. The earl is depicted with his faithful cat Trixie, who stayed with
him when he was imprisoned in the Tower of London.

The painting shows Henry Wriothesley, 3rd Earl of South-ampton, with his black-and-white cat Trixie. The earl had been imprisoned by the queen, Elizabeth I, in the year 1601, and according to legend his cat made its way across London and climbed down the chimney of his cell, where it remained faithfully by his side for the rest of his incarceration. This is clearly an embellishment of the true story, because, although cats have an excellent homing ability, they cannot 'home' to a place they do not know. A more likely explanation is that the earl's wife took the cat to the Tower and either pretended that it had followed her there, or simply gave it to her husband, who then embellished the story himself.

What does seem to be true is that the cat did remain with its master for the two years of his imprisonment. He was so grateful for its company that at the end of his internment, when he had a portrait commissioned, he had the cat included in the composition, sitting alongside him. It must be said that if the portrait is an accurate one, the cat was in a thoroughly disgruntled mood at the time: it is glowering at the artist as though it would like to throttle him.

The earl was described variously as 'gentle and debonair', quar-relsome and a born fighter. He was involved in jousting, duelling and even brawls at court, and was forever being banned or allowed back by the queen. He was eventually condemned to death by her for being involved in a rebellion that was an attempt to overthrow her, but she was later persuaded to reduce his sentence to life imprisonment. Then, in 1603, the queen died and the earl and his cat were released by her successor.

It has been claimed that the portrait was commissioned and hurriedly completed during the earl's final days in prison, so that it could be rushed to the new monarch, King James, in the hope that it

would help the earl find favour with his new master. Both James and
the earl were reputed to be bisexual, and the portrait was said to have
been designed to make the prisoner sexually attractive to the king.
It shows off the beauty of his long, elegant fingers and displays his
hair cascading, unadorned, around his shoulders. If that is the case,
it would help to explain why the earl was prepared to be portrayed
in the presence of a cat, which, as we have seen, was typical of formal
portraits of women but not of men.

During the seventeenth century, the cat continued to appear
as an accessory in many portraits, but it did not yet warrant a full-
sized portrait itself. One of the few works to focus on the cat rather
than its owner at this time is by the Flemish artist Jacob Jordaens,
but this early feline portrait is only the size of a postcard, about 16 ×
11 cm (4 × 6 in.). Modest as it is, it represents a major shift of status
for the cat, coming at the time when feline persecution was waning
and people were beginning to admit to having cats as friendly pets.
Still, Jordaens's *Study of a Cat* does not depict a relaxed animal but
rather one with an expression of sad resentment. This is a cat who
has endured a bleak, stressful life and has suffered hard times.

Another Flemish artist of the period, Abraham Bloemaert,
also chose to show an unhappy cat, in his painting *Youths Playing
with the Cat*. This yowling animal is being held by one youth while
another grabs and pulls its tail. This ill treatment may be mild when
compared with the brutal cat-burning rituals of earlier days, but
the cat is still not shown in anything approaching a friendly, loving
context. One can only hope that the cat did not have to pose for this
painting for any length of time.

The Dutch painter Jan van Bijlert is another seventeenth-
century artist who shows the cat as a companion animal, but one

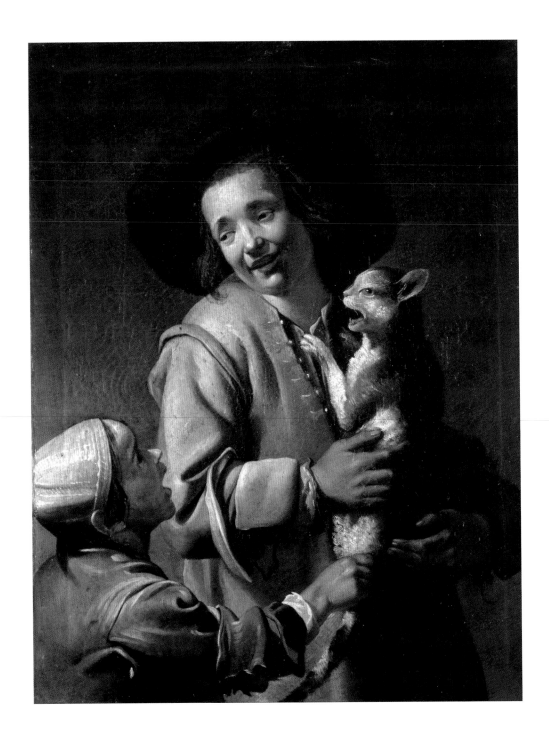

Abraham Bloemaert, *Youths Playing with the Cat*, 1620–25, oil on canvas.

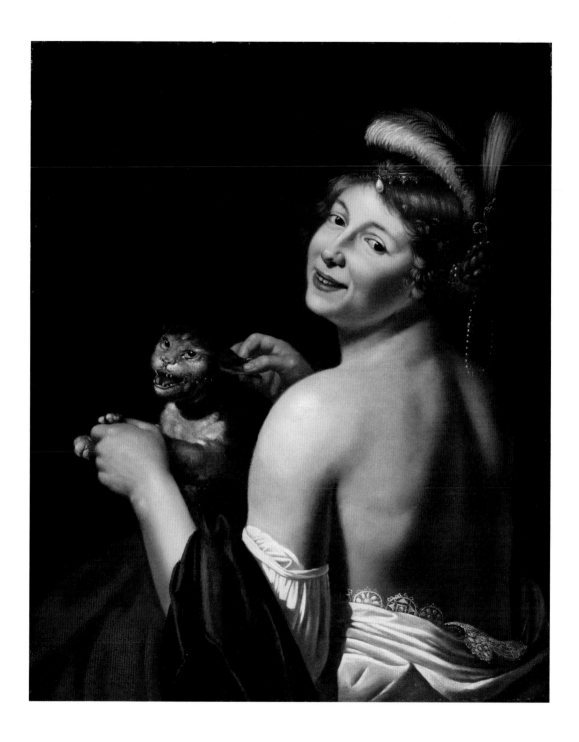

Jan van Bijlert's painting *Courtesan*, also known as *Young Woman Playing with a Cat*, 1630–35, oil on canvas, shows a half-naked prostitute pulling a distressed cat's ear.

that is not treated with much affection. In his portrait of a courtesan, the smiling, half-naked woman holds the cat's front legs firmly in her left hand while she squeezes its ear with her right. The cat's reaction to this, according to the artist, is to display an angry face, mouth open and sharp teeth glinting. Whether it is hissing, growling or meowing we cannot say, but this is obviously meant to be an indignant cat.

One thing is clear: Van Bijlert has cheated with the cat's expression. The precision with which he has painted the animal's front paws makes it possible for us to see that its claws are sheathed. If the animal were as angry as its face suggests, its claws would be extended and the woman would have to be grasping its front legs much more firmly. In other words, the woman is not tormenting the cat as much as its face implies. She is posing with the cat in the artist's studio and is probably only lightly pinching its ear; Van Bijlert has decided to use a little artistic licence and amplify its discomfort to full-blown anger. This means that he was not faithfully depicting a cat that was angry at being held in the studio, but was adding the anger as a dramatized theme. His motivation may have been personal or it may have been cultural, but, whichever it was, it was in keeping with the other portraits of his day that involved feline companions.

It is hard to decide whether the artist simply disliked cats – perhaps still influenced by their supposed satanic associations – or whether he was making some kind of symbolic statement concerning the courtesan. There was a popular Dutch saying at the time, *de kat in het donker knijpen* (to squeeze a cat in the dark), which meant to do something on the sly. In other words, if you squeeze a girl in the dark, nobody will know what you have done. ('Cat' was slang for a girl in a sexual context.) The erotic nature of the phrase is emphasized by a poem from the time that includes the words: 'But Bavo squeezed

the kitten in the dark,/ He squeezed the kitten at night . . ./ He squeezed them, but squeezed them softly.'

Viewed in this light, the painting takes on a special meaning. We see a half-naked girl at night, squeezing a cat. She turns and smiles at us, in effect saying: 'You may squeeze me in the night, just as I am squeezing this cat, and nobody will know.' Whether this is a valid interpretation or not, the fact remains that, as a portrait, the painting depicts a pet cat in a miserable state, something that would be unacceptable in later centuries.

In a slightly happier scene, a young cat is shown in the grasp of a child in the painting *Two Children and a Cat* by the Dutch artist Judith Leyster. The child and his companion, wreathed in smiles, are clearly enjoying themselves enormously, but the poor cat looks most uncomfortable. It shows no interest in its human companions, no affection towards them, and is staring into the distance with an air of bored resignation, but at least it is not being hurt or having its tail pulled. There is no suggestion that the children dislike the cat, merely that they are insensitive to its needs. It is more a toy for them to play with than a much-loved companion.

In the eighteenth century a slight improvement occurred in humans' relationship with their feline house guests. In his painting *An Old Man with Cat* of the 1740s, the Italian artist Giacomo Ceruti shows us an elderly man who obviously cares about his cat and is shown caressing its head. The cat may look bored, but the old man is attentive to it and embraces it in a loving way.

The French artist François Boucher, who was the toast of Paris in the mid-eighteenth century and had Madame de Pompadour as his patron, was the master of the romantic scene. He was notorious for his comment that nature is 'too green and badly lit'. In his painting

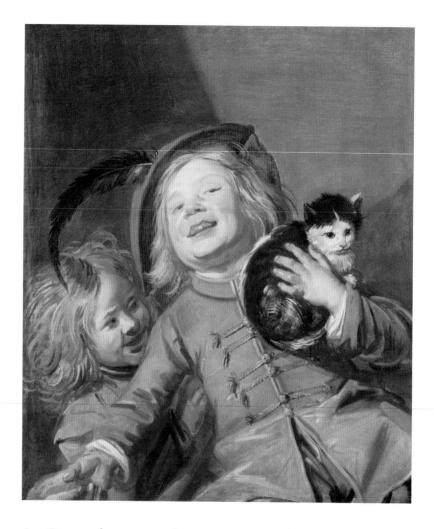

Les Caresses dangeureuses (Dangerous Strokes) of 1730, he shows a scrawny-looking cat on the lap of an elegant lady who appears to be rubbing its back gently – if rather absent-mindedly – with her fingers. The cat's expression suggests that it has had enough and is either about to scratch her or to jump down. Here, again, the cat is being treated kindly but is not at ease.

In the second half of the eighteenth century there are signs that cats were being given more respect, as the dark phase of their history

Judith Leyster, *Two Children with a Cat*, 1629, oil on canvas. The children are happy but the cat looks bored.

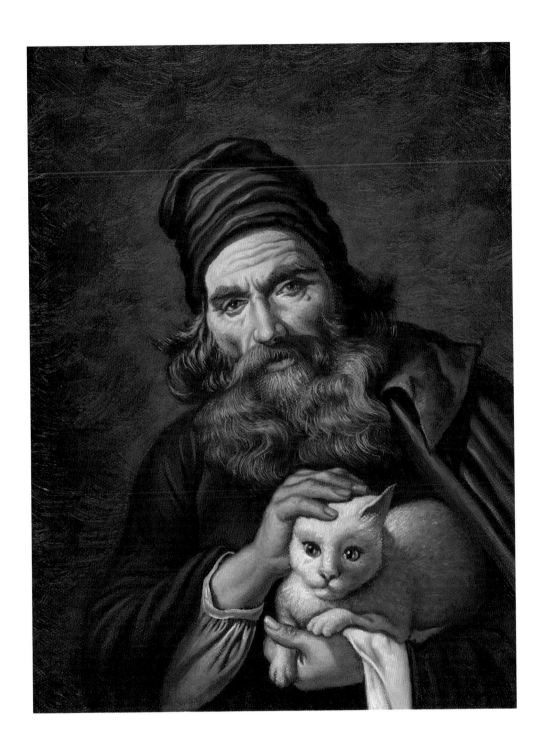

Giacomo Ceruti, *An Old Man with Cat, c.* 1740, oil on canvas,
shows greater care for the cat.

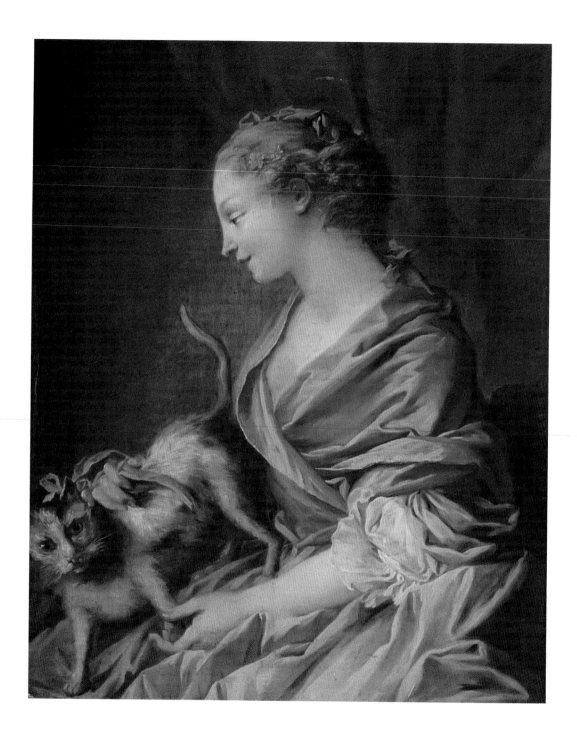

François Boucher, *Dangerous Strokes*, 1730, oil on canvas. The elegant lady seems unaware that her cat is becoming restless.

receded into the past. In 1761 the French artist Jean-Jacques Bachelier produced one of the earliest full portraits of a cat, *White Angora Cat Stalking a Bird*, a painting that he exhibited at the Paris Salon that year. This magnificent animal was clearly not a rough-living, working cat, but a valuable, pampered pedigree, with its spectacular long, white coat that removes it as far as possible from the appearance of the short-haired satanic black cat.

The exotic angora cat was the first long-haired breed known in the West. A few had been sent as gifts to the English and French nobility by Turkish sultans in the sixteenth century, and in the seventeenth century a few more were imported into France from Turkey by the distinguished cat-lover Nicolas-Claude Fabri de Peiresc. He was known as a scientific patron and kept a pair of angoras in his exotic personal menagerie. He had been alerted to some unusual felines in the Levant that he had heard described as having 'long

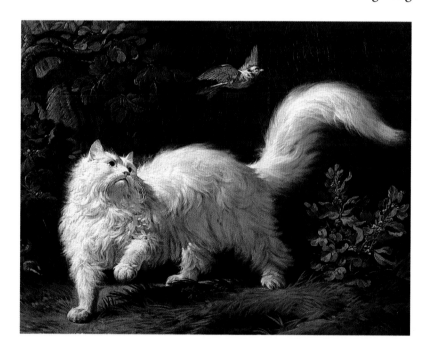

77

Jean-Jacques Bachelier, *White Angora Cat Stalking a Bird*, 1761, oil on canvas.

frizzy hair like a water spaniel's, whose tails, uplifted, form the loveliest plumes ever seen', and his scientific curiosity demanded that he acquire some. The splendid cat portrayed by Bachelier was probably a descendant of those that de Peiresc had imported.

Angoras remained novelties for about two hundred years, until the nineteenth century, when they were eclipsed by the Persian cat, with its even longer fur. Eventually angora cats died out altogether in the West, until being revived by enthusiasts in the 1960s. A few were found living near Ankara (formerly Angora) in Turkey – the original home of the breed. They were collected by the city's zoo, and a breeding programme was started to re-establish the breed. In the 1970s examples were sent to the United States and Europe and the breed began to appear at cat shows, although even today it is by no means common.

Another portrait of this elegant white cat breed appeared in the 1780s, when Marguerite Gérard and her mentor, her famous brother-in-law Jean-Honoré Fragonard, worked together on a portrait of a young woman with an obviously pampered angora cat. The young cat is striking out at her with both front paws as she approaches it with the hated grooming brush, and it is clear from her expression that this is not the first time she has met with this hostile response.

What we have here is a rich cat-owner with a high-status pet that will be submitted to a disciplined lifestyle whether it likes it or not. This may be a cat fed on delicacies and living in the lap of luxury, but it has not yet, at the end of the eighteenth century, arrived at the point where it is allowed to call the tune.

This specialized, long-haired rarity, the angora, was an exception to the general rule concerning the low status of cats in earlier centuries. It was pampered because it was so valuable and confined to

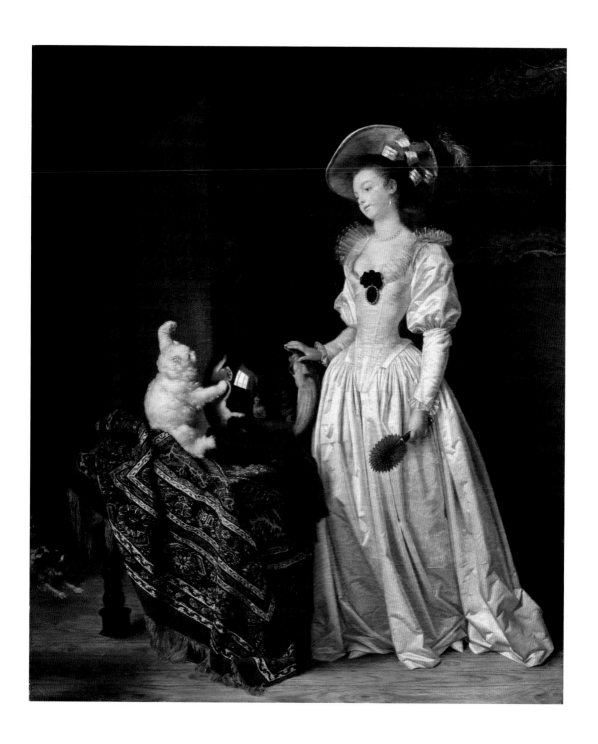

Jean-Honoré Fragonard, *The Angora Cat*, 1783–5, oil on canvas,
shows an angry cat resisting a grooming session.

such an elite ownership, but it had not yet managed to take over the household in the way that much-loved modern cats are prone to do. A new, more extreme stage had to be reached for this to happen. To find images of ordinary cats that are being smothered with love and allowed to have their own way, we must advance to the nineteenth century, when Victorian sentimentality took hold and almost all the portraits of people with their cats depict an idyllic relationship.

6

Nineteenth-century Cats

In *The Cat's Lunch*, painted by Marguerite Gérard at the turn of the nineteenth century, the cat has become the dominant figure in the composition, and its human companion crouches in the role of willing servant. This is a complete reversal of roles compared with paintings from earlier periods. It is almost as though the cat has become sacred again – not in a religious sense, but as an adored pet in front of which one knelt to pay homage with a ritual glass of milk. Even the family dog gazes up enviously as the cat fastidiously sips the offering held before it.

The girl's costume allows us to date the setting of this work to the years immediately after the end of the French Revolution. Gérard, who lived in the Louvre for thirty years, was untouched by the great change in power in France, except that in her nineteenth-century work she concentrated more on domestic scenes, most of her rich eighteenth-century patrons having lost their heads to the guillotine. In *The Cat's Lunch* she foreshadowed what was about to happen in Western attitudes towards cats and to the mood of feline art as the new century progressed. Although this work is pre-Victorian in date, it is thoroughly Victorian in sentiment. Good times were coming for the cat, and Gérard was the herald of this shift.

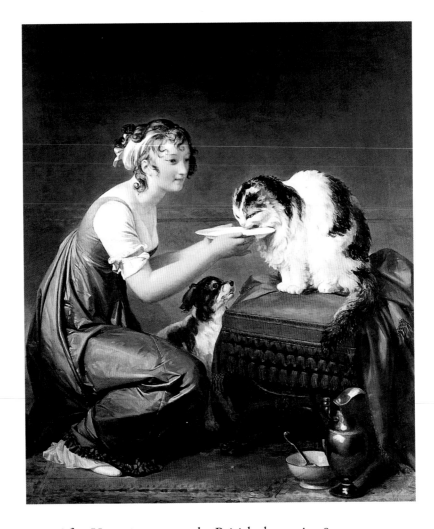

After Victoria came to the British throne in 1837, cats were at last treated with greater kindness and understanding by their owners. Now the family life of the cat was considered important enough to be presented as the centrepiece of a composition, with no humans present. A good example is the Dutch/Belgian artist Henriëtte Ronner-Knip, who became famous as a cat portraitist. Her felines were usually shown in cosy family groups, with a mother cat protectively watching her kittens at play.

82

Marguerite Gérard, *The Cat's Lunch*, c. 1800, oil on canvas.

The cats depicted in these nineteenth-century paintings are seen to be relaxed and living in comfort. This was a period of major reform in concerns over animal welfare, especially in Britain. In 1824 the first animal-protection society in the world was set up in London, the Society for the Protection of Animals. After Victoria came to the throne, the society was given her blessing, and in 1840 it became the RSPCA – the Royal Society for the Protection of Animals. Two of its first major achievements were the outlawing of animal baiting and the control of scientific animal experiments. It was in this atmosphere of growing concern for the welfare of animals, especially animal companions, that the artists of the Victorian period produced their paintings. The best of them reflected the growing respect for animal life; the worst became embarrassingly sentimental and coyly anthropomorphic.

83

A typical cat painting by Henriëtte Ronner-Knip,
A Cat with Her Three Kittens, 1893, oil on canvas.

Technically, one of the best of the British cat artists of the period was Horatio Henry Couldery, whose skill at depicting the texture of animal fur was remarkable. In 1875 the critic John Ruskin, reviewing one of his paintings, described it as 'quite the most skillful piece of minutiae and Dureresque painting in the exhibition – it cannot rightly be seen without a lens – in sympathy with a kitten's nature, sensitive to the finest gradations in kittenly meditation and motion – unsurpassable.'

Couldery, who trained at the Royal Academy and lived in London, was so fond of painting cats that he became known by the nickname 'Kitten Couldery'. Despite his talent and the popularity of his work in Victorian times, his style of cosy, anecdotal animal painting fell out of favour in the turmoil of the twentieth-century art world. When he died, in 1918, his whole estate was valued at only £250, but in the twenty-first century his work has been re-evaluated,

84

Horatio Henry Couldery (1832–1893), *Playing with Jewels*, oil on canvas.

and one of his animal paintings was sold at auction in 2008 for more than a hundred times that figure.

Couldery's counterpart in the United States was John Henry Dolph, who was apprenticed to a carriage painter as a young man. In the mid-1860s he moved to New York and started to exhibit his paintings, and after a few years, seeking a broader training, he spent three years in Antwerp and another two in Paris. He subsequently began to concentrate on depicting animals, especially dogs and cats. In 1882, at the age of 47, he returned to New York and became established there as the leading figure of his genre. The *New York Tribune* praised him for 'painting one of the prettiest household sights, a bundle of vari-colored fur lying on a cushion and filling the beholder with perplexing doubts as to which heads, tails, and paws belong to which bodies.'

The compositions of Charles Burton Barber, another famous Victorian cat artist, usually included a small girl playing with her pet

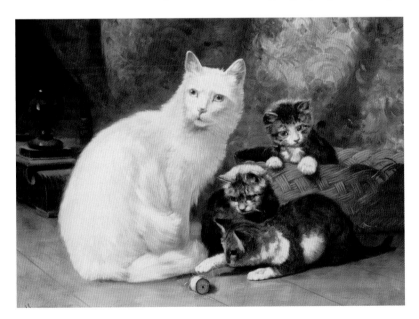

85

John Henry Dolph (1835–1903), 'the Landseer of America',
Mother Cat and Kittens, oil on canvas.

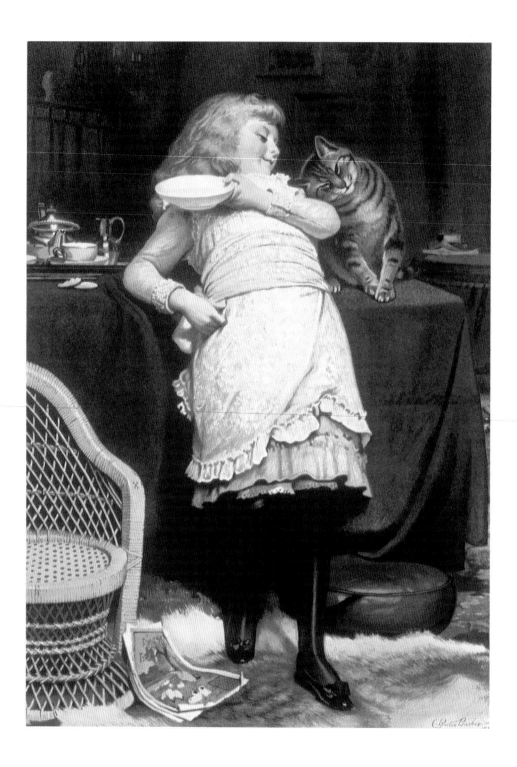

Charles Burton Barber, *Coaxing is Better than Teasing*, 1883.

or holding it in her arms. This was not because small girls held any particular fascination for him, but because their rich parents would pay large sums for his portraits of their children, and he needed the money. His preference, if he could have afforded it, would have been to depict the animals by themselves, in their natural environment, but because he had to earn a living he had to reduce them to a subsidiary role and make humans the focus of his work.

Although his animals were not the main feature of his paintings, Barber nevertheless paid a great deal of attention to their anatomy, actions, postures and expressions. In his portrait *Coaxing is Better than Teasing*, the cat rubbing the side of its face against the girl's arm is caught perfectly by the artist in the act of depositing its personal scent on its young companion. On the side of a cat's face there is a patch of shorter hair containing specialized scent glands. A cat will rub this patch against any object or person that it wants to 'scent-mark', leaving its personal fragrance – barely detectable by humans – on the surface. In this way a cat will create a bond of attachment between itself and its owner, and other cats will be able to detect this.

Barber was a favourite artist of Queen Victoria, and the small girls in his paintings were often portraits of the queen's grandchildren. Born in Norfolk and trained at the Royal Academy in London, he was a slow painter who did not complete many works before he died at the early age of 49. A number of his pictures are in the Royal Collection.

Towards the end of the nineteenth century a revolution began in the European art world. The new invention of photography – originally called photogenic art – meant that precise portrayals of the world could now be made by pressing a button, instead of spending weeks slaving over a canvas to reproduce the exact details of a scene.

As photography improved, it slowly took the place of naturalistic art, and, relieved of that duty, many painters began to experiment with novel techniques and new styles. The era of modern art was about to dawn.

7
Modern Cats

The birth of photography allowed painters to break away from the styles and techniques that had dominated the art world for so many years. Their work became looser, less meticulous, less precise. Brushstrokes became bolder and images more sketchy. This was the time of Impressionism, Fauvism and Post-Impressionism, and some of the leading figures of these movements were fascinated by cats. Feline shapes, now sometimes rather vague, appeared in the works of major artists.

The first important figure to appear in this modernist revolution against the meticulous work of the traditionalists was Édouard Manet, whose paintings heralded a new freshness and immediacy. His portrait of his wife, Suzanne, with his beloved black-and-white cat Zizi nestling in her lap, was such a favourite of his that he hung it in his Paris apartment. Although it no longer shocks us today, when it first appeared its bold, visible brushstrokes and deliberately blurred edges made it controversial. Its genius lies in the fact that, although the cat is not precisely delineated and is only vaguely suggested by its blurred image, it is nevertheless a perfect feline presence as it dozes on his wife's lap.

Manet was a great cat-lover, and Zizi appears in many of his paintings. Friends who were lucky enough to receive a letter from

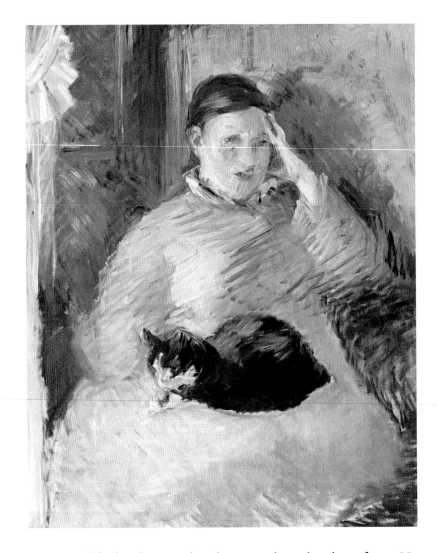

him would find it decorated with watercolour sketches of cats. He also included a symbolically wicked black cat in his most notorious painting, a portrait of a naked prostitute called *Olympia*, but the animal is rarely even noticed because he positions it against an almost black background, as it stands silently at her feet. One critic said of this work: 'If the canvas of the Olympia was not destroyed, it is only because of the precautions that were taken by the administration.'

Édouard Manet, *Woman with a Cat, a Portrait of Madame Manet*, 1882–3, oil on canvas.

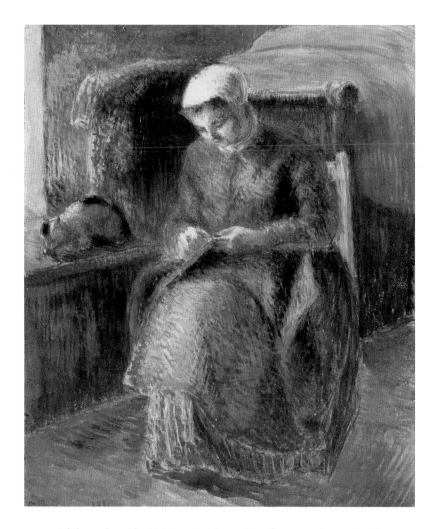

Although today Manet is thought of as a major artist, he was far from popular in the nineteenth century. He was accused of being deliberately provocative and of having a taste for the 'inconceivably vulgar'. It was not going to be an easy matter to change the face of art in the new age of photography, but his work led the way for even more revolutionary artists to follow.

The work of the group of young artists who were called the Impressionists had been rejected by the traditional salons in the

Black-and-white cat sleeping while its mistress does her needlework, by Camille Pissarro, gouache over pencil on linen laid down on stretched paper, 1881.

1860s, and they were forced to arrange their own group exhibitions. The first of these shows was held in 1874, and the critics of the day attacked it vehemently. One coined the word 'Impressionism' as an insult, saying that the paintings gave only a faint impression of a landscape, adding: 'Wallpaper in its embryonic state is more finished.' The artists adopted the term Impressionism to describe their style of painting, and, as time passed, they developed an ardent following of those who, like them, had become bored with the straightjacket of traditional salon styles.

There were eight group shows between 1874 and 1886, when the group split up and the rebel artists went their separate ways. Only one of the thirty or so Impressionists exhibited in all eight of the shows, and he was one of the purists of the group. His name was Camille Pissarro and, like all the others, he preferred to work quickly out of doors, painting scenes that attempted to capture the fleeting moment and the changing light. Brushstrokes were bold and rapid, and detail was suggested rather than precisely delineated.

Most of the canvases painted by the Impressionists were land-scapes, but they did occasionally focus on a single figure. One such

92

Claude Monet, *Sleeping Cat*, 1896.

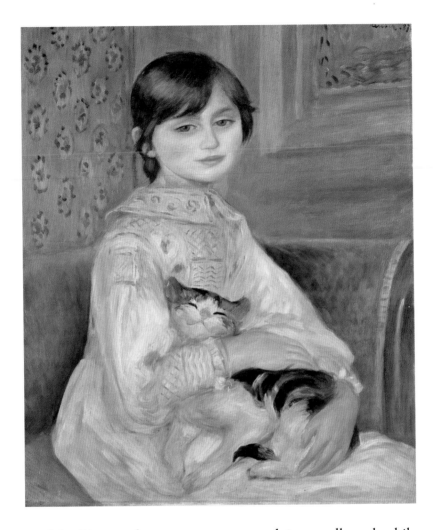

work by Pissarro shows a young woman doing needlework while her black-and-white cat snoozes contentedly on a windowsill at her side. As with Manet's cat, this one is only hinted at, and the details are filled in by the viewer's imagination. The same is true of a cat painted by Claude Monet, the artist most famous for his paintings of water lilies and for his Japanese garden in the south of France. Again, it is a sleeping black-and-white cat, this time curled up snugly on a soft bed.

Auguste Renoir, *Mademoiselle Julie Manet with Cat*, 1887, oil on canvas.

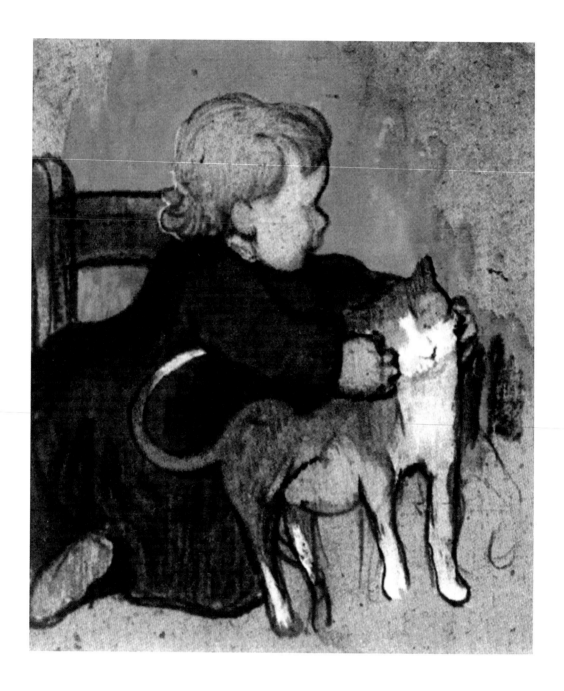

Paul Gauguin, *Mimi and Her Cat*, 1890, gouache on card.

Another member of the Impressionist group, Pierre-Auguste Renoir, was the greatest cat-lover of them all, and a number of his paintings feature feline companions for the subjects of his portraits. The most famous example is a study of a young Julie Manet gently cradling her tabby-and-white cat in her arms, made in 1887. Julie was the daughter not of the famous artist Édouard Manet, but of his brother Eugène, a friend of Renoir. Much earlier, in 1862, Renoir had devoted a whole painting to another sleeping cat, this one a blotched tabby. It is amusing to see that nearly all the cats painted by the Impressionists were fast asleep. This enabled them to complete their paintings without the cats moving and ruining the composition.

Cats also appear in the paintings of the revolutionary artist Paul Gauguin, whose work was included in the final Impressionist exhibition, in 1886. He went on to take the pictorial rebellion a major step further than the other Impressionists, however, abandoning natural colour schemes and introducing vivid hues that expressed emotions and ignored the demands of the natural scenes before him. Inevitably, his work was attacked by traditionalists, but his response was defiant – 'To me, barbarism is a rejuvenation' – and he defended his rebellious style by saying that 'Art is either plagiarism or revolution.'

Cats seem to have been of less interest to Gauguin than they were to Renoir, and the only work of his in which a cat plays a major role is a portrait of a tiny child called Mimi playing with a ginger-and-white cat. She is reaching out to grab the animal with both hands, but it does not appear unduly worried by this approach, keeping its eyes lazily closed as if used to this sort of attention from the toddler, who probably treats it as an amusing toy.

Mimi and Her Cat is a tiny painting, only 17.8 cm (7 in.) tall and just over 15 cm (6 in.) wide, done in gouache on a piece of cardboard.

Gauguin made it when he was on a visit to Brittany with his friend the Dutch artist Meijer de Haan. He had just returned from his disastrous visit to Arles as a guest of Vincent Van Gogh. While there, during a furious row Gauguin, who happened to be a skilled sword-fencer, had slashed Van Gogh's ear with a sword, an injury they pretended was self-mutilation on Van Gogh's part. He was therefore badly in need of a relaxing break, which he took with some friends at a seafront inn run by one Marie Henry in the remote village of Le Pouldu. De Haan fell passionately in love with Marie, and she later had a baby by him. A single mother, she already had a small daughter, Marie Leah, whose nickname was Mimi. Both De Haan and Gauguin painted the toddler's portrait, and it is Gauguin's version that shows her playing with the family cat. Mimi was born in February 1889, so even if the Gauguin painting of 1890 was done at the very end of that year, the child must still have been less than two years old. At that tender age, her play with the cat will have been rather uncoordinated and insensitive, and Gauguin has caught that well in his painting.

Later, when he travelled to the South Seas, Gauguin allowed cats to appear in some of his tropical paintings, but there they always play a minor role. There is a white cat asleep next to its owners in his painting of a Tahitian couple resting in their hut, *Eiaha Ohipa* (Not Working, 1896). The snoozing feline perfectly symbolizes this moment of quiet relaxation during the heat of the day. There are two white cats in his masterpiece *Where Do We Come From? What Are We? Where Are We Going?* (1897). One is asleep; the other is reaching out in front of it. It is generally agreed that these two cats have some specific symbolic significance, but what that might be is not clear.

Back in Paris, at about the same time, the diminutive French artist Henri de Toulouse-Lautrec featured a long-haired tabby cat

in a painting he called *Minette the Kitten*. It shows the cat in an alert posture staring fixedly straight ahead. Although the French word *chaton* means kitten, this particular kitten looks remarkably well developed and almost a fully grown cat.

The following year, 1895, Toulouse-Lautrec created a poster for the popular Irish singer May Belfort that showed her dressed as a little

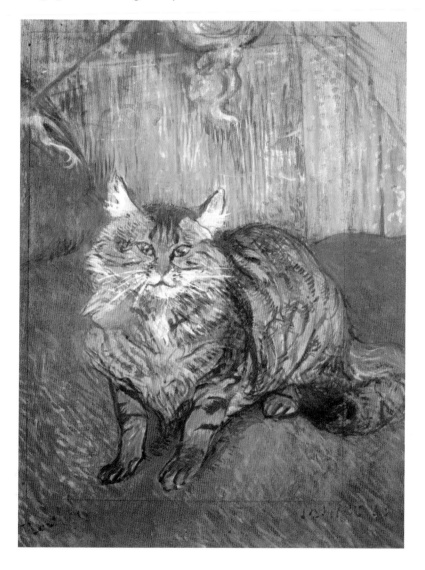

97

Henri de Toulouse-Lautrec, *Minette the Kitten*, 1894.

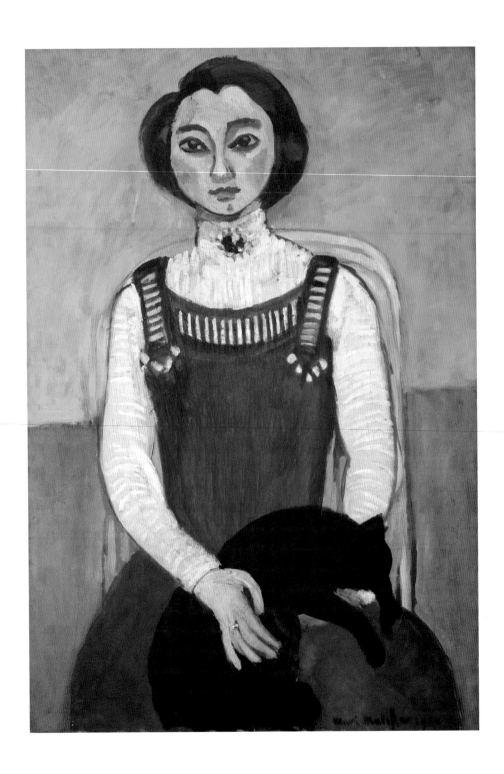

Henri Matisse, *Marguerite with a Black Cat*, 1910, oil on canvas. Matisse's pet cats
lived in a house full of temptations, including caged birds as well as goldfish.

girl and holding a black cat tightly in her arms. Her favourite song, 'Daddy Wouldn't Buy Me a Bow-Wow', included the line 'but I've got a little cat and I'm very fond of that.' These were not Toulouse-Lautrec's first cat images, however. As a teenager he painted a portrait of a kitten, called simply *Le Chat*. Perversely, in his titles, he called a cat a kitten and a kitten a cat.

Henri Matisse adored cats, and a series of photographs of him as an old man propped up in bed, with his cats Minouche and Coussi lying beside him, reveal the intimacy he shared with them. Cats appear in only a few of his paintings, however. In one, his daughter Marguerite is portrayed with a black cat curled up on her lap, and in another a cat is shown dipping its paw into a large bowl of goldfish. Since Matisse also enjoyed the company of caged birds, his cats must have found themselves to be frustrated hunters on many occasions.

The German artist Franz Marc had a strong preference for animal studies, and cats often figured in his adventurous compositions. He was born in Munich in 1880, so he was a child when Gauguin was taking the rebellion against traditional salon painting a step beyond the Impressionists. When Marc came of age, at the very start of the twentieth century, he would become one of the rebels who would go a step beyond even Gauguin. In common with the earlier artist he used bright, often primary colours that bore little relationship to nature – a horse might be blue, a fox purple, a dog yellow. But he was also beginning to play with the shapes of the animals, turning them into semi-abstract forms.

With Marc, we are on the verge of the major aesthetic revolution of the twentieth century, in which major artists turned their backs on representational work and explored all kinds of new visual possibility. If he had enjoyed a long life, he would almost certainly have played

an important role in the upheaval of the avant-garde, but sadly he was struck on the head by shrapnel on a First World War battlefield in 1916 and killed instantly, at the age of just 36.

Marc left us several extraordinary images of cats. In one, two cats – one ginger-and-white and the other black-and-white – lie asleep together on a red cloth, their bodies curled up to create a circular composition in which the outlines of the cats are almost lost. In another, bolder painting, an orange cat lies asleep on the ground, half-hidden by a bright blue tree in the foreground. The field in which the cat lies is yellow, green and red. This work, from 1900, displays a dramatic crudity beyond anything that has gone before it, and heralds a new primitivism that eventually swept across much of modern art in the twentieth century.

This boldness is also on display in Marc's painting of two cats, one yellow and the other blue. The yellow cat is sleeping, with its

100

Franz Marc, *Cats on a Red Cloth,* 1909–10, oil on canvas.

Franz Marc, *Two Cats, Blue and Yellow*, 1912, oil on canvas, a work that heralds the
aesthetic rebellion that was about to erupt in the 20th century.

head lowered on to the ground, while the blue cat is busy cleaning itself. The ground on which they lie is blue, green and red. It was dramatic compositions like this that finally drew a line under the art of the nineteenth century and heralded the explosively new epoch of the twentieth-century avant-garde.

In his late work called simply *Three Cats* (1913), Marc pushed himself even further towards abstraction, almost hiding the three cats – one red, one yellow-and-black, and one black-and-white – in the composition. Style now dominates realism, and neither the postures nor the feline details owe much to nature.

8

Avant-garde Cats

The avant-garde artists of the twentieth century, who abandoned realism and began to seek out the essence of visual imagery rather than its natural outlines, were often cat-lovers in their private lives. Some, such as the exotic Leonor Fini, were obsessed with cats and surrounded themselves with whole colonies of feline friends in their studios. Andy Warhol had 25 cats at one time, and the Chinese artist Ai Wei Wei owns no fewer than forty. Others, such as Pablo Picasso, simply enjoyed the company of an occasional house cat.

The outrageous Salvador Dalí, who had to be different at any cost, insisted on owning a Colombian ocelot rather than an ordinary domestic cat. Named Babou, the animal accompanied him on trips to Paris and New York, where he would take it into restaurants and tether it to his table while he ate. When one alarmed diner complained that it was a dangerous wild animal, Dalí informed him that it was an ordinary pet cat that he had painted to look like a wild relative.

In many cases where a feline figure appeared on the canvases of the avant-garde artists, the animal was portrayed in a transformed – simplified, exaggerated or symbolic – condition. Sometimes there might be little more than a pair of pointed ears or a set of whiskers

to reveal its presence; in other cases the animal was present in a more elaborate, if distorted form.

In addition to Fini and Picasso, Paul Klee, Marc Chagall, Joan Miró, Francis Picabia, Victor Brauner, Balthus, Alberto Giacometti, Jean Cocteau, Frida Kahlo, Warhol, Lucian Freud and David Hockney all depicted cats in their work.

PAUL KLEE

The Swiss artist Paul Klee was devoted to his pet cats, but his style of painting did not suit their portrayal and out of the 9,418 paintings and drawings he completed in his lifetime, only about twenty include feline shapes. His most famous cat painting, *Cat and Bird*, dates from 1928. In it, the cat has the expression of an intensely focused, hunting feline. The bird at which it seems to be staring is imprinted on its forehead, as if the picture is saying, this cat has a small bird on its mind – literally.

In a more fanciful composition, *The Mountain of the Sacred Cat* (1923), Klee has raised the cat to the level of a deity. The painting shows a giant cat presiding loftily over its sacred mountain, with tiny human figures dwarfed down below. In this work he depicts the cat as a domineering figure that reduces mere humans to a minor role – reflecting the temperament of many pet cats in their more aloof moments.

Klee was rarely without a feline companion during his life. His love of cats began early, when he was a child growing up in a cat-filled house. One of his first cats as an adult, in 1902, was a dark, long-haired animal named Mys. As a young artist, his studio companion in 1905 was a long-haired cat called Nuggi. Later, when he was teaching at the Bauhaus, Nuggi's place was taken by Fripouille,

Paul Klee, *Cat and Bird*, 1928, oil on canvas.

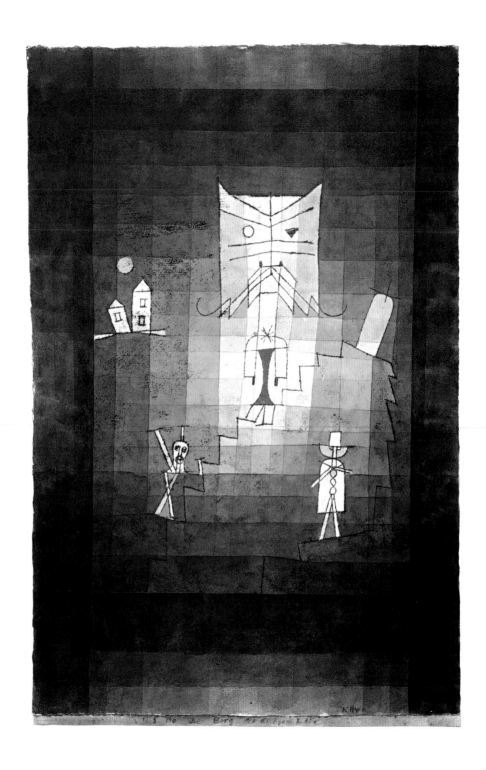

Paul Klee, *The Mountain of the Sacred Cat*, 1923, mixed media.

and, in his later years, a large, long-haired white cat called Bimbo was always with him in his studio. Said to follow him everywhere, Bimbo shared the last nine years of the artist's life, between 1931 and 1940. Judging by photographs of this pure white cat climbing on his shoulders, Bimbo was a glamorous, pure-bred cat similar in appearance to an angora. There was also at some point a mackerel tabby called Fritzi, and they were all remembered in a book by the art historian Marina Alberghini, *Il Gatto Cosmico de Paul Klee* (The Cosmic Cats of Paul Klee, 1993).

The wife of the artist Kandinsky, Klee's friend and neighbour, remembered Bimbo well: 'Paul Klee adores cats. In Dessau, his cat always looked out the window in the studio. I could see him from my private room. Klee told me the cat looked at me insistently: You can't have any secrets. My cat will tell me all.'

PABLO PICASSO

Picasso enjoyed the company of several pet cats during his life. One of the first was a starving Siamese that he found wandering the streets of Paris when he was a struggling artist in his twenties. Seeing her as a kindred spirit – someone struggling to survive in the great city – he befriended her, took her in and named her Minou. Much later, in 1954, when he was in his seventies, he was photographed embracing a tabby cat tenderly. The photographer noted that, when Picasso was sitting down, this cat never left the artist's lap. However, despite this gentle relationship, when it came to depicting cats in paint the mood was very different. In almost all his paintings in which a cat is the main feature of the composition, the animal is portrayed as a brutal predator in the act of savaging some kind of prey animal. In one,

the victim is a bird, probably a pigeon, held firmly in the killer's jaws and fluttering pathetically. The cat's jaws can be seen to have broken one of its wings. In a sketch for this painting, Picasso shows the cat snarling viciously as it tears at the bird's body. In another feline portrait, he presents the cat in the process of tearing the flesh from the struggling bird's chest. In yet another, the predator is devouring what appears to be some kind of small mammal.

Each time Picasso returns to the theme of a domestic cat, he seems to feel the need to depict a moment of violence. He has a cat slaughtering a cockerel, biting a large spider, attacking a lobster and

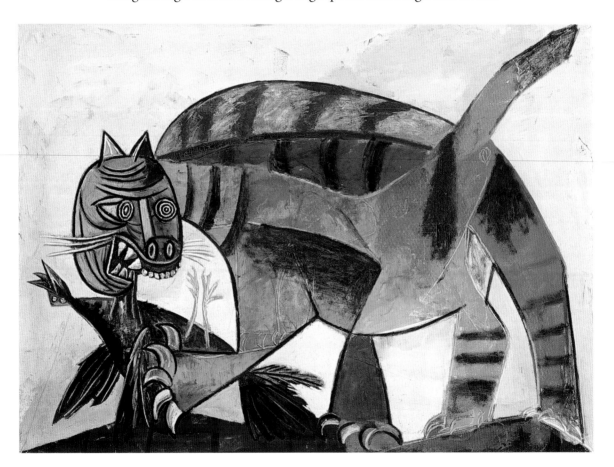

108

Pablo Picasso, snarling cat, 1939, oil on canvas.

holding in its jaws a freshly caught – or stolen – fish. In the rare cases when a cat is shown in a non-violent mood, it is usually depicted as a kitten playing with its owner.

In his written records, Picasso had this to say about his attitude to the cat as a subject for painting: 'I want to make a cat like those true cats that I see crossing the road. They don't have anything in common with house pets; they have bristling fur and run like demons. If they look at you, you would say that they want to jump on your face and scratch your eyes out. The street cat is a real wild animal.' Despite such negative comments, one gets the feeling that secretly it is this kind of cat that Picasso prefers. Notorious for his own numerous amorous exploits, Picasso also seems to have admired the sexual excesses of felines, adding: 'And have you ever noticed that female cats – free cats – are always pregnant. Obviously they don't think of anything but making love.'

In his old age, Picasso seems to have mellowed slightly in his attitude to pet cats. In 1964, when he was 83, he at last allowed a cat to be cuddled by its owner in one of his paintings. However, even here the expression on the cat's face gives the impression that it resents being held and would much rather be out in the bushes causing havoc among small nesting birds.

In 1964 Picasso's wife Jacqueline had a pet black cat, and it is this animal that features in at least eight of his oils from this period. In some, Jacqueline is sitting with the cat; in others she is a reclining nude playing with the animal. But these felines are now small accessories to the main subject of the compositions – his wife. In none of these works is the cat the central feature, as it was in his earlier works dating from 1939, painted just a few months before the outbreak of the Second World War.

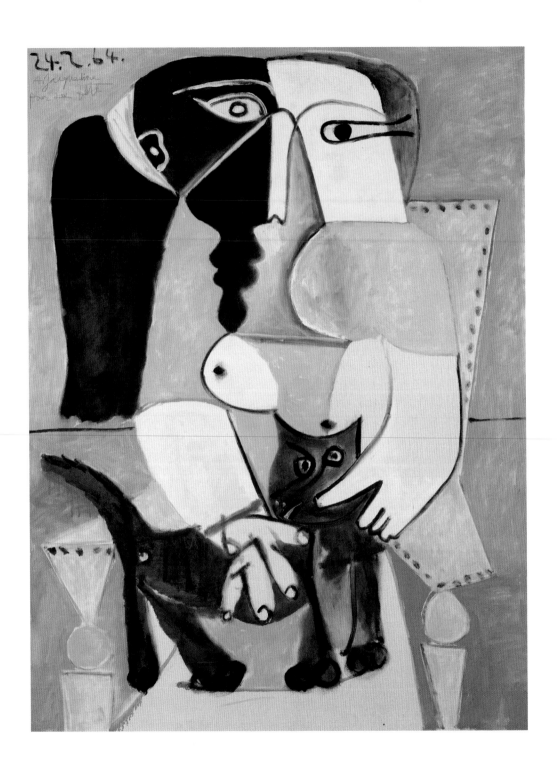

Jacqueline with Cat, 1964, by an elderly Picasso, oil on canvas.

BALTHUS

If for Picasso the cat was a symbol of ruthless killing, for the Polish artist Balthus it was more associated with female sexuality. His most famous paintings show very young girls on the cusp of puberty, isolated in heavily curtained rooms, their seemingly innocent bodies sprawled in unconsciously erotic postures. They are often depicted in the company of a friendly cat, as though the cat itself somehow represents their pent-up, barely understood sexuality.

In one of his most famous paintings, *Thérèse Dreaming* (1938), Balthus depicts the daydreaming, adolescent girl casually exposing her thighs, while her large ginger cat busily laps milk from a dish at her feet. In *Nude with Cat* (1949), he shows one of his girls naked, leaning back and lazily reaching out to touch a cat that lies sleeping on the cupboard behind her chair. In *Getting Up*, painted much later, in 1955, he reveals another naked girl, waking up in the morning and idly playing with a mechanical toy bird. Her cat, allowed out of its sleeping box, stares intently at the bird with a predatory gaze. As in many of Balthus's paintings, the scene is suffused with an ambiguous sexual symbolism.

In one, highly uncharacteristic work, Balthus shows a grinning cat dressed in men's clothes, sitting at a café table, about to tuck in to a seafood meal. The table is positioned at the end of a jetty, and in the sea nearby is a small canoe in which sits a young girl with the unmistakeable face of Balthus himself. Bizarrely, a rainbow appears to be pulling fish out of the sea and into the air, so that they land on the cat's plate. Far from friendly, despite its smile, the cat has an unpleasantly menacing air.

Part of the mystery of this strange painting is solved when one discovers that it was commissioned for the famous Parisian seafood

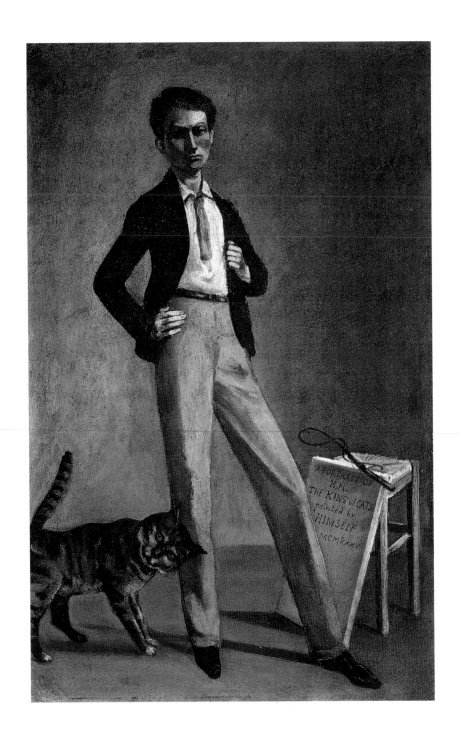

Self-portrait of 1935 by Balthus, oil on canvas, to which he gave the title
The King of Cats.

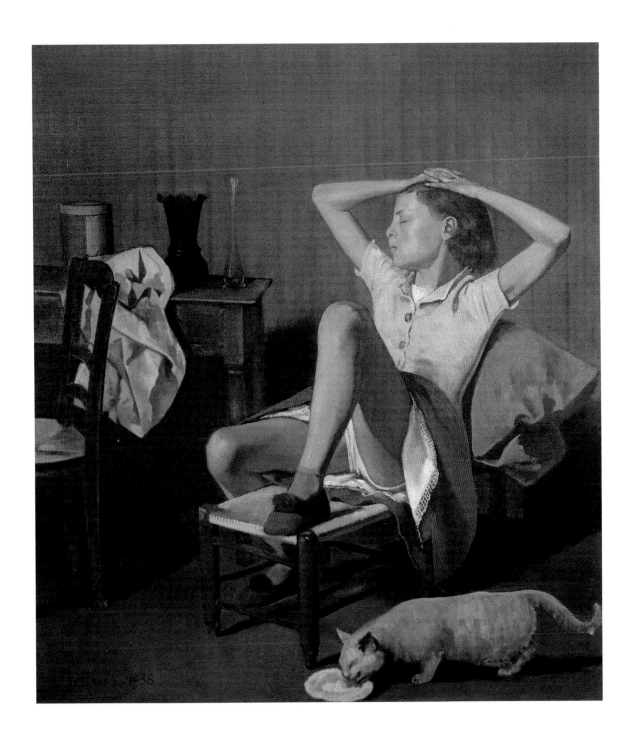

Balthus, *Thérèse Dreaming*, 1938, oil on canvas. The daydreaming girl ignores
her thirsty cat.

restaurant La Mediterranée in 1949 and hung inside the entrance of the establishment. It was meant to illustrate how fresh the fish were – so fresh that they were whisked straight from the ocean and on to your plate. But this explanation falls short of telling us why it is that the cat figure dining on the fish is so sinister or why the strange, mini-skirted girl sitting in the little boat has the face of the artist. The painting, *Cat at La Mediterranée*, is now in a private collection and no longer on view at the redecorated restaurant, which is still thriving.

Photographs of Balthus with his cats reveal his deep love of his feline pets. It is always easy to tell, from photographs of artists with their cats, whether they are simply posing for the camera or are genuine cat-lovers. With Balthus there is no doubt, and one of his self-portraits shows his cats actively responding to his deep affection for them. A large tabby tomcat rubs his leg with its head – as we have seen, an action that deposits the animal's personal scent on his trousers. Amusingly, in this portrait, a small canvas is propped up beside Balthus, on which he has painted the words 'A PORTRAIT OF H.M. THE KING OF CATS painted by HIMSELF'. This is a reference to an old folk tale in which a traveller sees a royal cat funeral. When he gets home he tells what he has seen and the house cat shouts, 'Then I am the King of the Cats!', rushes out of the door and is never seen again.

LEONOR FINI

The Argentinian Leonor Fini was one of the most exotic of the Paris Surrealists, and to say that her love of cats was excessive is an understatement. At one point her Paris apartment housed no fewer than 23 of them, and they were allowed to dominate her life. She gave them complete freedom of movement in her apartment and shared both her bed and her dining table with them. When she had dinner guests, her visitors were astonished to see that the cats were allowed to roam the table at will, sampling any food that took their fancy. Any guest who complained was in serious trouble.

So passionate was Fini about her cats that whenever one of them fell ill, she would sink into a deep depression. She once said: 'In every way cats are the most perfect creatures on the face of the earth, except that their lives are too short.' Part of the reason for this powerful emotional attachment was the fact that she hated the idea of giving birth and having children. Any foetus that started growing in her womb was quickly aborted. It is clear that her cats were her child substitutes, and it is not surprising that they featured prominently in many of her paintings and drawings. She favoured long-haired Persian cats, and it is these that are seen most often in her art, but she also owned Abyssinians, Scottish Folds, Himalayans, an American shorthair and strays of mixed ancestry. During her lifetime it is said that she owned more than fifty cats; along with Brigitte Bardot, she was also active in a society that protected French strays. In the summer, when she left Paris to pass the warmer weeks in the Loire valley, her pampered cats travelled in a separate car, each in a small wicker basket, five in the front and fifteen or more in the back, all complaining with non-stop meowing during the two-hour journey.

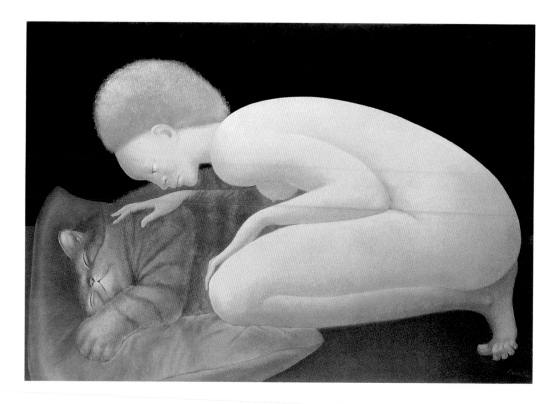

Some of Fini's cats were usually present when she was painting. They would sit around her, on her easel and even on her palette. One collector of her work remarked that you could always tell a genuine Fini by the cat hairs sticking to it. Another observed that, when you walked into her studio, your movements would create 'a billowing of cats' hairs' in the air. So deeply involved was she with her cats that she was often photographed wearing a cat mask. The costumes she designed for Roland Petit's ballet *Les Demoiselles de la Nuit* even incorporated elaborate feline masks for all the dancers. A row developed when the prima ballerina, Margot Fonteyn, refused to wear hers, saying it made her feel grotesque. Fini was adamant and threatened to burn down the theatre if Fonteyn did not appear in her mask. Petit eventually managed

116

Leonor Fini, *Psyche*, 1975, oil on canvas.

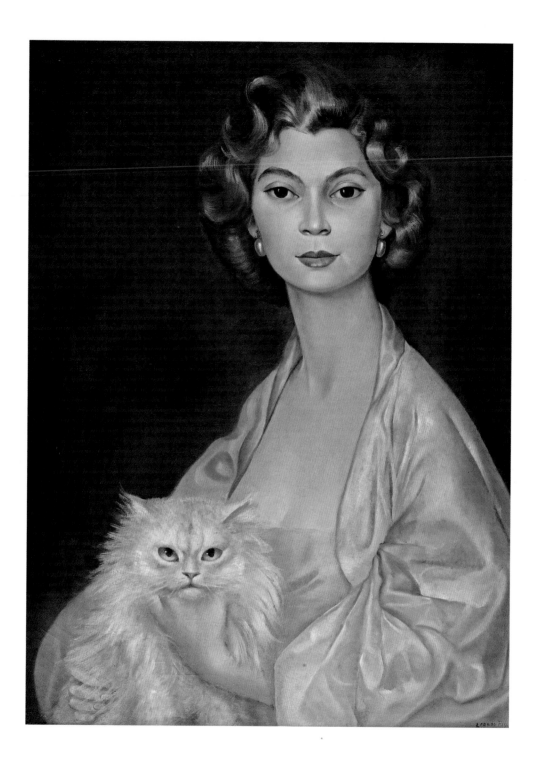

Leonor Fini, *Princesse Nawal Toussoune*, 1952, oil on canvas.

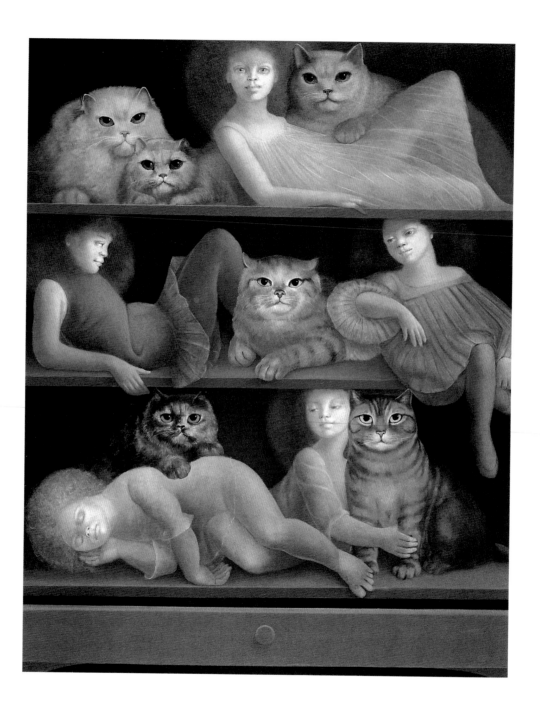

Leonor Fini, *Sunday Afternoon*, 1980, oil on canvas. Her most famous feline painting, in which five young girls are crowded into a cupboard with six large cats.

to restore peace by persuading the two prima donnas to agree on a smaller mask.

Many of the female figures in Fini's paintings became sphinxes – half woman, half feline – and some of her sketches of girls show them with the heads of cats. In her illustrations for a book called *Histoire de Vibrissa*, she caused a stir by depicting some of her famous friends as cats. She probably saw this as a way of complimenting her friends, but some were reported to have found the images insulting.

In her painting *The Manul Cat*, Fini depicts the characteristically flattened shape of that rare species of wild cat *Otocolobus manul*, from Central Asia. Sometimes known as Pallas's cat, with its beautiful, very long fur it looks like an exotic version of her own favoured domestic Persians.

In many of Fini's feline depictions, the cat is shown enlarged, sometimes even bigger than its human companion. Distortion of this kind, in which something important is shown bigger than it should be, was common in the art of ancient Egypt, where a pharaoh might be portrayed several times bigger than one of his wives. In following this trend, Fini deliberately raised the status of her cats and expanded them into powerful feline symbols. She somehow managed to give them a sexual significance, as though they represent the libidos of their human companions seen in animal form.

Perhaps Fini's most famous cat painting is *Sunday Afternoon*, in which six large cats are crowded claustrophobically on to three shelves, along with five young girls wearing what appear to be diaphanous nightdresses. This was a favourite painting of the artist's, and she kept it in her studio until her death.

Writing about her feline obsession, Fini said: 'The cat is the best and most accessible mediator between us and nature. Before his

grace, his innocence, his gentleness, his trust, that ambiguity caused by humans and their circumstances evaporates. The cat is for us the warm, furry, moustached and purring memory of a lost paradise.'

JOAN MIRÓ

In his personal life, the Spanish Surrealist Joan Miró had no great affinity with cats, but they did appear in several of his major paintings. In *The Farmer's Wife* (1922–3), the woman stands next to a strangely marked black-and-white cat that stares at the observer. In *The Harlequin's Carnival* (1924–5) there is a playful striped cat at the bottom of the painting, engaged in some sort of game with another small creature. And in a very early near-abstract work, *The Cat's Whiskers* (1927), Miró reduces the cat to a small pair of eyes, a white face and eight curling whiskers. In a later work, a lithograph of 1951 in his mature style, Miró created a kitten with just two black

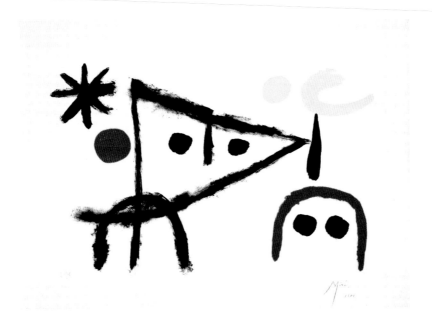

120

Joan Miró, *The Little Cat*, 1951, lithograph also known as
The Little Cat in the Moonlight.

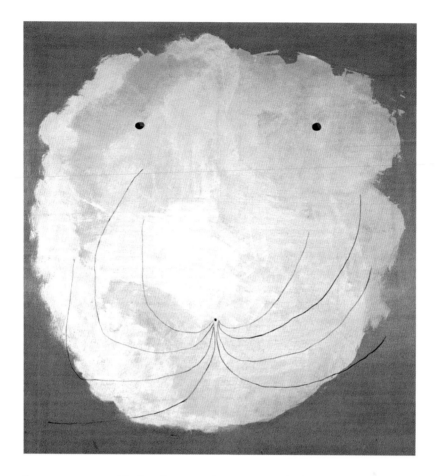

lines, an inverted 'U' and a triangle. The triangle forms the head, with its two uppermost points acting as the ears. The identity of the cat is only recognizable by these widely pointed ears.

VICTOR BRAUNER

The Romanian artist Victor Brauner was an out-and-out Surrealist whose irrational images often contained animal elements. As a schoolboy he became passionate about zoology, and a fascination with animal shapes seems to have survived throughout his artistic

Joan Miró, *The Cat's Whiskers*, 1927, oil on canvas, also known as *The White Cat*.

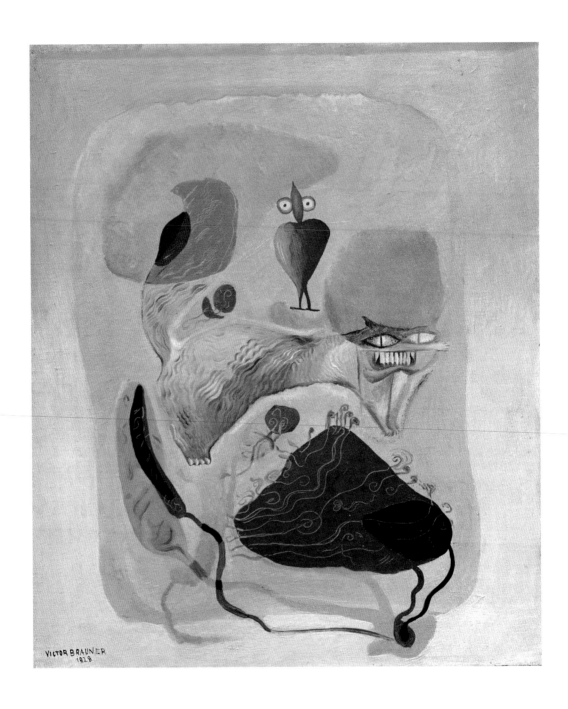

Victor Brauner, *Plants and Animal*, 1928, oil on canvas.

life. His paintings include images of a chameleon, frog, fish, eagle, bat, snake, camel, fox, crocodile, bird, horse, dog, cow and various monsters. Feline forms appear in a number of his compositions, often combined with other figures, creating bizarre chimeras that deliberately defy common sense.

One such work is *The Arch-cat* (1948), in which a human figure consisting of a large blue head and two small red legs sprouts an arch-shaped cat from the top of its flattened skull. In another, *Catfish* (1954), a large fish with a human face floats in the air above a startled cat. The cat stares up at the fish in anguish, as the fish clamps its jaws around the tip of the cat's tail.

In a painting done at the height of the Second World War, *Woman as a Cat* (1940), Brauner presents us with a nude figure, the right side of which is human and the left feline. In a drawing done in the following year, he shows a cat standing on the legs of a recumbent nude girl whose hair is grasped by a hand that emerges from the tip of the cat's tail. In another work, *Motan de Lune* (1946), a reclining woman balances a blue cat on her feet, and the animal's tail curves around her head to become her hair. In yet another, *Rainbow* (1943), a woman's black hair becomes the body of a cat. Perhaps the most peculiar is *Mitsi* (1939), in which a nude girl stands on cat-shaped feet. Brauner was forever playing with illogical combinations of humans and animals to create a private mythology that defies analysis and has to be enjoyed purely for its appealing strangeness.

ANDY WARHOL

For Miró, Picasso, Brauner and many of the other experimental artists of the twentieth century, the cat was an image to be played with – to be stylized, exaggerated, distorted and elaborated. It was a starting point for visual explorations and flights of fancy. These artists had no respect for the precise dimensions, postures or textures of cats, but simply enjoyed the key features of the feline form – the pointed ears, the long whiskers, the striped fur, the sharp claws – and retained some of them as clues to the source of their imaginative inventions.

For one of the most extreme artists in the modern movement, however, the cat conquered his rebellious spirit and emerged in its natural form. Andy Warhol may have outraged the art world with pictures of cans of baked beans, or celebrity faces painted in gaudy colours, but when he went home to his Upper East Side townhouse, put his rebellious activities to one side, took off his infamous silver-blond wig, lay back in his Victorian parlour and enjoyed the company of his 25 pet cats, he found himself unable to exploit the feline shape. Instead, he made a long series of naturalistic, sentimental sketches of them. The sketches are totally unlike anything else in his output, and reveal the extent to which he was in thrall to the feline presences in his life.

One of Warhol's first cats, a male called Sam, was provided with a mate – a Siamese kitten called Hester – that was given to him by the actress Gloria Swanson. Hester and Sam had several litters of kittens and, eccentrically, every one of these kittens was called Sam. In 1954 Warhol published his cat paintings in a small book called *25 Cats Name Sam and One Blue Pussy*, but he made sure that these feline-dominated works would not become widely known – and interfere with his carefully contrived public persona – by having the

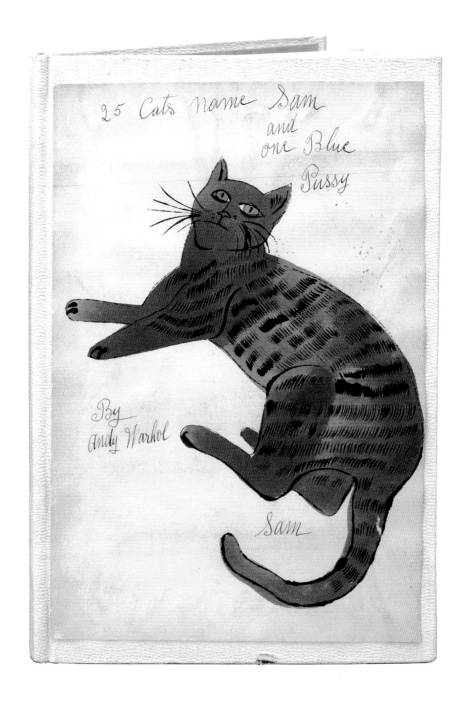

Andy Warhol, cover of *25 Cats Name Sam and One Blue Pussy* (1954).

book privately printed in a limited edition of only 190 copies. These were not put on sale to the general public, and were used simply as gifts for his close friends. It was not until 1988, a year after his death, that they were given a new, unlimited edition and sold in bookshops.

FRANCIS PICABIA

Another rebel in the upheaval of the art world in the twentieth century was the outrageous Spanish/French artist Francis Picabia. What made him unusual as a member of the Parisian avant-garde was that he was extremely rich. At his zenith he owned no fewer than 127 vehicles, mostly expensive luxury cars but also some glamorous yachts. He was obsessed with mechanical devices, and, in some of his more unusual

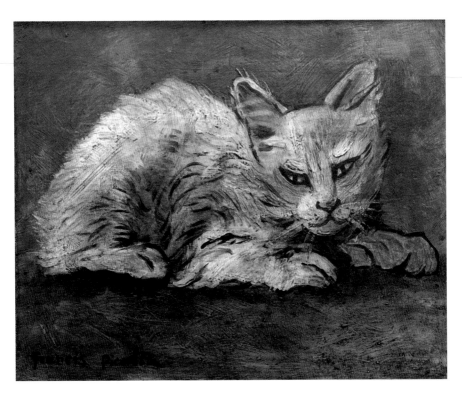

126

Francis Picabia, *The Cat*, 1929, oil on canvas.

paintings, he had startled the art world by exhibiting portraits not of people but of engine parts. Monographs of his work show his wide range of styles, from pointillism to Surrealism, but cats are nowhere to be seen. Like Warhol, he kept his feline work private and, also like Warhol, he found himself unable to exploit his cats by presenting them in an abstract or Surrealist manner. Instead, they are straightforward pet cats, lovingly painted and clearly so close to his heart that he did not wish to distort their shape or exaggerate them in any way.

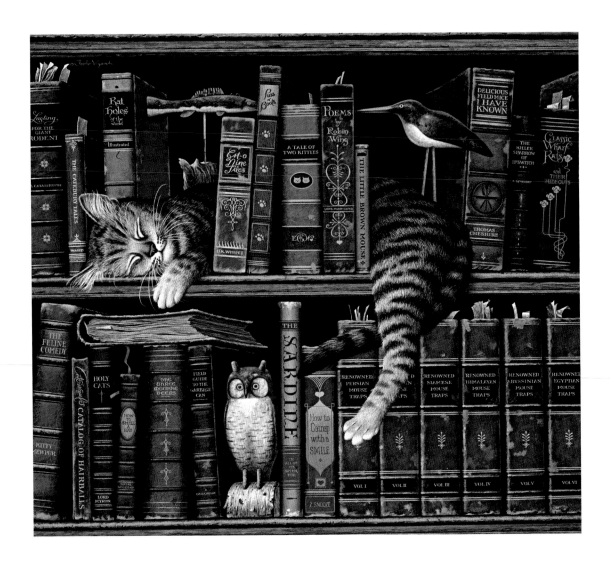

Charles Wysocki, *Frederick the Literate*, 1992, oil on canvas.

9

Contemporary Traditional Cats

Although a major revolution occurred in the twentieth century in the world of fine art, traditional, representational art did not disappear. It simply went quiet, while the avant-garde artists stole all the headlines. Artists who wished to continue making accurate copies of the natural world chose to ignore the fact that colour photography could now do this with even greater precision, at the press of a button. Even though their work was, in a sense, redundant, their remarkable technical skill remained something to admire.

One such artist, who happened to love cats, was the Polish-American Charles Wysocki. He began his working life as a commercial illustrator, after which he ran an advertising agency. Then, through his wife, he became interested in the rural life of America and in American folk art. When he eventually turned to painting, much of his work was pseudo-naive and focused on rural landscapes and village scenes, but his best work was done when he used his by now considerable painting skill to create highly realistic scenes involving cats.

In one such painting, a cat lies deeply asleep in a bookcase, having managed to find just enough space between the books into which to squeeze its body. The cat is a mackerel tabby named Frederick, and Wysocki called the painting *Frederick the Literate*.

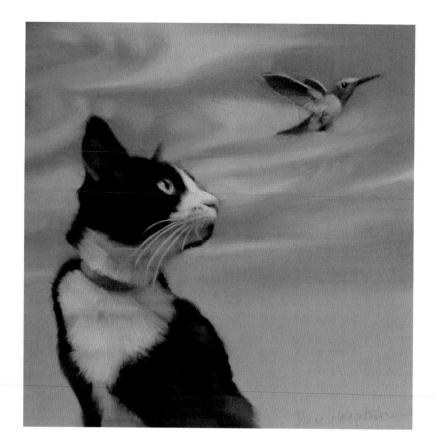

In another, a black cat with a white patch – an angel's mark – on its chest lies among a collection of vegetables. Since this food is clearly meant for the table, someone (unseen) has approached the cat and is probably going to shoo it away from its resting place. What the artist caught perfectly is the cat's annoyance at this impending disturbance.

Some of Wysocki's paintings create an improbable scene, even though they are painted with painstaking realism. His nine cats clustered on a row of mailboxes is an unlikely scenario, but makes an attractive composition. It would be difficult for a photographer to assemble cats in this way, so here Wysocki can be said to have

Diane Hoeptner, *Fly Away*, 2000, oil on wood.

added a creative element to his work that made it more than simply the slavish copying of nature.

Another contemporary American artist who specializes in cats is Diane Hoeptner of Ohio. She moved to Los Angeles in the 1980s and took an art degree there, then returned to Ohio in 2004, after working as an animator. Her feline portraits are as precise as any colour photographs and capture perfectly the varying moods of these animals. She says: 'I see ethereal beauty in cats . . . I discovered this when I started painting my own cats who are perfect embodiments of sweetness and snark. They are enigmatic little beasts, the kind who never smile. Portraying cats in a way that doesn't reduce them to sentiment and cliché is important to me.'

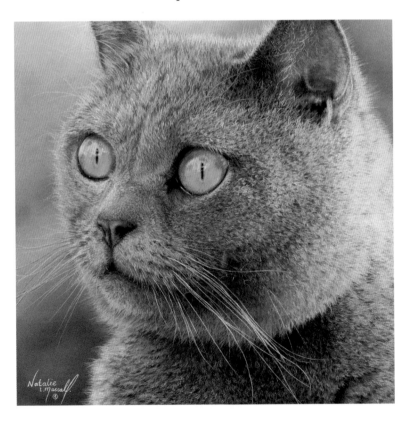

Natalie Mascall, *Blue*, 2014, pastel. The prize-winning wildlife artist Mascall occasionally turns her attention to domestic cats.

The British twin artists Janet and Patsy Swanborough were born in Maidstone, Kent, but moved to the Scilly Isles in 1978 because of the colour, light and tranquillity they found there. They began a 'Cats in the Window' series of paintings because they felt that, once hung on the wall of a room, the pictures would create the impression that the viewer was looking out at the attractive scene beyond. The Swanboroughs have the rather unusual distinction of being the only living twins to have exhibited at the Royal Academy of Art in London in the same year.

Natalie Mascall is a prize-winning wildlife artist who occasionally turns her hand to painting portraits of domestic cats. A typical example is *Blue*, whose fur texture and anatomy she has caught with remarkable skill. She is one of the many cat-loving artists working today in a naturalistic style that stubbornly ignores all the wayward experimentation in the world of the fine arts at the beginning of the twenty-first century. For artists like those who have been selected here to represent the many traditionalist painters who have been active in recent times, technical skill and a devotion to portraying the natural world exactly as it is are all that matter. There is no deep symbolic meaning involved in these works, no complicated aesthetic philosophy, merely the joy of celebrating the beauty of the feline world.

10

Naive Realist Cats

Self-taught artists who, in recent times, have worked outside the world of professional art have been given various names. Some have been called folk artists or primitive artists; others have been described as Sunday painters or naive artists; and still others have been classified as naive realists or naive primitives. In France, the painter Jean Dubuffet, who amassed a major collection of their work, referred to it as L'Art Brut, or 'Raw Art'. In 1972 Roger Cardinal coined the term 'Outsider Art' to cover the whole genre, and since 1993 there has been an annual Outsider Art Fair in New York. Because modern collectors – tiring of the excesses of the professional art world, with their increasingly vapid installations and events – have begun to take outsider art more seriously, there has also sprung up a new type of artist: the faux-naif, or pseudo-naive. These are individuals with professional art training who decide to paint in the naive style. A few have succeeded, but others have about them an air of contrived superficiality. They lack the perverse oddities and the idiosyncratic obsessions of the true naives.

Outsider artists can conveniently be separated into two major groups: the naive realists and the naive primitives. The former artists are characterized by their attempt to create very precise, meticulously painted scenes or portraits. Their work is painstaking

and time-consuming. It is as though they are attempting to paint pictures in the style of old masters without any training or specialist knowledge. The results are nearly always strangely stiff, with an awkward rigidity that gives them a visual intensity. It is this intensity that is part of their charm.

NINETEENTH-CENTURY AMERICAN FOLK ART

The first flowering of naive realist art occurred in the northeast of the United States early in the nineteenth century. It was essentially a rural phenomenon, with jobbing artists travelling from place to place, offering to paint the portraits of anyone who would pay them. Most of these artists began as sign painters or furniture decorators, and were craftsmen who were now turning their hand to a new source of income. Local families were persuaded to have their children painted, and it became common practice to include a pet cat in the composition.

These portraits had a special quality. They were clearly attempts to create traditional works of art, but because the artists involved were outside the urban mainstream of formal art training, their brushwork lacked the confidence of their professional city counterparts. Their handling of paint was meticulous, with every detail sharply defined, but the result was strangely flat, over-precise and stilted. Their work did, indeed, look like a sign painter's attempt at an academic portrait, which is precisely what it was. Today this gives naive realist art a visual oddity and strange intensity that, for many, makes it preferable to the technically more accomplished, but often boringly routine portraits produced by urban academic professionals.

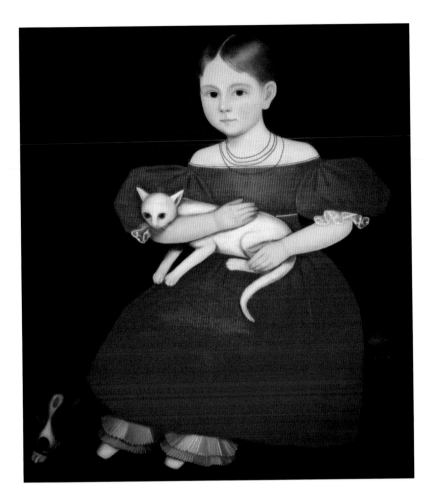

Happily, the value of these American folk paintings was recognized and they have now been lovingly collected and preserved. Many have found their way, as gifts, into the great museums, such as the Metropolitan Museum of Art in New York. Often, the name of the artist is unknown, but in a few cases identities have been established. One of the most delightful of all the child-with-cat studies is by Ammi Phillips. Painted in the 1830s, it shows a young girl in a red dress holding in her arms her pet white cat. The cat looks ill-at-ease, as though it was getting restless at being held in position

135

Ammi Phillips, *Girl in Red Dress with Cat and Dog*, 1830–35, oil on canvas.

for the benefit of the portraitist. The original is now in the collection of the American Folk Art Museum in New York.

Another cat that appears to be irritated by the (in this case, unknown) artist's demand for it to sit for its portrait is a black-and-white tom that glowers out of the portrait of a chubby toddler, also in a red dress, who reaches out hesitantly, as if to stroke the animal's back.

The artist John Bradley emigrated to America from Ireland early in the nineteenth century. His portrait of two-year-old Emma Homan, painted in 1844, shows her with her pet cat, which is climbing up a potted rosebush and reaching out playfully to touch her hand with its paw.

HENRI ROUSSEAU

Born the son of a plumber in northwestern France in 1844, Henri Rousseau provides a starting point for the recognition of naive art as a genre in its own right. There had always been naive artists – local people who dabbled in picture-making for their own satisfaction – but it was not until Rousseau appeared on the scene that this type of painting was taken seriously. At first, his work was ridiculed by the French public and by art critics, and rejected by the official art salons. Towards the end of the nineteenth century, however, his cause was taken up by the younger artists of the Parisian avant-garde, and it was they who insisted that his work was important. A young Picasso even organized a special Banquet Rousseau in his honour in 1908.

Rousseau, who earned his living as a tax collector on the outskirts of Paris, is most famous for his exotic jungle scenes, many of which depict a big cat lurking in the undergrowth or savagely attacking a prey animal. His portraits are less well known, but in one of

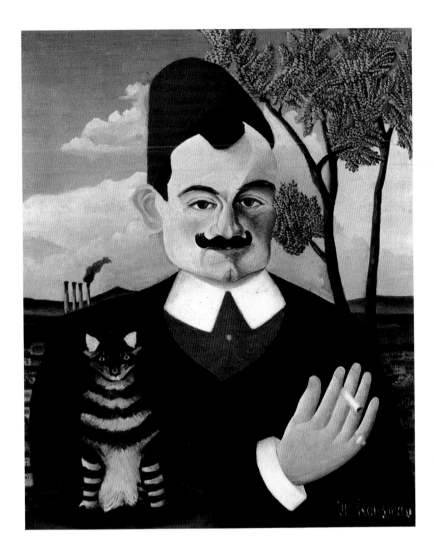

them, painted in 1891, he shows his subject standing behind a boldly striped mackerel tabby cat that squats on what appears to be a red cushion. This painting, *Pierre Loti*, depicts the famous French novelist in his garden, wearing a Turkish fez.

It is not surprising that the animal figures so conspicuously in this portrait, because Loti was passionate about cats and owned a large number, many brought back from his foreign travels. He even

Henri Rousseau, *Pierre Loti*, 1891, oil on canvas, showing the French novelist with one of his many feline pets, an alley cat that he has rescued.

wrote a book about them, and admitted that he was more worried about their fate than that of his human companions, because the cats 'are speechless and unable to get out of their half-night, and especially because they are more humble and despised'. He rescued many strays, and the cat in Rousseau's portrait was an alley cat that he had taken in. In 1908 Loti became honorary president of the French Society for the Protection of Cats. In his writings, Loti tried to express the deep affinity he felt for his pets, saying of one of them: 'It was necessary that my eyes were for her eyes, the mirrors of her little soul anxiously looking to seize the reflection of my own.'

MORRIS HIRSHFIELD

The most impressive of all the American naive artists is, without question, the Polish-born Jewish painter Morris Hirshfield. When he moved to New York at the age of eighteen, he entered the garment industry and earned his living there until he was forced to retire in 1935, at the age of 63, owing to poor health. With time on his hands he started to paint, and the subject of his first picture was a cat. It took him two years to finish this work, because his hands refused to carry out the orders of his brain: 'My mind knew well what I wanted to portray but my hands were unable to produce what my mind demanded.' Even when his technique had improved, he was never a quick painter because of the minute details he insisted on applying to all his images. As a result, his lifetime output of paintings amounted to only 77 works, created over a nine-year period.

The special quality of Hirshfield's work was strongly influenced by his years of handling and designing fabrics. This had given him a sensitivity to textural detail that made his works unique in the

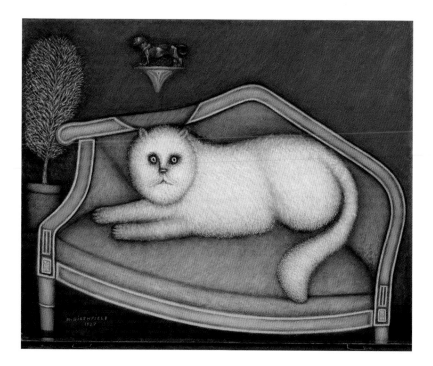

field of naive painting. Despite the brilliance of his idiosyncratic compositions, however, his work was badly received by the public and by critics. The Museum of Modern Art in New York acquired two of his paintings in 1941, and two years later gave him a solo exhibition, an extraordinary accolade for a self-taught artist who had completed only 33 paintings at the time. The museum's curators expected the public to react joyfully to their new discovery, but were shocked when the show was savaged. Indeed, it was attacked so severely that it led to the sacking of the museum's director. Hirshfield, meanwhile, was ridiculed as 'The Master of the Two Left Feet'.

Happily, this setback did not deter the artist, who spent the remaining three years of his life producing as many of his painstaking canvases as he could manage. Today, in the recently redesigned Museum of Modern Art, it is pleasing to see that the two works of

Morris Hirshfield, *Angora*, 1937, oil on canvas. A staring, white cat on a sofa, the first painting created by this American naive realist artist.

his that it purchased have not been relegated to the basement storeroom and are still proudly on display.

Hirshfield's first great painting, completed in 1937, showing a delightfully odd white cat defiantly stretched out on an elegant sofa, was entitled simply *Angora*. It is one of the most arresting of all naive feline portraits and, considering that it was his first, a remarkable achievement. Other feline paintings followed, but none of them match the intensity of this hypnotic work.

FRED ARIS

Born in Dulwich, southeast London, in 1934, Fred Aris was an eccentric, retiring, intensely private artist. He worked as a cook in his mother's café and, when she died, he inherited the business and continued to run it until his own death in 2012. He lived there with his sister, and his only pleasure appears to have been listening to classical music.

Aris began painting in his thirties. In 1969, hearing that the Portal Gallery, off Bond Street in the West End of London, was specializing in outsider artists, he took a couple of his paintings to show them. One of the first to be sold was of a large, black tomcat sitting against a brick wall. During the forty years that followed, he continued to deliver his paintings to the gallery regularly, and several hundred were sold to collectors in Britain, Holland, France, Germany and the United States.

Aris's visits became a ritual event. Every three months he would appear with two more paintings under his arm, talk briefly about them, collect his cheque for previous sales, and leave. This was the only direct contact the gallery had with him. If they wished to

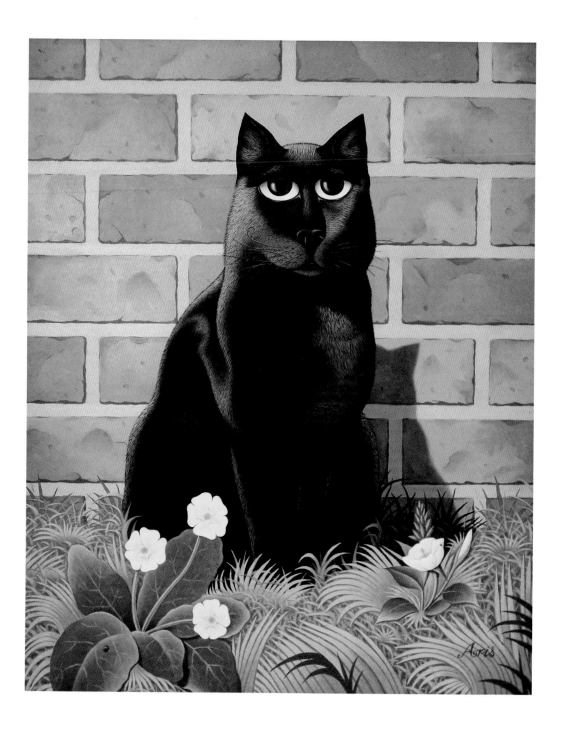

Fred Aris, *Black Cat*, 1969, oil on board. An intense portrait of a black tomcat
standing guard over his urban territory.

communicate with him at other times they had to write him a letter, because he had no telephone in his home.

Because of the growing popularity of his work, his gallery begged him to have a solo exhibition. He refused because, he said, he would find the publicity too stressful. As a result, there has never been a one-man show of his work, nor did he ever give a single interview. His determination to remain in the shadows and allow his work to speak for itself was not helpful to his career, but reflected the fact that, for him, the work of art itself was all that mattered. This was frustrating for those who worked in the gallery, but they remained extremely fond of him and always found him warm, friendly and unassuming. One of the gallery staff said of him: 'Fred Aris was a good painter, a superb technician with a great imagination, totally unpretentious, a dream to deal with, and I am sure unaware of his exceptional talent.'

In appearance, Aris was described as 'dapper' – always neatly immaculate, like his paintings. As an artist – entirely self-taught – he was obsessed with precise shapes and edges, and smooth, blemish-free tonal gradations. His lack of formal training meant that he had an exaggerated respect for a carefully crafted detail. The idea of employing the looser, casual brushstroke of the professionally trained artist would have filled him with horror. Uninterested in the work of other artists and influenced by nobody, he was the epitome of the outsider artist – a man who cared only about his painstaking creations and rejected all aspects of the professional art world.

He hardly ever accepted commissions to paint specific subjects, but on one occasion did agree to do a portrait of a large ginger tom that belonged to a film producer. He did not, however, follow the usual rules of animal portraiture. When the portrait arrived it showed the cat at sea in a small boat, accompanied by an owl – Aris having

decided to incorporate his own tribute to the famous poem by Edward Lear.

Cats were a favourite subject for Aris. One of his earliest works, from 1969, is of a charismatic, jet-black tomcat – a powerful urban territory owner so confident of his local status that he sits, statue-like, alert but relaxed, against his personal brick wall. Clearly no feline rival would dare to encroach on his carefully guarded home range, but he must stand guard, just in case. Despite Aris's attention to realistic detail in the cat's silky black coat, he perversely gives him a pair of large human eyes – all the better to stare with. It is a formidable feline portrait.

BERYL COOK

Beryl Cook, born in southern England in 1926, was an outsider artist who was so successful that she was allowed briefly to become an insider – when her work was shown at the Tate in London in the exhibition 'Rude Britannia: British Comic Art' in 2010, two years after her death. Despite this recent overture from the official art world, she remains a true outsider – a seaside landlady who did not start painting until she was in her forties. Her life story was chaotic until she hit her stride as an artist and discovered that a large number of people enjoyed her work.

Cook's first job was in an insurance office, after which she went on the stage and became a showgirl in a touring production of the operetta *The Gypsy Princess*. Next, she was a showroom model for a dress manufacturer and, following that, she helped with her mother's tea garden, overlooking the River Thames. She was married there and celebrated the occasion so liberally that both she and her new

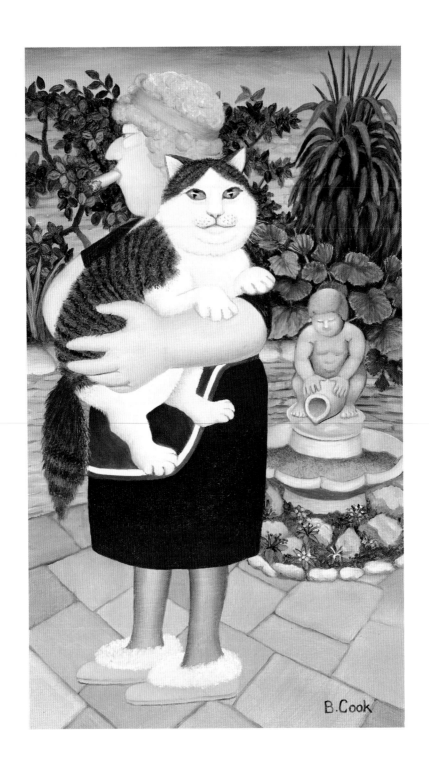

Beryl Cook, *Bunny and Nipper*, c. 1970s, oil on panel.

husband fell into the river at their wedding reception. For a while they ran a pub in Essex, but they then went to live in Africa, where she worked in an office. It was there that she borrowed her little son's paintbox and made her first modest attempts at painting. After a few years they moved back to England and settled in Cornwall, where, as a seaside landlady, she passed her time by painting in oils on scraps of wood or cardboard. She refused to sell her work, keeping the paintings on her own walls and pretending that it was her young son who had done them. It was not until she was 49 that she allowed a few to be sold; she was so surprised when they were snapped up that she started painting full-time.

Cook – by now living with her family and her cats Cedric and Lottie in Plymouth – subsequently became increasingly well known, and widely exhibited and collected. Like all true outsider artists, however, she remained shy and retiring, and was reluctant to join the publicity bandwagon that accompanied her growing success. She never turned up at the private views of her exhibitions, and even failed to appear at Buckingham Palace when she was awarded the OBE. Her admirers are legion. The broadcaster Clement Freud said of her: 'Where Lowry missed it, Bacon distorted it . . . Hockney made it antiseptic . . . Beryl Cook serves up pure unadulterated pleasure.'

Cook's love of her cats is obvious from her paintings. She usually combines them with one or more of her human caricatures, such as the woman in her garden wearing pink slippers and with a cigarette dangling from her mouth while her large cat stoically suffers her casual embrace. Or the tiara-adorned dowager whose pampered black cat snootily ignores the roast chicken in the refrigerator. Or the elderly gardener who, taking a rest in a deckchair, finds himself submerged beneath a huge, territorially minded black-and-white

cat. Or the classic cat lady doling out bowls of food to her nine time-consuming felines. In all these cases, Beryl Cook tells us with comic exaggeration what it is to enjoy, or suffer, the company of cats.

WALTER BELL-CURRIE

The English artist Walter Bell-Currie is not well known, but his naive cat portraits are among the most charming and sensitive of any in the genre. Born in Burnley, Lancashire, in 1913, he spent his professional life as a commercial artist designing advertisements for department stores in Manchester, Liverpool and London. After forty years of creating painted advertisements, he was made redundant when handmade artwork began to look old-fashioned and advertisers insisted on replacing it with colour photography.

Bell-Currie and his wife retired to rural Oxfordshire, where he began to paint 'humpy hill' landscapes and rejoiced in the freedom that non-commercial painting gave him. Perhaps as a reaction against

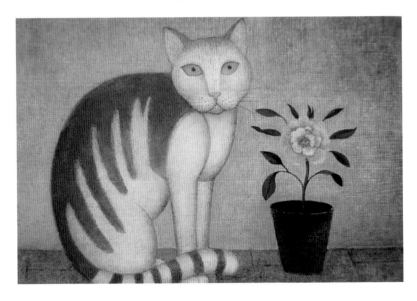

146

Walter Bell-Currie, *Ginger Cat with a Flower*, 20th century, acrylic on board.

decades of commercial art, he became more and more naive in his style until his work had the appearance of being that of a true primitive. He no doubt had the ability to paint precisely realistic scenes if he wished to do so, but instead preferred to create wonderfully stylized images. In his cat paintings he is delicate in his detail and restrained in his use of colour, and his images lack the sometimes overblown boldness and high contrast of some of the naive artists. It is the gentle care with which he crafts his feline portraits that gives them such subtle visual appeal and has made them so sought-after by private collectors.

LOUIS WAIN

Louis Wain is a contradiction. He was technically skilful and could produce a serious cat portrait if he wished, but his most typical works, it has to be said, are the epitome of bad taste. He is scorned by the art establishment because of his comic anthropomorphism, but his work is remarkably popular and his original paintings have become eminently collectible. Today his watercolours command remarkably high prices.

Wain's personal life was not a happy one. Born in 1860 with a cleft lip, he was not allowed to go to school until he was ten, and after that often played truant and wandered the streets. Later, he attended art college and became an art teacher. One of his sisters was certified as insane and placed in an asylum. He married her governess, who died of cancer a few years later. In the 1880s, following his wife's death, he abandoned his early, naturalistic style and began humanizing his cats. Sentimental Victorians loved this new work of his, and he continued with it for the next thirty years. Despite his success, he was always

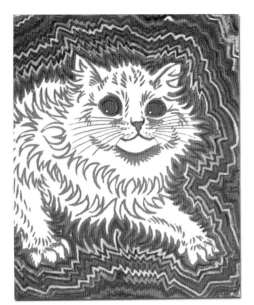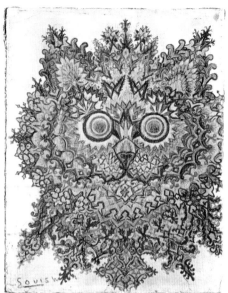

in financial difficulties because he was easily exploited by publishers of his illustrations and made bad investments.

In his early sixties Wain became mentally disturbed, and, when his behaviour became too erratic and even violent, he was confined in the paupers' ward of an asylum. When his predicament was discovered, his supporters rallied to his cause and he was moved to a more pleasant institution, where he could spend the last fifteen years of his life painting pictures of his beloved cats. Some of the later works are almost abstract, and involve explosive patterns busy with minute details. These so-called kaleidoscopic cats were said to represent Wain's 'psychotic deterioration', but they are too finely drawn to be the result of mental disintegration. Instead, they reflect an obsession with the feline image carried to visual extremes. Condemned to social isolation in the confines of the asylum, Wain was driven to work with increasingly frenzied attention to detail. The result, it could be argued, was his most original work.

148

Confined to an asylum in his later years, Louis Wain produced a series of almost abstract, kaleidoscopic cats with amazing attention to detail.

MARTIN LEMAN

Martin Leman, an English artist born in London in 1934, is a feline specialist, and almost every painting of his features a feline subject. He has been described by his gallery as 'the most sophisticated of "naive" British artists, but unlike many so-called naive or primitive painters, he had a thorough artistic training'. Of course, this is a contradiction, for no formally trained artist can ever be described as truly naive. The fact that Leman decided to paint in a naive style because that made his paintings more appealing does not make

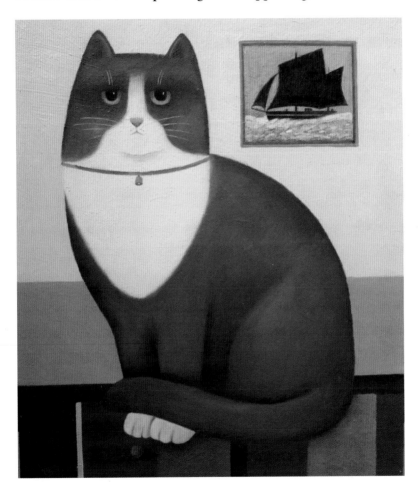

149

Martin Leman, *The Captain's Cat*, undated, oil on board.

him a genuine naive. He can best be described as an insider artist pretending to be an outsider.

After training as an artist first at Worthing Art School and then at the Central School of Art and Design in London, Leman became an art teacher at several art colleges, including the distinguished St Martin's School of Art. This makes him a fully paid-up member of the professional art world. But then, at the age of 45, he published (with Angela Carter) a book of *Comic and Curious Cats* and made the discovery that people love exaggeratedly rounded, excessively cuddly, comically cartoony cats. He realized he had struck gold and never looked back, producing no fewer than 28 books of his cat paintings over the years that followed. He also held 25 solo exhibitions and became one of the most successful faux-naive cat artists in the world.

Unlike those of the true naive painter, Leman's cats lack stiffness. Their contours flow in graceful curves around his canvases, and the paintings have the air of being accomplished rather than painstaking. For some collectors, this gives them the edge over the clumsier, more awkward images of the true naives. For others, it creates a rhythmically smooth cuteness that jars slightly.

WARREN KIMBLE

Another faux-naive artist who creates highly stylized felines is the American Warren Kimble, born in 1935. His cats, like Martin Leman's, have the eccentric appearance of being the work of a true, self-taught naive, but it turns out that, like Leman's, Kimble's background is highly professional. Kimble, a Vermont artist famous for his appealingly folksy Americana, graduated with a degree in fine

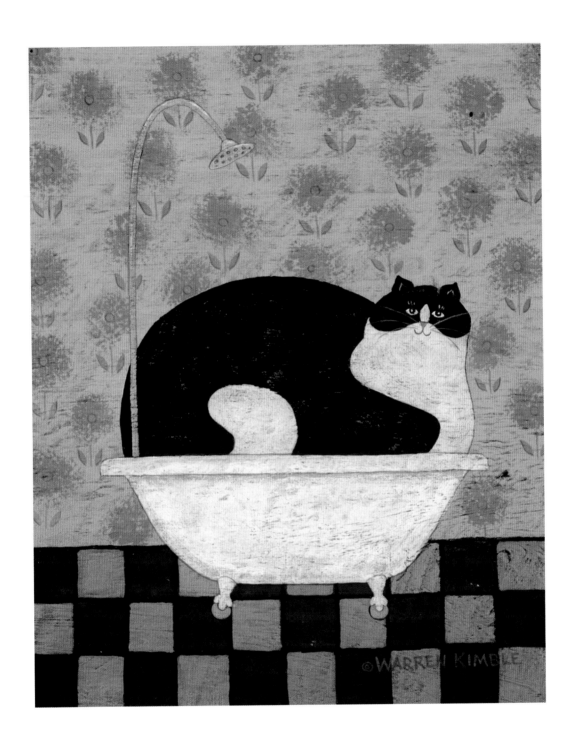

Warren Kimble, *Cat in Hot Tin Tub*, late 20th century, oil on panel, is a typically appealing feline portrait by this artist, with a wood-grain texture to give it a pseudo-vintage quality.

arts from Syracuse University and was later a professor at Castleton State College in Vermont.

In addition to being faux-naive, Kimble's work has also been described as 'faux-vintage', because he gives it an antique finish that makes it look like a work of art that has just been discovered in the corner of an attic, where it has lain gathering dust for many years. To create this impression, he often paints on old, carefully selected fragments of wood. He has been known to paint on eighteenth-century tabletops and on doors taken from old cabinets to add a period texture to his work. This technique adds to the anti-modern feel of his paintings, a quality that appeals to many who have grown tired of outlandish contemporary art experiments. Although they know the work is new, it nevertheless reminds them of the good old days when life was less complicated, slower, kinder and more serene.

In an interview, Kimble was asked about the validity of his role as a famous outsider artist: 'It seems there's a bias in the art world that "folk" art has to either be from, say, a century ago or created by a so-called "outsider" artist to be "authentic". Have you found that to be true?' He replied: 'Well, it hasn't affected me . . . I've found that wealthy America and poor America can afford my work and like it. They don't care that I've been trained.' His paintings may have a contrived innocence, but their popularity is undeniable.

EDEN BOX

The twentieth-century British artist who always signed her work E. Box (her real name was Eden Fleming) is remembered for her charming little paintings in which felines of various kinds often figured. Her personal life – accompanying her husband, a professor

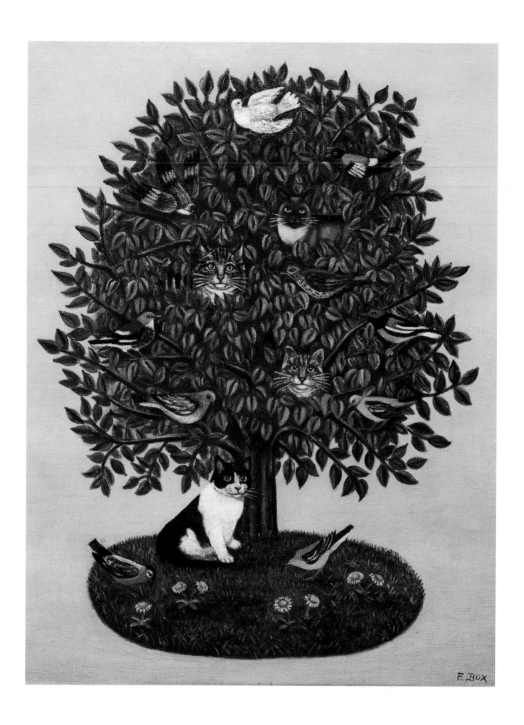

E. Box, *The Co-existence Tree*, 1949.

of mineral technology, on his research trips on four continents – provided her with useful material for her paintings. Her work often carries a moral message of some kind. In her best-known composition, *The Co-existence Tree*, for example, she shows cats and small birds living together peacefully in the foliage and on the ground below. This work has been viewed by some critics as a symbolic plea for human tolerance.

11

Naive Primitive Cats

The second category of naive artist is the modern primitive. Unlike the naive realists, these painters make no attempt to create well-crafted images, with painstaking attention to detail. Instead, they paint crudely, with a childlike exaggeration and little respect for precision. Either because they are unable to bring greater control to their brushwork, or because they have no interest in attempting to do so, they offer us wild, untamed visions of the world around them. In cases where their personal view of the world is distorted in an appealingly quaint or grotesque way, their paintings have commanded respect and, in a few instances, have become seriously collected.

MELINDA K. HALL

Melinda K. Hall is unusual in that she is a formally trained artist who nevertheless insists on painting in a crudely childlike manner. This makes her a rarity – a faux-naive primitive. Most faux-naive artists prefer to adopt a careful, naive realist style, but Hall has taken the more extreme step of throwing her training to the wind and launching into making crudely rough-and-ready images that have a powerful impact, despite their total lack of refinement.

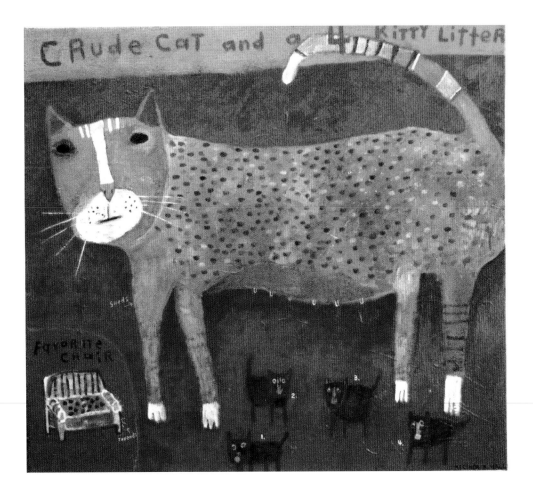

Born in Chicago in 1950, Hall graduated from the Southern Methodist University in Dallas with a degree in business administration and continued with postgraduate studies in the fine arts at New Mexico State University for two years. She moved to Santa Fe and began painting in an abstract style, but later turned to primitive imagery. A dedicated pet-owner, she frequently portrayed cats, often including written messages in her compositions. For example, in her painting *Crude Cat and a 4 Kitty Litter*, she writes the words 'favorite chair' above the image of a small yellow armchair, a strong

Melinda K. Hall, *Crude Cat and a 4 Kitty Litter*, 2012, oil on canvas. Despite its superficially crude appearance, this is a studied painting in a pseudo-primitive style.

suggestion that the Crude Cat of the title has taken over one of the seats in her home. Hall has said:

> I am a narrative painter by nature, telling stories on my canvases with image and text, observation and commentary, humour and history. This sort of painting playground appeals to me . . . Someone once asked who had given me permission to paint the way I do. I thought that was a wonderful question because in it was the implication that the work was somehow outside of some set of rules to which a painter had to comply. Painting is not a matter of rules, rather it is an arena of freedom and creative liberty where no permission is required . . . I like to draw the viewer into the environment of the painting, invite them to stay a while and there discover more subtle aspects of the work.

SCOTT DINEL

Scott Dinel is a Canadian self-taught naive primitive who, although he studied interior design in Toronto, has never had any formal training in fine art. He worked as an interior designer for only a few years before giving it up and starting to paint in the style of a primitive artist, in 1994. Unlike some primitives, he always sets his cats in a special environment. His painting *The Best Cat in the World* shows the animal standing boldly on roof tiles, while in another, the cat sits in a field among brightly coloured flowers. Commenting on these settings, Dinel has said:

> The folk art style of painting allows me to express, with directness and simplicity, the themes which interest me. A sense of place is a

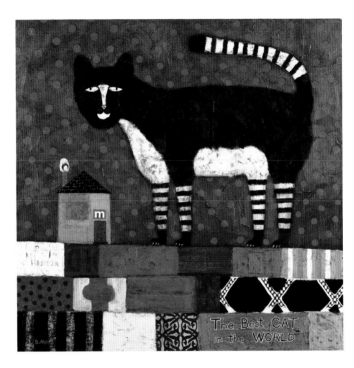

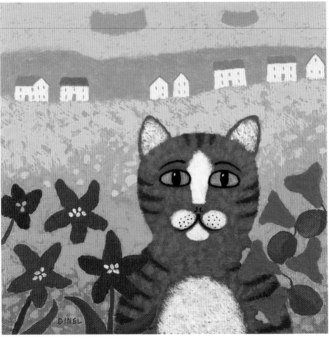

Scott Dinel, *The Best Cat in the World*, shows the animal enjoying the freedom of the tiles, as it surveys its urban territory.
Scott Dinel, *Garden Cat*, the artist's grey-and-white country cat roaming in a field near its village home.

dominant theme in my work, for where we live and how we live say a great deal about who we are. Given the rootlessness of modern society, and the uncertainty we all face in the new global economy, it is becoming increasingly important for people to establish a sense of place in the world.

Clearly, from these words, Dinel is an educated faux-primitive rather than a genuine outsider, but, despite this, his paintings manage to display the crudely unsophisticated charm of this genre.

SALLY WELCHMAN

The English artist Sally Welchman works in Brighton on the south coast. She paints on pieces of reclaimed wood, placing on each one a close-up image of a crudely drawn cat or other animal. Their crudity gives them a powerful visual impact that is the secret of their appeal. And their appeal is undeniable: when one of her works was accepted for the Royal Academy's annual summer show in 2012, it was sold within hours of the opening.

The kind of wood surface Welchman paints on is important to her:

I pick up wood found in the street and I use reclaimed wood from a local community enterprise in Brighton called the Wood Store: they sell all sorts of interesting reclaimed timber. The wood is already old but I distress it further by scratching into the paint, adding layers of paint under the background colour and then sanding areas off so that different colours show through. If I find oddities like holes or sticking-out nails in the wood I like to make them part of my design.

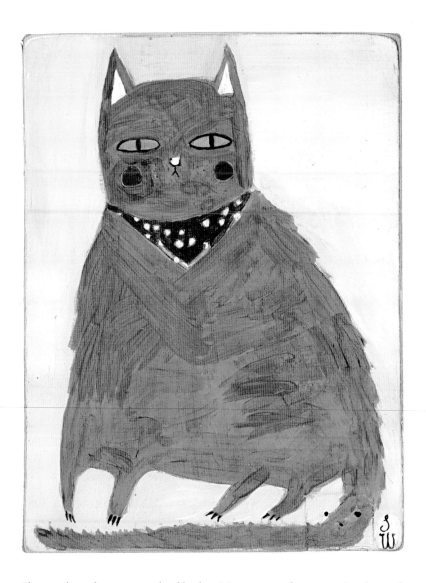

She works at home, watched by her Norwegian forest cat, Lodmund.
Among her other cats was a rescue animal called Hattie, who was
both deaf and blind. The fact that she adopted this cat and that it
lived to the age of fifteen says a great deal about her character. She also
co-runs art groups at the Brighton Museum for marginalized artists
– people with learning difficulties or problems with mental health.

Sally Welchman, *Orange Cat*, 2016, acrylic painted on a piece of reclaimed wood.

Although Welchman did not train as a painter, she does have a degree in ceramics, and it was when she was working at a pottery studio in Germany that she started painting on pieces of wood she found in the street. She used her pottery tools – 'sponges and scratching tools, sandpaper and wax, some oxides too' – and it is clearly those that influenced the controlled roughness of her finished work. She also employs an interesting technique to amplify the primitive quality of her work: she often draws and paints with her left hand, even though she is right-handed. She no doubt feels that by avoiding a more sophisticated technique she can produce work that is direct and compelling: 'I think outsider art communicates something interesting about the maker and their life that is harder to access in a more trained artist's work.'

Welchman has exhibited under several different names. At first she gave herself the improbable title Oswald Flump, which sounds as though she made it up to match the improbable anatomy of her primitively painted cats. Later she changed it to Sally Wolfe, before finally beginning to use her real name.

MIROCO MACHIKO

Finally, in Japan there is a young modern primitive artist who specializes in exotic animals and occasionally paints a picture of one of her pet cats. Born in Osaka in 1981, Miroco Machiko started painting in 2004 and now lives in Tokyo. She creates a sophisticated version of child art, employing bright primary colours and wildly exaggerated shapes. Her interest in child art extends to holding workshops for children where she tries to teach them to be bold in exploring exciting colours and shapes.

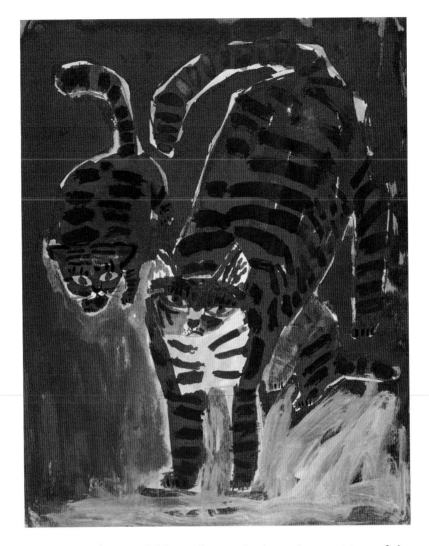

Machiko's art deliberately avoids the tight precision of the naive realists, and its direct, confident freedom sets it apart from typical outsider work. She was in fact trained in the fine arts at Kyoto Seika University and the Art School Umeda, which may account for her painterly brushstrokes. Her primitive imagery is therefore faux-naive, a deliberate choice rather than the unavoidable limitation of the true outsider.

Miroco Machiko, *Two Kittens and Their Mother*.

CHILD ART

It would be wrong to conclude this chapter on naive primitives without mentioning the most common expression of this category of feline art: the work of children. Young children may be limited by their lack of manual skill, but they all have an intuitive grasp of visual exploration. They enjoy 'taking a line for a walk', as Paul Klee once put it, playing with shapes and colours, making simple images and composing schematic scenes of the world around them. What is extraordinary about the work of children is its inventiveness and the fact that it occurs in much the same form the world over.

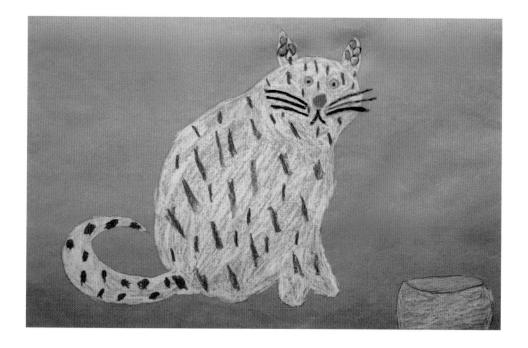

163

Cat waiting to be fed, as seen by a ten-year-old boy.

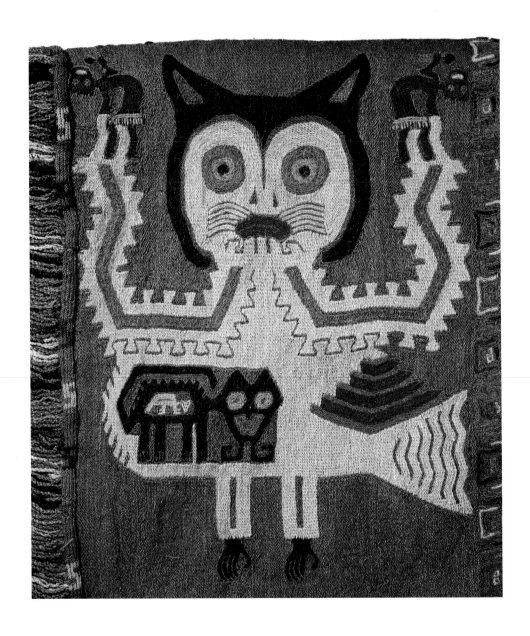

Detail of a Paracas mantle, 300–100 BC, Peru, showing a cat monster.

12

Tribal Cats

Domestic cats have not fared well in the art of tribal societies. There is a simple reason for this. Their importance as pest-controllers began in earnest only when the smaller human societies grew into complex communities with large stores of food. The first domestic cats were essentially urban animals, popular in the ancient civilizations of Egypt, Greece and Rome, so one would hardly expect to find the artists of the smaller tribal societies including them in their repertoire of animal images.

THE PARACAS

It comes as something of a shock, therefore, to find that cats featured repeatedly in the art of an early culture in South America. The Paracas flourished between 800 and 100 BC on the coastal side of the Andes in a region that is now part of southern Peru. At one of their major burial sites, discovered in the 1920s, each body was found to be wrapped in many layers of beautifully woven textiles. These textile mantles were covered in strange images, including many of cats. It is clear that these were not wild cats because, in one case, a human figure is shown carrying a cat under its left arm. The cat is depicted sticking out its very long tongue.

On the human figure's raised right arm there is a curious creature that appears to be some sort of mythological cat-headed snake, the tail of which disappears inside the human's mouth. This concept of a cat-headed snake is not unique to the Paracas. It appeared in an even earlier culture further north in the Americas, where it represented the Earth, disorder and darkness. This sacred serpent was constantly at war with the Birdman, a deity representing heaven, order and light. The people were told that if they tilled and cultivated the land, they would be controlling the Earth and reducing the disorder and chaos. As a religious device to keep the people working hard, this concept obviously helped the rulers maintain control over their society. If this belief spread to the Paracas culture in South America, it might help to explain the mysterious figure standing with a cat under one arm. If this figure represents the Birdman, or his equivalent, it would make sense if the cat-headed snake were

166

Paracas mantle made of llama or alpaca wool, from the Paracas peninsula
in Peru, dating from between 300 and 100 BC.

being devoured by him and disappearing into his mouth, rather than emerging from it. The composition would then stand for the triumph of heaven over earth. If this is the correct interpretation, it is amusing to think that, in that case, heaven has a pet cat (the one under his left arm).

This gives rise to the question: what sort of pet cat? It cannot be the domesticated cat from Egypt, via European explorers, because it would be centuries before they arrived in South America. Instead, it must be one of the small cat species that inhabit this part of the world. There are several to choose from, and it is known that one, the jaguarundi – a small, elegant, brown cat with a long, slim body – was kept as a pet by some of the Pre-Columbian tribes, which makes it the favourite candidate. What is more, the cat under the arm of the Paracas figure happens to be long, slim and pale brown in colour.

The decorated mantles so skilfully crafted by the Paracas date from between 300 and 100 BC, and there are several hundred of them. In one, a cat monster appears, standing on its hind legs and with its front legs raised above its head. Although it has a triangular tail that could belong to a fish or a bird, its head is unmistakably feline, with long whiskers and short, pointed ears. It appears to be pregnant with a small black cat that is shown inside its body. The black cat is also clearly feline: it has a long tail that curves up over its body, and its back is arched, its hair standing on end, as though the animal has seen something that has made it hiss angrily.

Another curious detail of this figure concerns the front paws of the cat monster. In each of these raised paws it appears to be holding a tiny black cat, and each of these little creatures is also holding something in a raised front paw, although it is hard to

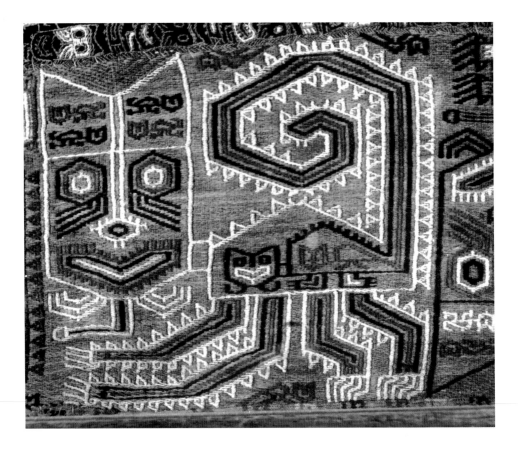

determine what that might be. This complex image undoubtedly illustrates some kind of tribal myth or legend, but whatever that might be, it is undeniably feline in its essence.

The combination of large cat and small cat is seen on another of the Paracas mantles, where the larger animal is once more outlined in white, while the smaller one, as before, is shown in black. Both are depicted with arched backs, their tails curled together over their bodies. On the borders of another mantle are eight eccentric cats of a truly bizarre kind. They have large black ears, blue-ringed eyes, huge protuberant whiskers, a mouthful of small teeth, a two-tone body, banded legs, long-clawed feet with a face on each one, an

168

White cat on a Paracas embroidered mantle (detail),
with a smaller black cat inside its body.

arched back and a thick tail. But their most peculiar feature is that along the back and the tail, there are five decapitated trophy heads.

THE NAZCA

The Paracas culture eventually combined with the Topará culture from the north of Peru to develop into the Nazca people, who flourished between 100 BC and AD 800. The Nazca are famous for their 'Nazca Lines' – huge images cut into the flat plains, visible only when flying over them in some kind of aircraft (or to the gods in heaven, of course) – but they also continued the Paracas textile tradition, and there is a fascinating cat monster on one of their

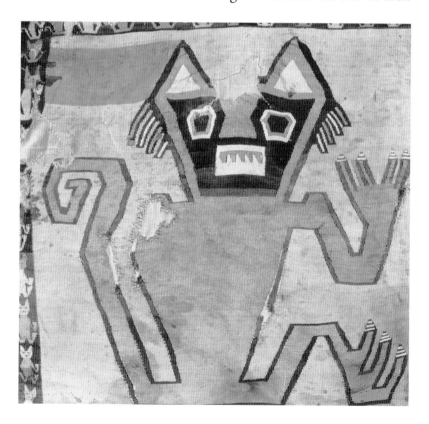

169

Cat demon from a Nazca textile panel, 2nd–3th century AD, Peru.

textile panels. It has sharply pointed ears and is making a strange gesture with its front paw. The paw is held up and the four fingers divide to form a V. This happens to be the gesture popularized by Mr Spock, the pointy-eared Vulcan in the television series *Star Trek*. Make of that what you will.

THE CHIMÚ

The image of a cat proved to be a remarkably persistent feature of Pre-Columbian art, lasting for many centuries. The people of the Chimú culture, who lived along the coast to the north of the Nazca region and flourished there centuries later, also included a cat with a curled-up tail in their textile designs. Between 1470 and 1532, for example, they created an amazing knee-length, feathered tunic showing a number of small black cats with their mouths open. Carefully stitched on to the cloth are literally thousands of small coloured feathers, completely covering the outer surface of the garment, so that no part of the underlying cloth is visible. What makes this garment so extraordinary is that the feathers have been identified as coming from a variety of exotic bird species, including macaws, parrots, tanagers, cotingas and toucans. These birds live in the tropical forests on the other side of the Andes, and their plumage must have been collected there and transported over the treacherous peaks of the mountains to reach their destination in what is now coastal Peru.

THE CHANCAY

The people of the Chancay culture, which inhabited a coastal region to the south of the Chimú, at about the same time, also depicted small

cats with tightly curled tails on their textiles. The feline presence was clearly widespread along the coast of what we now call Peru.

What is so astonishing about all these ancient Peruvian cultures is that their delicate textiles have survived for so long and in such good condition. The colours of many of them are still almost as bright as the day they were made. We have the structure of their tombs and the remarkable climatic conditions to thank for that.

Feathered tunic made between 1470 and 1532 by Chimu weavers.

THE KUNA

The Kuna (or Cuna) people of Panama are one of the last tribal societies on the planet to retain their cultural independence, their social customs, their supernatural beliefs and, above all, their artistic traditions. For centuries they have resisted all attempts to modernize their world, and have been ruthless in their determination to isolate themselves. Historically, they are descended from the Carib people who gave the Caribbean its name. With the exception of the African Pygmies, they are the smallest people on earth: the average height of the Kuna is less than 1.5 m (5 ft). Their ancestors lived on the mainland of what is now the Central American country of Panama, but then, in the mid-nineteenth century, they retreated to the archipelago of 365 small coral reef islands that borders its northern coast. Of these they inhabited only 36, but they considered the whole archipelago and its nearby mainland coastal region to be their own tribal territory, where they wished to be left alone to live according to their age-old traditions.

In the 1920s the Panamanian government decided to 'civilize' the Kuna and sent police to the islands to introduce them to a more up-to-date way of life. They were told to stop wearing their traditional body decorations and costumes, and to become fully integrated Panamanians. Although usually a remarkably peaceful tribe, the Kuna's response was to kill the intruders. A bloodbath was avoided when the Panamanian government wisely agreed to a treaty giving the Kuna local self-government. In theory the Kuna would be citizens of Panama, with the right to vote, but in practice they would retain all their tribal laws and customs, and would pay no taxes. And so it has remained to the present day.

Pair of cat-headed snakes on a Kuna *mola*, 20th century, Panama.
Kuna *mola*, 20th century, showing two bipedal cats with rounded bodies.

The men of the Kuna wear drab working clothes except on special occasions, when the important among them display their high status by wearing ties and European-style hats. The women, on the other hand, appear in full tribal costume every day. The most important item of female clothing is to be found on the blouse. On the chest there is a rectangular decorative panel called a *mola*. In fact, there is always a pair of these panels, one on the chest and another on the back. The chest image is usually similar to the back image, or they may show two scenes of the same subject.

It is the imaginative, artistic quality of these *molas* that has made such an impact internationally in recent years. They are more like original paintings than mere costume decoration, and considerable skill is employed in their laborious, time-consuming production. The technique employed to make these panels is reverse appliqué, and they take several weeks of intensive work to complete. Between two and five layers of cloth are placed on top of one another and then holes, slits and shapes are cut in these layers to reveal the colours underneath.

A wide variety of animals appear on the *molas*, and cats are among them. What is so extraordinary about the design of these cats is that they show similar features to some of the feline images on textiles that were made centuries ago. For example, the cats designed by the Nazca, the Chimú and the Chancay artists displayed a spiral, tightly curled tail. No real cat has such a tail. The spiral tail is an invention of Pre-Columbian textile designers, yet the same shape of tail is seen on some of the molas created by the Kuna in the twentieth century, between 500 and 1,700 years later. Even more extraordinary is the fact that there are Kuna *molas* showing two cat-headed snakes

– a legendary figure that was an important part of the mythology of the Paracas more than 2,000 years ago.

A strange feature of the Kuna designs is that they are wildly imaginative with their imagery, while at the same time being totally traditional technically. A *mola* is always easy to identify as such and can never be confused with any other art form, but the manner in which the female artists play with familiar subjects, depicting them in all kinds of unexpected ways, is extremely unusual for works of art produced by a tribal society.

On one *mola*, for example, two animals are shown with bird-shaped bodies and only two feet, but with the heads and tails of cats. It is as though birds have sprouted feline extremities. Combining different body parts to create chimeras in this way is a common device employed by the Kuna women to make their designs more surprising and more eye-catching.

Another Kuna oddity is the way in which they imply that a particular animal is important: by borrowing details from the costumes their menfolk wear to display high social status. If an artist wishes to show that an animal is unusually important, she will give it a tie to wear. One *mola* shows three domestic cats – presumably someone's much-loved pets – each wearing a smart bow tie. Superficially, this appears to be anthropomorphic, with the artist dressing up the cats, but it is not. It is a symbolic statement, employing a high-status device. There is no suggestion that the cats themselves would wear bow ties in real life. In another *mola*, for example, an important fish is also shown wearing a bow tie – something that could never happen in real life.

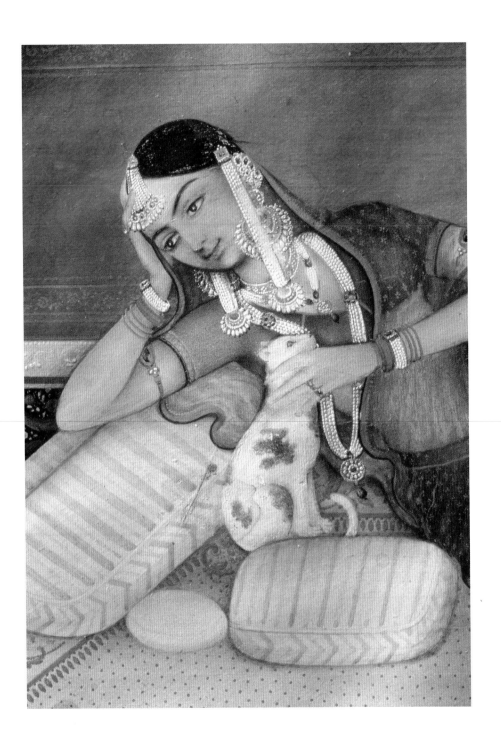

Indian miniature, 14th century, showing a reclining princess with a dreamy, wistful expression, stroking the neck of her pet cat.

13

Eastern Cats

Domestic cats were common in Asia and the Far East from an early date, and fortunate in that they escaped the long period of persecution suffered by their European counterparts. They appear frequently in the art of India, Korea, China, Japan and elsewhere in the East. Stylistically, such images are very different from those of the West: the lines, shapes and details are more delicate, more refined and less bold, and they are immediately identifiable as coming from an ancient Eastern tradition of picture-making.

INDIA

An unusual painting of cats can be found in an amazing volume of inventive images created in India in the eighteenth century, based on works that date from the thirteenth and fourteenth centuries. Known as *The Book of Wonders of the Age*, it is to be found in the University of St Andrews in Scotland. The volume is made up of two works, bound together. The first is part of *Lives of the Animals* by the fourteenth-century Egyptian theologian Muhammad Al-Damiri, itself a collection of material from a number of authors, and deals with the different animals that are mentioned in the Qur'an. Some are fanciful, imaginary creatures, while others, such as the cats, are

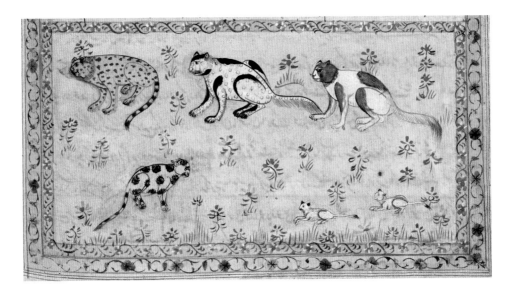

clearly recognizable. The second part of the *Book of Wonders* consists
of illustrated extracts from the *Wonders of the Seven Seas*, by the
thirteenth-century writer Zakariya al-Qazwini, a Persian physician
and great traveller who died in 1283. It is full of strange, mythical
animals. This combined volume represents an attempt to sum up
all that was known about living things at the time it was created.
Although it was made in India, the text, confusingly, is in Persian
and the Persian is a translation of the original Arabic. Its importance,
however, lies in its remarkable illustrations.

The image of cats shows one with small spots, one with
black-and-white markings, one with grey-and-white markings and
one with large spots. There are also two tiny grey-and-white cats,
probably meant to be kittens. The cat with small spots and a striped
tail is probably meant to be a tabby with broken body stripes. The
black-and-white cat also has faint spotting, suggesting that it is partly
tabby. The cat with large spots is puzzling, and it is tempting to think
of this as a wild cat, rather than a domestic one. Elsewhere, however,

Early images of cats from *The Book of Wonders of the Age*, 18th century. The artist
was keen to point out the various coat patterns that existed as early as the 14th
century.

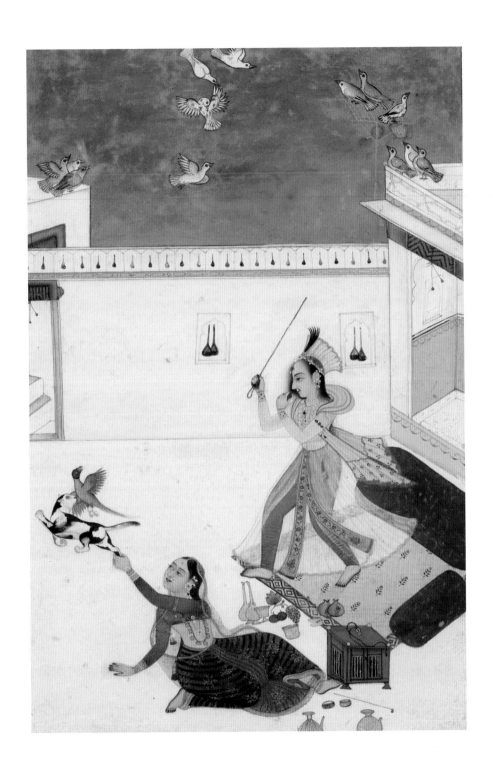

Detail from *Two Ladies, a Cat and a Parrot*, Mughal Empire miniature, 1750.

there is an early Indian miniature of a princess with her pet cat that suggests that the markings of pet cats in Asia in those days were often like this. It appears that by careful breeding white cats could be produced with remnant patches of colour that gave the impression of being large spots.

In the Mughal period (1526–1857) Indian miniature paintings became extremely popular and were produced in large numbers. Pet cats do put in an appearance occasionally in these busy, colourful works, but they are by no means common. In an example dating from 1630, two cats – one black and one white – are shown loitering on the fringes of an outdoor banquet, obviously hoping for morsels of food to come their way. They are both wearing collars and are clearly not lowly working cats, but accepted companions, although not, perhaps, expected to join in the feasting on this special occasion.

In a work dating from 1750 a domestic disturbance is depicted, in which a pet parrot is being attacked by a pet cat. The cat has leapt up and grabbed the frightened bird, while a young woman has managed to catch hold of the cat's hind leg and is trying to control it. Another woman is taking more severe action, approaching the warring pets brandishing a thin stick or cane in her right hand, although it is hard to see how she can strike the cat without running the risk of hitting the bird.

A slightly later Mughal work, from 1770, depicts another dramatic scene. This time a young woman is protecting three older women by deftly spearing a venomous snake through the head. The snake has ventured into the house in search of a tasty meal of pampered pet, but has been foiled by the prompt action of the young woman, to the obvious delight of the house cat, which is shown hurrying towards the victim in eager anticipation of a reptilian feast.

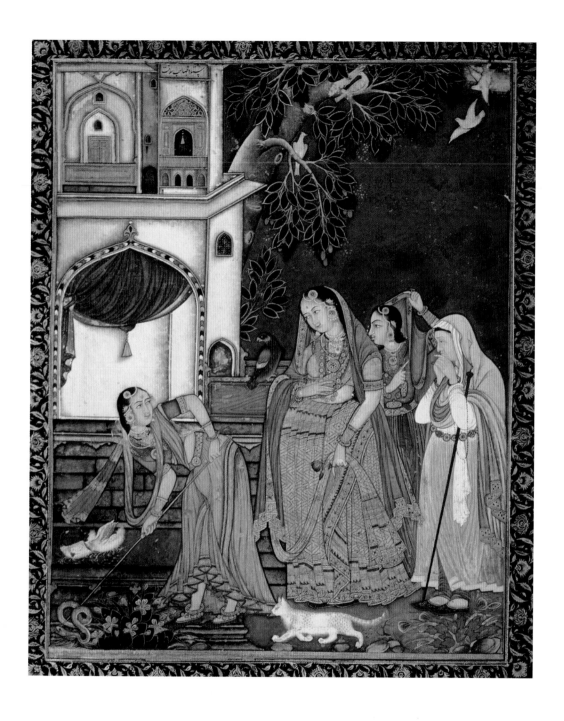

Detail of a Mughal miniature painting of a young woman killing a snake, to the
delight of the house cat, who is approaching fast.

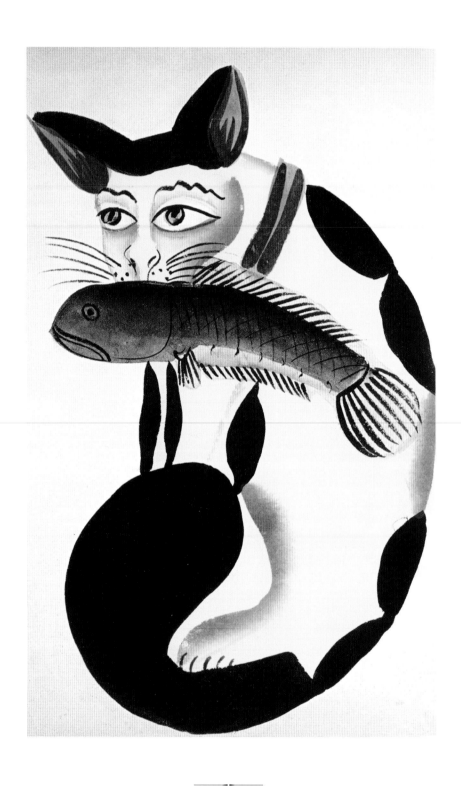

Cat with food in its mouth, from the Kalighat School in
19th-century Bengal.

In the nineteenth century a new style of painting arose in India, with simpler, bolder images than those made popular on the Mughal miniatures. Known as the Kalighat School, it was concentrated in Bengal, in the vicinity of the Kalighat Kali Temple. The British had established a school of art in Calcutta, and that attracted some of the rural scroll painters, who blended their traditional work with the new Western influences.

The increasingly popular new style was soon established as a distinct genre. The cat paintings these artists created are immediately recognizable and highly distinctive. No images in the whole history of feline art look remotely like these extraordinary Kalighat cats. One is shown holding a huge prawn in its jaws; another holds a parrot; and a third a fish. The cats themselves are black-and-white or brown-and-white and have huge, bushy tails. Their images use all the available space. Whereas in the earlier Mughal miniatures the cats are only a very small part of the overall composition, here they dominate it completely. There is nothing else – the backgrounds are blank.

SIAM

In the cat world, Siam (now Thailand) has become famous as the home of the breed referred to today as the Siamese cat. The early *Cat Book Poems*, the *Tamra Maew*, compiled sometime between 1350 and 1767 (probably in the 1550s), contains illustrations depicting all the breeds of domestic cat that were known at the time. There are 23 altogether: seventeen that bring good luck and six bad. Today only five of these early breeds survive.

The breed that we now know as the Siamese was originally called the *Vichien Mat* (or *Wi-Chi-An-Maad*). To Western eyes it was the

most striking breed, and one that was hitherto unknown to European cat-breeders. It was a blue-eyed cat with dark extremities and a body that was long, slim and angular. Compared with the fluffy, rounded Persian cat, it looked painfully thin, but it had an extraordinary, almost canine temperament that appealed strongly to certain types of cat-lover. In Thailand it was associated with royalty, and was sometimes referred to as the Palace Cat or the Royal Cat of Siam.

The first Siamese cats to arrive in Europe had slanted eyes and a crooked, kinked tail, but both characteristics were soon bred out. An oddity of the breed is that its dark extremities are caused by body-cooling. The kittens, hot from the womb, are pale all over. As they grow, the warm central parts of the body remain pale, while the cooler extremities become darker. If an extremity remains warm (as when a leg is bandaged owing to injury), the fur does not darken. This strange 'colourpoint' feature is unique to the breed. Today, in the world of feline specialists, the Siamese is a successful pedigree cat and is found worldwide.

KOREA

Cats were a popular subject among the eighteenth-century Korean artists who created the hanging silk scrolls in the Joseon Dynasty (1392–1897). One of the most famous of these was Sang-Byok Pyon, who was so fond of cats that he was nicknamed 'Pyon the Cat'. In one of his best feline studies, *Cats and Sparrows*, he also reveals his knowledge of bird behaviour. The smaller of the two cats, and therefore presumably the more inexperienced one, is seen clambering up a tree in a vain attempt to catch a sparrow. The sparrow and its companions, instead of fleeing in panic, have responded by 'mobbing' the cat.

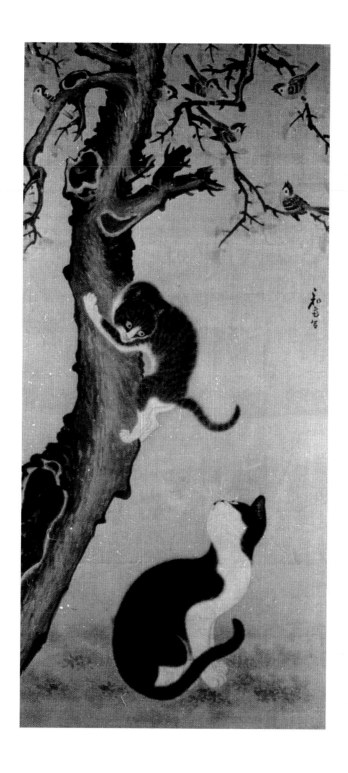

Sang-Byok Pyon, *Cats and Sparrows*, *c.* 1750, hanging silk scroll.

'Mobbing' is a special display performed by small birds when a predator is unusually conspicuous in daytime. They gather around it, flapping their wings and calling out as loudly as possible. The boldest then start dive-bombing the predator, and will even peck at it as they fly past. This is most likely to occur when the birds spot a bird of prey, such as an owl, resting in a tree in daylight, but a cat can also trigger this special reaction, as is happening in Pyon's study. The artist shows six sparrows sitting in the tree just above the climbing cat; three of the birds have their heads thrown back and their wings drooped – the display posture of the mobbing bird. The noise they are making has alarmed the young, striped tabby cat and it is turning to look down at the larger, black-and-white one on the ground, as if to say: 'What do I do now?'

CHINA

In the twelfth century, when cats were being depicted as crudely stylized caricatures in the bestiaries of Western Europe, they were already being given a subtle, delicate, skilful treatment by Chinese artists. During the Song Dynasty, from the tenth to the thirteenth century, Chinese painting techniques were already centuries old and had reached a point where pictorial details were intricate and complex. A typical example from the twelfth century shows two children playing in a garden and looking at a small black-and-white kitten with a short tail. The tail is important because it is halfway to being a bobtail – the short, twisted appendage that was present on the cats that were exported from China to Japan during the Song period as the foundation stock for the Japanese Bobtail cat breed.

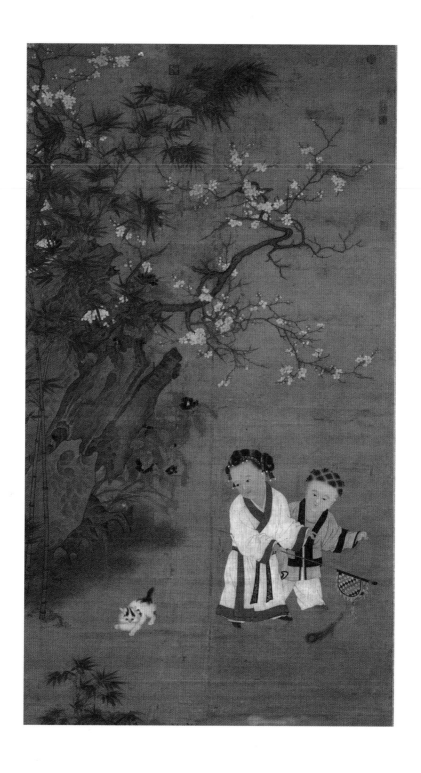

Children Playing on a Winter Day, 12th century (Song Dynasty), Chinese hanging scroll, displaying delicate painting skill at a very early date.

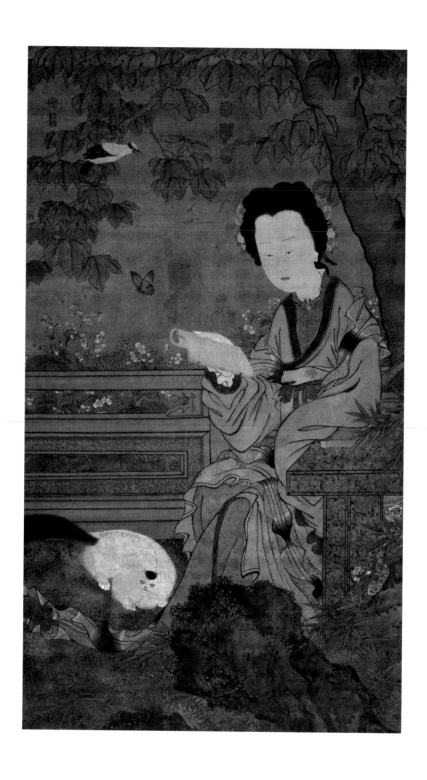

Zhou Wenjiu, *Lady Reading with Cat*, 13th century, ink and colour painting.

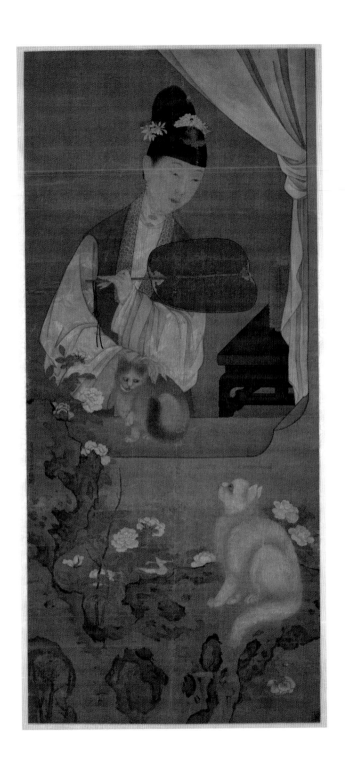

Zhang Zhen, *Lady at a Window with Two Cats*, late 17th century,
hanging scroll, ink and colours on silk.

Other cat paintings also show this shortening of the tail, and it is clear that this was a trend among cat-breeders in early China that ultimately led to the bobtail condition. It also reveals that cats were not simply allowed to run wild, as useful controllers of rodents, but were kept in the home and bred selectively for certain features. When they appear in paintings, these early cats are all shown in pleasant contexts, enjoying themselves in gardens or being petted by their owners.

In the thirteenth century the artist Zhou Wenju also depicts a pampered cat relaxing with its female owner. In an idyllic scene, it lies quietly at her feet as she reads a book in her garden. The long-haired white cat has a distinctive black patch on the top of its head and a bushy black tail. Here, there is no shortening of the tail, so it is clear that that trend did not apply to all cats. This particular pet looks unusually well-fed, even overweight, and has obviously been lovingly cared for, perhaps too much so.

This pleasant relationship with cats continued for hundreds of years. A charming scene in an early eighteenth-century painting by Zhang Zhen, *Lady at a Window with Two Cats*, shows a small ginger cat being stroked gently by its owner while a larger white cat watches jealously from the garden. The expression on the ginger cat's face, as it twists its head to look at the white cat, suggests that it fears it will have to pay for the pleasure of monopolizing the attention of their loving owner.

In modern times, the most famous Chinese artist was Xu Beihong (1895–1953). The boldness and looseness of his brushstrokes give his works a freshness and immediacy that make them instantly recognizable. There was a Western influence guiding this: in 1919 he had attended art school in Paris, and had seen the revolution

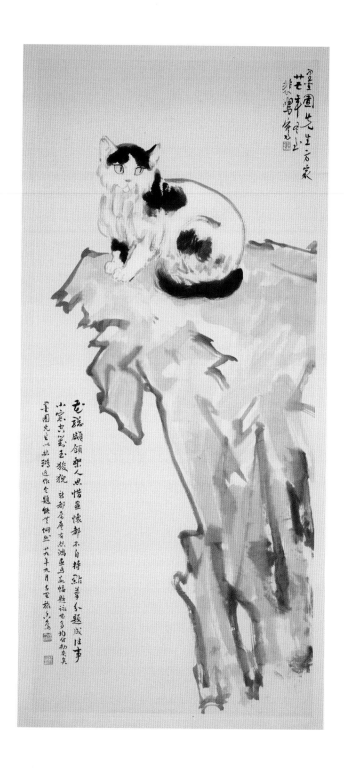

Xu Beihong, *Cat Sitting on a Rock*, first half of 20th century, ink and colour on paper.

in the arts that had taken place in Europe with the Impressionists and Post-Impressionists. He did not, however, embrace the latest developments of the avant-garde, and he denounced the art of Picasso and Matisse as degenerate. For him, it was the duty of art to capture nature on the painted surface.

Xu returned to China in 1927 and helped to organize exhibitions that travelled abroad. With the founding of the People's Republic of China in 1949 he rose to power in the art world, becoming president of the Central Academy of Fine Arts, and continued to exhibit internationally.

Animals were Xu's favourite subjects. He painted countless pictures of his black-and-white cat, in many different settings – climbing trees, sitting on rocks, hunting and resting – always managing to catch exactly the right body posture and tilt of the head.

JAPAN

Domestic cats arrived in Japan from China in the middle of the sixth century AD, but it is not until the start of the eleventh century that we have any details of them. It was then, during the reign of the popular young Emperor Ichijo, that a diplomatic mission from China arrived with five bobtail cats as a special gift. The emperor installed them in his palace in Kyoto and became an ardent cat-lover. One of his cats, a female, was given the official title of Chief Lady-in-Waiting of the Inner Palace, giving it a high rank in his court. The cats wore silk collars and leads and were treated to a life of luxury.

Cats remained the treasured pets of the Japanese aristocracy, and it was forbidden to let them run loose until a royal decree released them in 1602. There was a practical reason for this: rats

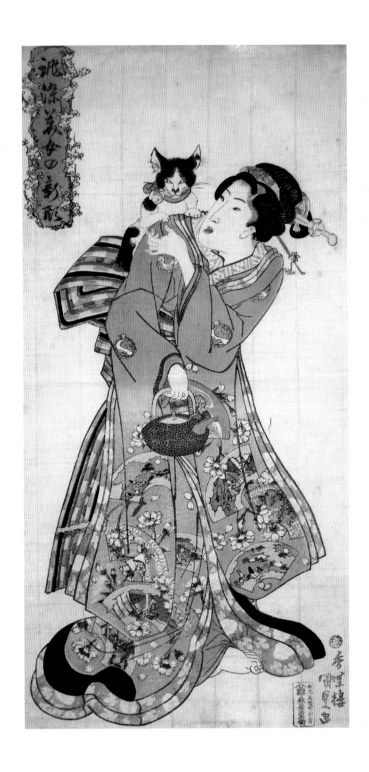

Utagawa Kunisada I (Toyokuni III), 'Cat and Beauty' from the series *Beauties in New Styles Dyed to Order*, late 1830s, woodblock print.

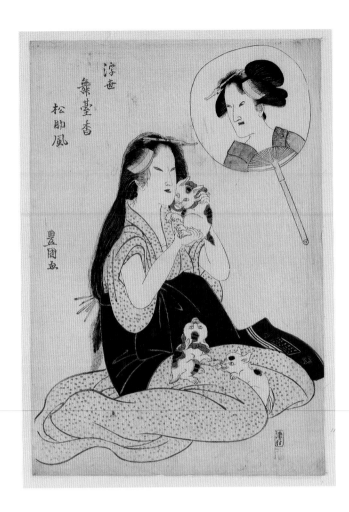

浮世
舞臺香
松助風

豊國画

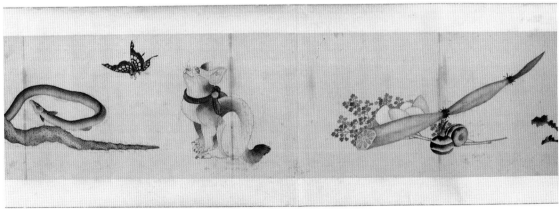

Utagawa Toyokuni, *Woman Holding a Cat*, early 19th century, woodblock print. She
appears to be the owner of a litter of three Japanese Bobtail kittens.
Hokusai (1760–1849), *Cat and Butterfly*, *ukiyo-e* school, woodblock print.

and mice were ruining the silk industry and attacking the grain stores. Something had to be done, and the introduction of the cats as predators was the answer. It became forbidden by law to own a cat. The pampered bobtail cats suddenly found themselves living as street cats, and were forced to start hunting in order to survive. As time passed their numbers increased and they were once again taken in as house companions, but this time they were the pets not of the elite, but of the masses. A century later, in 1702, in an early book about Japan written by a foreign visitor, the author wrote: 'There is only one breed of cat that is kept. It has large patches of yellow, black and white fur; its short tail looks like it has been bent and broken. It has no mind to hunt for rats and mice but just wants to be carried and stroked by women.'

During this time – the Edo period (1603–1868) – the growing Japanese obsession with domestic cats spawned some great artists. It was a stable, peaceful time for the country, and the arts flourished. Instead of producing paintings of the cats, however, the artists of the time chose to portray them on woodblock prints. This form of art, known as *ukiyo-e* (meaning literally 'pictures of the floating world'), involved carving an image into a block of wood, covering it with paint and stamping it onto paper. This quickly became a mass-produced form of art, popular across the whole of Japan.

The name *ukiyo-e* is derived from the Buddhist concept that we live in a transient, fleeting world. Instead of bewailing this idea, the wealthy middle classes of Japan decided to 'seize the day' and live for the present, enjoying the pleasures of life and the popular arts. High-quality woodblock prints became favourites with the richest people. These prints used the highest grades of paper and the most permanent mineral pigments. As time passed, the less wealthy also

began to collect woodblock prints, which were now being made using cheaper paper and pigments to reach a mass market. Soon the country was flooded with such prints, and everyone was busy making their own personal collection, usually of a particular subject. Some collected landscapes, others favoured warriors or courtesans, and there was a thriving following for prints of cats.

The major artists of this genre who sometimes portrayed cats were Kano Tan'yu, Katsushika Hokusai, Utagawa Toyokuni, Utagawa Kunisada, Utagawa Hiroshige and Utagawa Kuniyoshi. Hokusai, who was known by no fewer than thirty different names during his life – an unusually large number even for a Japanese artist – gained international fame with his landscapes showing Mount Fuji and his painting *The Great Wave* (1832), but he also created woodblock prints of cats from time to time. His best-known example shows a seated cat wearing a red collar and staring up at a flying butterfly, as if contemplating whether it is worth attacking. In another of Hokusai's prints his rather ferocious black-and-white cat, wearing a red collar with tassels, clasps a black-and-white rat in its jaws. Hokusai was important in Europe because his work inspired the Impressionists. Claude Monet's famous water-lily garden at Giverny was based on a Japanese design, and he owned 23 of Hokusai's woodblock prints, which he displayed all over his house. The French painter even encouraged his wife to wear a kimono when she was at home.

Utagawa Toyokuni was best known for his prints of actors in kabuki theatre, and for erotic shunga works, but he also made some attractive prints that included the popular Japanese Bobtail cat. In one early nineteenth-century example, he shows a young woman squatting on the floor with two Bobtail kittens in her lap and another held up to her cheek in a tender embrace. Two of the kittens are

wearing the traditional red collar. Toyokuni was not rated as one of the greatest of his genre, but was nevertheless praised for his 'decorative bombast' and his 'bold, taut designs'.

Among the next generation of Japanese woodblock print-makers, Utagawa Kunisada was, in his day, the most popular and successful artist of his school. He was astonishingly prolific – one of the most productive artists who has ever lived – creating an estimated 25,000 designs over his lifetime. Two portrayals of a woman with a pet black-and-white Bobtail cat are particularly lively. In one from 1810 the artist perfectly captures the cat's awkward posture, its legs dangling in the air, as the woman raises it high above her head. It is clear that the animal is tolerating the game, but not exactly enjoying the experience. In the other, from the 1830s, the animal appears to be kneading her shoulder with its front paws, digging its claws into her delicate flesh; she twists her head to stare at it and reaches up with her left hand, her fingers grasping as if to interrupt it and protect herself.

This kneading action, sometimes performed by an adult cat when it feels particularly comfortable with its owner, is borrowed from infancy, when it is used by kittens to stimulate the flow of milk as they feed at their mother's teats. Pet cats, even when adult, are being fed by their owners and are thus psychologically in an infantile relationship with their human companion. As a result, they sometimes express their acceptance of the pseudo-maternal role of their owner by regressing to a kittenish state. Kunisada has caught such a moment perfectly.

Born at the very end of the eighteenth century, Utagawa Hiroshige was considered one of the great masters of the *ukiyo-e* tradition. He was greatly admired in the West, and Vincent Van Gogh

Utagawa Hiroshige, *Cat on Window*, 1858, woodblock print. The picture captures
the resigned frustration of a cat that is confined to an indoor life.

copied some of his compositions. His most famous cat painting is *Cat on Window* (1858). Unusually, this painting includes no human companion; the cat takes centre stage. It shows a white Japanese Bobtail cat sitting hunched disconsolately on a windowsill, staring out at the open country in the scene below. This is a pampered cat, resigned to being kept indoors, unable to hunt and mate and experience the more exciting life of an outdoor, working cat. Hiroshige catches its deprived, if luxurious, condition perfectly in his painting.

Less successful is Hiroshige's curious work *Cat Washing*. Here, he has abandoned his accurate observation of feline behaviour and posture, and has allowed himself some poetic licence. This is not a cat; it is a girl with a cat's head, doing her washing, or it is a cat with a girl's body, doing its washing. The right hand, or paw, of this ambiguous figure is raised and holding a small piece of cloth. It is impossible to tell whether this cloth is being squeezed, or is being used to wipe the brow of the washer. The other hand, or paw, is hidden in the water of the shallow, round bowl, and the whole posture of the figure and its frozen action are typically human rather than feline. It appears to be a joke at the expense of the notoriously lazy house cat, which sleeps twice as long as its owners and whose only labour consists of catching the occasional mouse. The artist has decided, for fun, to put the cat to work, and from its demeanour, the animal is clearly not happy about this.

Hokusai's contemporary Utagawa Kuniyoshi was famous for his images of lively felines. He seemed to be obsessed with cats: his studio was overrun with them, often more than ten at a time, and he maintained a Buddhist altar in his home for his deceased pets, adding a mortuary tablet for each when it died. He also kept a register book of cat deaths.

In his woodblock prints Kuniyoshi depicted his cats, usually Japanese Bobtails, in many situations. In one, a cat is peering over the edge of a goldfish pool with its tongue literally hanging out at the thought of the tasty meals to come. In another, the cat's owner is shown spanking her cat. There are also sheets covered with Bobtails in a variety of feline postures.

Cat art continued after the end of the Edo period with the work of the next generation. This period, which runs from 1868 to 1945, is generally known simply as the Pre-war period in Japanese art. Its first phase (1868–1912) is also called the Meiji period. It was a time when, at one point, the Japanese government encouraged

Kuniyoshi, Japanese Bobtail cats shown sleeping, squatting and beckoning, 1861, woodblock print.
Kuniyoshi, Japanese Bobtail cat being spanked by its owner, woodblock print.

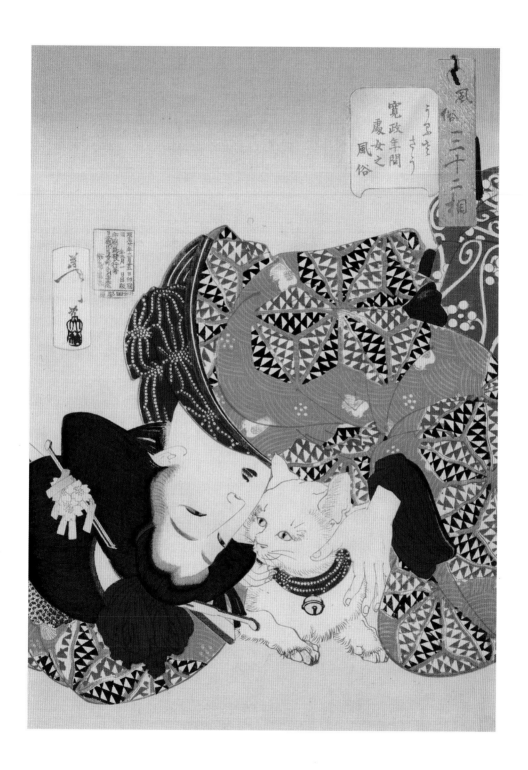

Tsukioka Yoshitoshi, detail from a woodblock print of 1888.

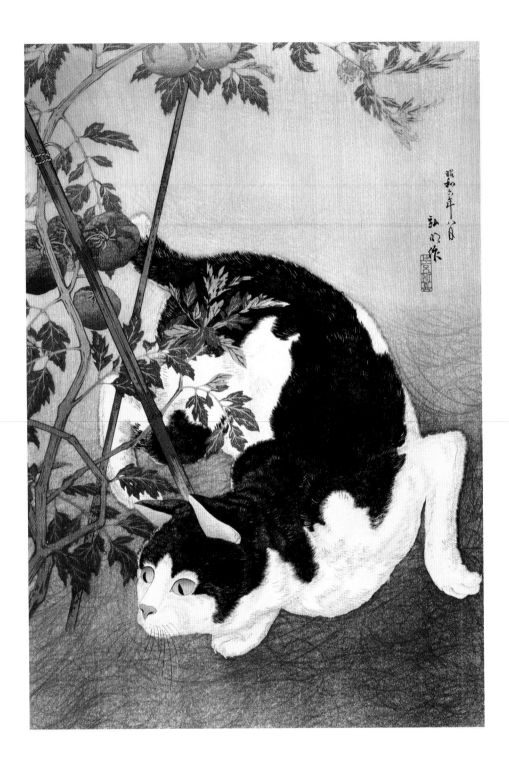

Takashashi Shotei, *Cat Prowling Around a Staked Tomato Plant*, 1931. Shotei continued
the colour woodblock print tradition of the *ukiyo-e* artists.

young artists to travel to Europe to gain information about the new trends that were developing there. There were subsequently repeated struggles in Japan between European-influenced artists and the more conservative traditionalists. Overall, the traditionalists won, and much of the art produced during this period was an attractive continuation and development of the work of the Edo period.

There were at least 25 important artists working during the pre-war period, but among those featuring cats, five are represented here. The first, Tsukioka Yoshitoshi, was a young man when the Edo period ended, but his roots were in it because he had been an apprentice to Kuniyoshi and was strongly influenced by him. Yoshitoshi's main work appeared at the start of the new period, and he was the last major proponent of the long tradition of woodblock printmaking. Although he showed a strong interest in foreign developments in the arts, he also felt that there was a need for Japanese artists to keep the old techniques and design styles alive. He was up against newly imported techniques of reproduction, such as lithography, but he struggled on and his late work is now highly valued as the final expression of a long and great tradition. One of his designs, created in 1888, a few years before his death, shows a girl bending low over her pet white cat and pressing her cheek against the side of its face. The cat is wearing the familiar Japanese red collar with a tinkling bell attached. Although this bell was useful to the owners if they wished to locate their pet, it must have put the animals at a disadvantage when they were trying to hunt. The implication is that these were well-fed, pampered felines, rather than hard-working pest-controllers.

Although he was able to create charming images of this kind, Yoshitoshi's private life was anything but serene. In the 1870s he was living in extreme poverty with his faithful mistress Okoto. They were

so poor that they were forced to tear up and burn their floorboards to keep warm, and Okoto even sold her clothes so that they could survive. The stress of the situation caused Yoshitoshi to suffer a mental collapse. Eventually, Okoto had to sell herself into a brothel to help him financially – the ultimate act of devotion. Astonishingly, when Yoshitoshi took a new partner a few years later, a geisha called Oraku, history repeated itself. She, too, sold her clothes to support him and finally sold herself into a brothel to provide him with enough money to survive. There can have been few painters in the history of art who have been able to inspire such extremes of loyalty – twice.

Yoshitoshi's tragic life ended bizarrely. Following a productive and much more successful period in his later years, he suffered another mental breakdown after all his money was stolen from his home. Most of his final year was spent in a mental hospital, and he died at the age of just 53. His reputation waned after his death but was subsequently revived, and his importance as the last of the woodblock printmakers is now secure.

Takahashi Shotei was a well-known all-rounder who founded the Japan Youth Painting Society in 1889. He produced paintings, magazine illustrations, woodblock prints, lithographs and line drawings. Sadly, five hundred of his prints were destroyed in a major earthquake in 1923, but afterwards he produced a further 250, ensuring his reputation. His *Cat Prowling Around a Staked Tomato Plant* (1931) continues the long tradition in which an animal is shown in relation to some kind of botanical detail. In most such images there is a space between the animal and the plant, but here the two are closely interwoven in an intricate composition.

When hunting, wild cats skilfully take advantage of dense undergrowth to conceal their presence from their prey until the

moment when they pounce at lightning speed, and domestic cats still adopt this strategy, even when the environment starves them of suitable cover. Here, the cat is crouching low and twisting itself as close as possible to the tomato plant, but is sadly all too visible.

A study by Shotei from about the same time, *A Black Cat with a Bell Round its Neck Stretching*, is a failed attempt to capture the moment when a cat, waking, stretches its body in a characteristic way. Although Shotei caught the body posture well enough, with the front legs stretched fully forward and the extended claws pressing into the floor, he tried to give the animal a yawning expression. That is where he failed: it looks more like an aggressive hiss than a sleepy yawn. The result is that, without knowing the title he gave this work, it would be impossible to guess what he intended to depict.

Hishida Shunso was well known for establishing the *nihonga* style during the Meiji period. He was also known as a specialist in painting cats, and there are many examples of his feline studies. In his late twenties he began travelling abroad to gain experience, and visited Europe, the United States and India. When he returned he enjoyed great popularity, but a new style he later developed was criticized strongly by some, who called it *moro-tai*, or vague style. His new technique replaced precise line drawings with colour gradations, but he came to realize that this was useful only when applied to such features as morning mists or the glow of sunset. He then modified it, combining gradations with detailed line drawings, and created for himself a new style that was more successful. It was this compromise that became known as *nihonga*.

In his feline painting *Plum Blossoms and Cat* Shunso shows the old-style, traditionally painted details against his new-style graduated background. The same is true of his *Black Cat* (1910), a

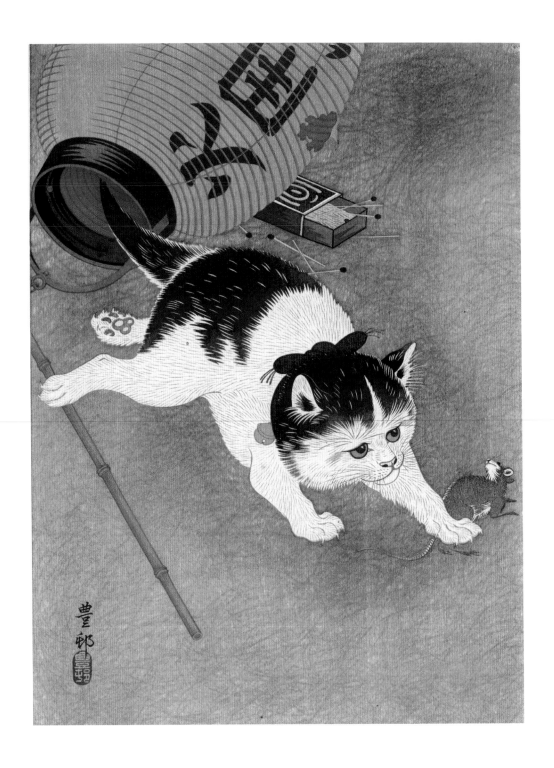

Ohara Koson, *Cat Catching a Mouse*, 1930, woodblock print.

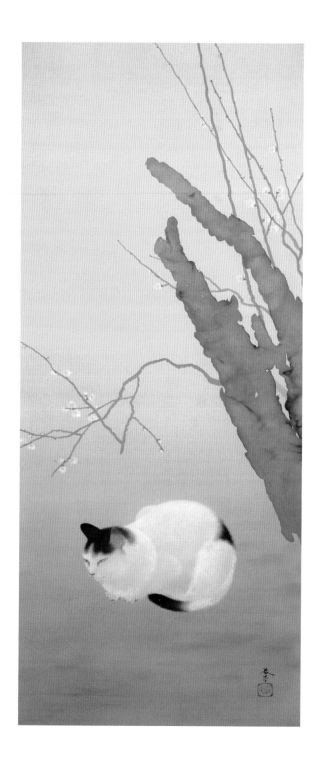

Hishida Shunso, *Plum Blossoms and Cat*, 1906, hanging scroll,
ink and colours on silk, showing a graduated background.

painting so admired that it was used as a commemorative postage stamp by the Japanese government in 1979, some 68 years after the artist's death.

The woodblock printmaker known as Ohara Koson, or Shoson Ohara, came from the north of Japan but moved to Tokyo when he was about twenty, and remained there for the rest of his life, dying in his home at the end of the Second World War. He earned a good living as a teacher at the Tokyo School of Fine Arts. His work was especially popular in the United States, and much of it was in fact produced specifically for export, aimed at American taste. He concentrated largely on animal studies, and his pictures of kittens catching mice or staring longingly at goldfish had an immediate appeal for American collectors. As a result of this focus on the American art market, he was not taken seriously in Japan during

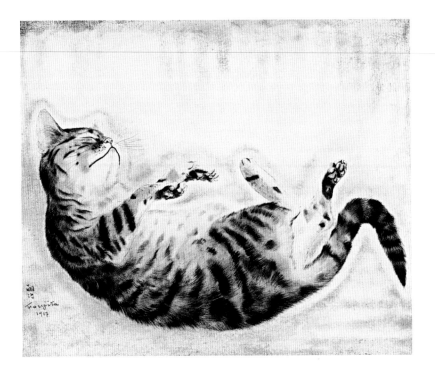

208

Tsuguharu Foujita, *Study of a Sleeping Cat*, 1927, ink on paper.

his lifetime, and enjoyed a resurgence of interest there only in the 1970s, long after his death.

Tsuguharu Foujita was born in Tokyo and studied art there before leaving Japan for Paris in 1913. He was fascinated by the aesthetic revolution that was taking place in the French capital at the time, and met many of the modern artists working there, including Picasso, Fernand Léger, Amedeo Modigliani, Matisse and Juan Gris. Plunging into Parisian society, he was taught to dance by the legendary Isadora Duncan. His paintings of beautiful women and cats became famous, and he started earning more money than the other avant-garde artists in Montparnasse, where he had his studio. In 1925 he was awarded the Légion d'Honneur (the highest decoration in France), and in 1930 twenty of his feline studies were published as a volume called *Book of Cats*.

The following year Foujita left Paris for Brazil and spent three years travelling all over South America, painting and holding exhibitions. His work was immensely popular there, and one of his shows in Buenos Aires attracted 60,000 visitors. In 1933 he returned to Japan as a celebrity; he remained there until after the war, when he returned to France, converted to Catholicism and was baptized at the age of 73 in Reims Cathedral. His final work, at the age of eighty, was the design and building of the Foujita Chapel in Reims, in which he would be buried.

Inevitably, Foujita's style was a blend of East and West, and was much more influenced by developments in European art than was that of the Japanese painters who had travelled abroad before him. There was a looseness and intimacy in his feline portraits that made them warmer and more friendly than the typically rather restrained works of his predecessors.

Perhaps the most extraordinary portrayal of cats by a Japanese artist is found in the work of Tokuhiro Kawai, who was born as recently as 1971. What makes his feline images so unusual is that they owe nothing whatsoever to the Eastern tradition of picture-making. Although he was born in Tokyo, obtained his art degrees there and works there, Kawai's style is firmly in the European tradition. His technique is meticulous and his cats are so precisely painted that they

Tokuhiro Kawai, *Tame Cat's Delusion*, 2006, oil on canvas, a portrait of 'the cat who desires to be the boss of the world'.

could be mistaken for photographs, were it not for the presence of cherubs and other imaginary beings.

In his painting *Tame Cat's Delusion*, Kawai presents a black-and-white cat being crowned by a winged cherub while two other cherubs place a fur-lined red cloak around his shoulders. This is the King of Cats, quietly accepting his coronation with a confident, expressionless gaze. The European flavour of the work is emphasized by the kind of cat the artist has chosen to depict. Instead of a local Japanese Bobtail cat, the breed he has selected is the Scottish Fold, a pedigree breed immediately recognizable by its down-folded ears. The artist has described the scene as showing 'the eternal fulfilment of the cat who desires to be boss of the world'. It celebrates the feline quality that all cat-owners know very well: the animal's refusal to become the subordinate of its owners. Dogs are happy to see their owners as their pack leaders, but cats come from a solitary ancestry, and are intent on being their own leader when on home territory. As an experienced cat-owner once put it, the man owns the dog but the cat owns the man. This painting presents a fairy-tale version of the haughty, independent spirit of the cat. But why a twenty-first-century Japanese artist should choose to employ the device of winged angels, of the kind made popular in the art of the Italian Renaissance, is hard to understand. Kawai has been referred to as a neo-Surrealist, but no true Surrealist would employ imagery with such a strongly religious flavour.

Other cat paintings by Kawai also display a strange mixture of Surrealist irrationality and traditional religious imagery. In one, for example, he shows a tabby cat sitting on top of a classical Ionic pillar with tall palm trees in the background. The cat has been hunting and is seen with its kill hanging lifeless in its jaws. What is bizarre

about this work is that the cat's prey is not a mouse or a bird, but an angel.

In another remarkable work, Kawai shows us three cats on a beach with a slim, smartly dressed young man standing nearby, holding an umbrella. He is staring up at distant forked lightning, which heralds a thunderstorm. The religious element is present, even here: high in the clouds is the figure of a bearded sky god brandishing a staff, from the end of which the lightning bolt is emerging. But the interesting feature of this painting lies in the behaviour of the cats. Each one is caught in the act of grooming itself. For cats, grooming follows a characteristic, set sequence that begins in the following way:

- Lick the lips.
- Lick the side of one front paw until it is wet.
- Rub the wet paw over the head, including ear, eye, cheek and chin.
- Wet the other front paw in the same way.
- Rub the wet paw over that side of the head.

After that the sequence continues, dealing with the rest of the body. In the painting, each cat is shown in the act of washing its face with its forepaw. The one on the left raises its paw to start the action; the one in the centre licks the inner side of its paw; and the one on the right rubs the side of its face.

The artist's attention to detail here is astounding. By showing each cat at a slightly different stage in the face-washing action, he gives us the complete movement. This was clearly important to him, and it suggests that he knows the old saying that when a cat washes

Tokuhiro Kawai, *Harbinger of Storm*, 2003, oil on canvas. The interesting
feature of this painting lies in the behaviour of the cats.

The Beckoning Cat, the *maneki-neko* good luck figure sold by the Gotoku-ji temple
near Tokyo, where cat worship still takes place.

its face you can expect rain. He may also know that a thunderstorm causes electromagnetic disturbances to which cats are sensitive, as we have seen, and which cause them to start grooming themselves nervously. The scene in Kawai's painting sums all this up perfectly and reveals that, in addition to his technical skill, he is also a true observer of feline behaviour. We know that he had a close bond with two family cats, one for the first twelve years of his life and the other, obtained when he was seventeen, for a further nineteen years. He must have observed their reactions when heavy storms broke over Tokyo and based his careful painting on his observations.

Kawai may not realize it, but his painting is also an elegant demonstration that an old Japanese legend, thought to be fictional, is probably true. It concerns the famous Beckoning Cat, or *maneki-neko*, known to every Japanese family. The legend has it that near Tokyo there was an ancient and very poor temple, the Gotoku-ji. Although the monks were starving, they shared their food with their pet cat. One day the cat was sitting by the side of the road outside the temple when a group of rich samurai rode up. The cat beckoned to them and they followed it into the temple. Once inside, heavy rain forced them to shelter there, and they passed the time learning about the Buddhist philosophy. Later, one of the samurai returned to take religious instruction and eventually endowed the temple with a large estate. His family was buried there, and near their tombs a small cat shrine was built to the memory of the beckoning cat. The reason for the samurai's gratitude was that when the terrible rainstorm arrived it brought lightning, which struck the ground exactly where he had been standing just before they followed the cat into the temple. The cat therefore saved his life, for which he was immensely grateful.

It has always been assumed that this was a fanciful tale with no basis in reality, but a close examination of the nervous grooming actions of a cat upset by an approaching thunderstorm reveals that, when they swipe their paw down the side of their face, it looks remarkably like a typical Japanese beckoning action in which the right arm is extended, with a bending down of the wrist. So, when the samurai thought the cat was beckoning to them, what they in fact saw was a nervous cat washing its face as the storm approached. It could actually have happened. Certainly, the cat on the right in Kawai's painting does look remarkably as though it is beckoning, making the explanation of the origin of the *maneki-neko* story more understandable.

The temple still operates today, and if you visit it you can buy a ceramic Beckoning Cat, with its right paw raised to the side of its head, to place among the thousands already there and bring yourself good luck. It is said to be the only temple in the world where cat worship still exists.

The good-luck cat has become very popular in Japan, and almost every shop or business has one on display to bring good fortune. An enterprising businessman decided to double his trade by introducing pairs of cats, one to protect the business and one to protect the home, with one cat having its right paw raised and the other its left paw.

It would be misleading to give the impression that, because of the direction Kawai's work has taken, modern Japanese art has abandoned its traditional past completely. Although a healthy avant-garde movement is active in Japan today, there are still painters whose work pays homage to the past. One such is Kudou Muramasa, whose work *Cat and Wasp* creates the atmosphere of one of the hanging silk scrolls of earlier centuries, despite the fact that it is painted with gold

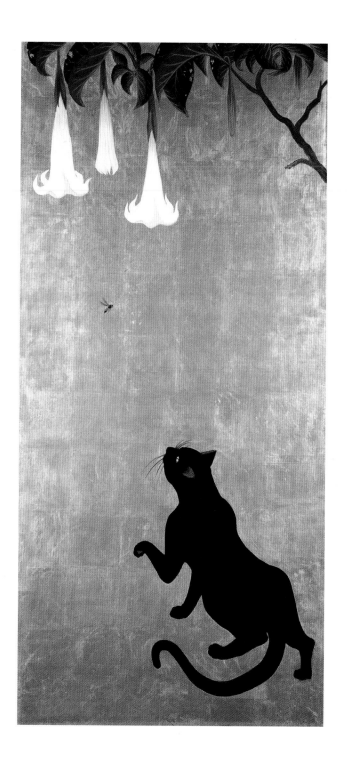

Kudo Muramasa, *Cat and Wasp*, late 20th century, a modern Japanese work in the traditional style. From its shape the picture appears to be a hanging silk scroll but is instead acrylic on canvas.

leaf and acrylic on canvas. His composition, leaving empty spaces and including delicate botanical details, is typical of the work of the Edo period, and this traditional element is cleverly combined with a more modern crispness. He trained in Japanese calligraphy from an early age, and it has been said that he has a 'surgeon's wrist', giving his brushstroke a perfect line.

14

Cartoon Cats

Since the eighteenth century, the cat has been a popular subject for political cartoonists and caricaturists. In earlier centuries such artists might have found themselves in serious trouble with their candid and often ribald comments about the leading figures of the day, but the greater freedom of expression that came in the eighteenth and nineteenth centuries was exploited wholeheartedly by the uninhibited and often bawdy imaginations of such artists as Thomas Rowlandson and James Gillray. Many of their works had a sexual theme and in Rowlandson's ironically titled *Cat Like Courtship*, a sexual assault on a virginal young woman is interrupted by her three cats, which have leapt onto the rapist's body and are attacking his back, rump and thigh.

In Gillray's *Female Curiosity* (1778), an aged servant holds up a mirror so that the lady of the house can examine her buttocks – a part of her anatomy normally so concealed by the exaggerated fashions of the day that she has forgotten what it looks like. The sight of her naked behind, seen in the mirror, terrifies her pet cat, which arches its back and hisses at the reflection.

These cartoons of the eighteenth and early nineteenth centuries often included a cat to make a particular point. In Gillray's *Harmony before Matrimony* (1805), the loving couple sing together and all is

serene, but behind them a pair of cats are fighting furiously on the floor, symbolizing what is to come after the couple have been married for some time. The moral of the story is that the current fashion for upper-class girls to learn music in order to attract a husband did not provide them with an education that would prepare them for the life of a married woman.

It would, however, be out of place to illustrate these works by Gillray in a book on the subject of cats in art, because the cats shown in them are always such a minor part of the compositions. It is humans that are his real subject. To find an eighteenth-century cartoon that depicts the cat as the central figure, we must turn to Russia, where a favourite subject was the burial of a cat by a band of triumphant mice.

It has been suggested that in eighteenth-century Russia political cartoonists enjoyed the idea of resurrecting a Russian folk tale about

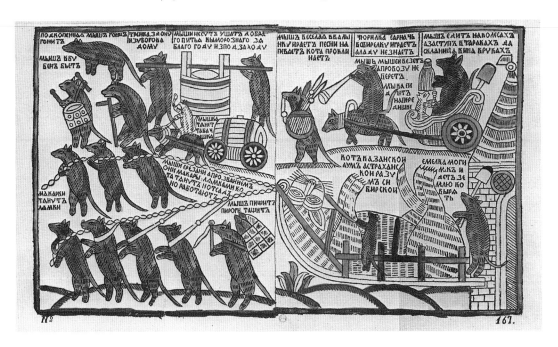

The tables are turned in this Russian cartoon of 1760, with the mice burying the cat, a satire on the funeral of Tsar Peter the Great.

mice burying the cat, to satirize the funeral of the domineering tsar Peter the Great. The mice were supposed to represent the unfortunate people he had been taxing so heavily, and he was shown as the dead cat, no longer to be feared. Recent research has shown, however, that this theme of the cat's funeral was repeated endlessly over a period of 200 years and contains a more basic message than satirical comment on the tsar's death. It is now thought to be simply a general observation on the joy of the weak seizing power from the powerful, and, as it turned out, was a premonition of what was to come with the Russian Revolution of 1917.

Among modern print cartoonists who have portrayed cats, three stand out: Gerald Scarfe, Ronald Searle and Saul Steinberg. Almost all Scarfe's images are so melodramatically violent that he gives the impression of being out to shock in the most outlandish way he can imagine. His image of a cat in *Cat-astrophe* is so exaggeratedly savage that it goes beyond caricature. If it were less extreme it might allow the viewer to focus on its subject matter, which is the mass killing of garden birds by roaming domestic cats. This is something that ornithologists feel strongly about, but which is a price that cat-lovers must pay for choosing to harbour natural predators.

By contrast, Searle's countless amusing images of overweight felines appear to be the work of a man who loved cats, but who was also acutely aware of their moods and foibles. He has obviously observed the nervous withdrawal of an ugly cat that has been badly treated in the past because it is so unappealing, and therefore misreads a rare friendly greeting. He portrays this moment in *Unusually Repulsive Cat Startled by a Gesture of Affection*. In a similar work, he presents us with a comic image beneath which lies serious feline abuse. Some vegetarians believe that it is possible to feed their pets on a herbivorous

diet, but this is a serious error and can even lead to their pet's rapid decline and early death. Searle's forlorn *Vegetarian Cat Regarding a Plate of Fried Eggs* makes this point gently, taking a swipe at the cruelty of treating a carnivore as a herbivore.

Since all Searle's cats are seriously overweight, he uses this feature to make a sly dig at the 'Fat Cats' – rich and powerful supporters of right-wing politics – in his sketch *Gluttonous Right-wing Cat Trying to Digest the Left Wing of a Chicken*. This may be classed as a political cartoon, but the truth is that – unlike many modern cartoonists – Searle was not especially political. His primary concern was always to raise a smile rather than give a lecture, and his hundreds of cat images do just that. He was so prolific in this feline genre that he was able to fill several books with his images, including *Searle's Cats* (1967; revised 2016), *More Cats* (1975), *Big Fat Cat Book* (1982) and *Cat O' Nine Tales* (2007; with Jeffrey Archer).

222

Ronald Searle's cartoon *Unusually Repulsive Cat Startled by a Gesture of Affection,* 1987, may be a joke but it also tells us something about the poor treatment of unattractive felines.

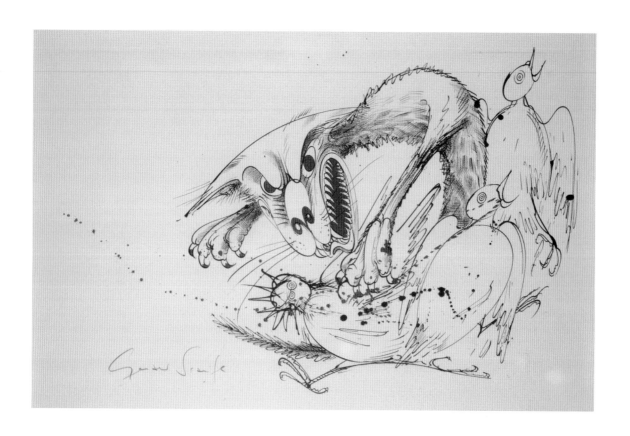

Cat-astrophe, the ultimate depiction of cat hatred summed up in a single image by
London newspaper cartoonist Gerald Scarfe.

Steinberg, a cartoonist in New York, was also obsessed with cats, and on several occasions his feline creations featured on the cover of the *New Yorker* magazine, for which he worked for nearly sixty years. His work is memorable for the deceptive simplicity of his lines. It was said that he 'elevated the language of popular graphics to the realm of fine art'. This may be a slight exaggeration, but it is certainly true that his immediately recognizable style set him above many of the twentieth-century cartoonists who presented us with supposedly comic cats but failed to create anything of special aesthetic value. Unfortunately, cats seem to have attracted an unusually large number of inferior artists whose work is best forgotten.

Cartoon cats are perhaps best known through the work of the animators of children's films. Most famous is the long-running series *Tom and Jerry*, about the continuing war between Tom the cat and

Ronald Searle's cartoon *Vegetarian Cat Regarding a Plate of Fried Eggs*, 1987, takes a swipe at the cruelty of keeping a pet carnivore and treating it as a herbivore.

Jerry the mouse, his intended victim. Unfortunately for Tom, he must always fail in his pursuit of a mouse meal, or the series would come to a sudden halt. MGM showed the first of the *Tom and Jerry* shorts in 1940, and the last appeared in 2005. Altogether there were 163 of these films, and Tom's cartoon image became familiar worldwide.

Other popular cartoon cats include Garfield, Leopold the Cat, The Cat in the Hat, Felix the Cat, Figaro, Krazy Kat and Top Cat. There was even an X-rated cartoon feature film, *Fritz the Cat*, which appeared in 1972. Fritz, who epitomized the freewheeling morals of the 1960s, spent most of his time doing what cats do when they

A typically eccentric Saul Steinberg cat.

are not hunting, sleeping or cleaning themselves. In one memorable scene he enjoys group sex in a bathtub. Although these animated film cats have given pleasure to millions of cinema-goers, they belong to a special category that is beyond the scope of this book.

Ronald Searle's obese *Gluttonous Right-wing Cat Trying to Digest the Left Wing of a Chicken*.

15

Street Art Cats

In recent times paintings have appeared on the walls of buildings all over the world, sometimes officially, sometimes illegally. Modern graffiti began in the United States in the 1960s, when rival gangs would leave their signs on walls to mark out their territories. In the 1970s these 'tags' grew into elaborate images and the New York subway system became infested with them, much to the distress of the authorities. In the twenty-first century the rough scribbles of the early days were replaced by more and more expert compositions. These started to appear internationally, and a new art form, Street Art, was born. In France, the street artist Blek le Rat took the genre to a new level, producing stencilled images that showed considerable skill. His style was later adopted by the English artist Banksy, whose work has recently made a major impact because of the political messages it transmits.

One memorable wall painting by Banksy depicts a kitten playing with a ball of mangled wire. The wire was collected from the streets of Gaza, to which the artist made a secret visit in 2015 to highlight the plight of the Palestinians. He entered the Gaza Strip through a series of tunnels and created his painting on a surviving slab of wall that stood among the ruins, all that was left of a house in the town of Biet Hanoun that was destroyed by Israeli shelling.

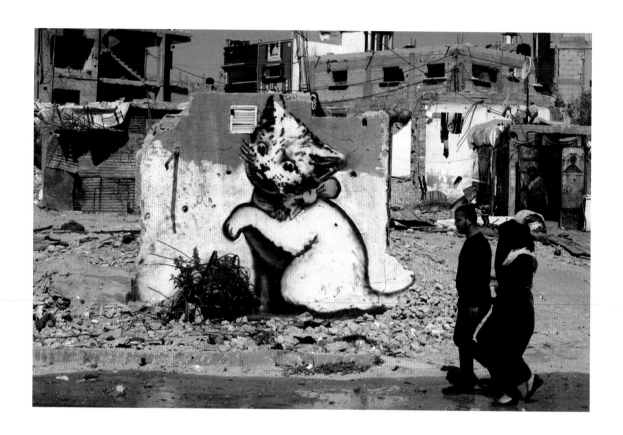

Banksy street art image in Gaza of a kitten playing with a ball of mangled wire.

When asked by a local man to explain why he had painted a kitten, Banksy said: 'I wanted to highlight the destruction in Gaza by posting photos on my website – but on the internet people only look at pictures of kittens.' By using this appealing image, he was able to attract people's attention to a major problem that has recently been overshadowed by other events in the Middle East. The kitten on the ruined wall, he said, is there to remind us that 'If we wash our hands of the conflict between the powerful and the powerless, we side with the powerful and don't remain neutral.'

Banksy's kitten is only one of many examples worldwide of the use of feline imagery in modern street art. In the small village of Ding Si in Yunlin County, on the west coast of Taiwan, two local artists recently began a project to cover the walls with images, many of them portraying cats. These are not crude graffiti, but competent, finished paintings showing the cats in a variety of situations. In one, the cat on the main wall has become three-dimensional by making the low, projecting wall of the garden into one of its legs. A Canadian blogger who visited the remote village reported that

> A cluster of murals, painted on brick walls and garage doors lined each side of the road. Painted images of cats were neatly scattered all over the walls. Flawless 3D images covered several areas with cats being the stars of the show . . . Two artists steadily worked side-by-side creating two more 3D art murals. I noticed that every few minutes, they would pause, step back, evaluate their work, and re-adjust if needed. The artists took the time to explain to me what the overall painting would look like upon completion . . . One said, as he pointed to the blank canvas of the buildings, that they plan to paint every single wall.

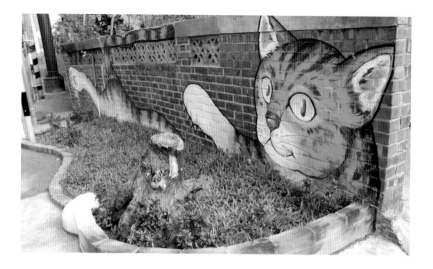

What the local residents think of this visual transformation of their buildings is not known.

The United States has its own cat-decorated town: Miami, Arizona (not to be confused with the larger and better known Miami, Florida). Miami, Arizona, has a population of less than 2,000 and is home to the artist Marianne Collins. In 1993 she started an ambitious project to decorate the town with 121 cat murals. She rose at 5.30 a.m. each day and painted until it became too hot to work. This routine continued for months, as she painted on shopfronts, doorways and even rubbish bins in Miami's historic downtown area. Asked why she did it, she said: 'I had felt a civic duty to the Town of Miami in trying to add a little pizazz to the community.' Unlike some street artists, who work despite the disapproval of the residents, Collins asked each one for permission before beginning to paint. She also charged them $25 per cat, which they all agreed to pay. Ten years after she began her feline project, the town held a cat-themed art festival in Veteran's Park. Other artists, inspired by her work, have since added their own cats to the walls of the town. When the local

The village of Ding Si in Taiwan has been decorated with a collection of large cat paintings, covering many of the buildings. In one case the image has acquired a third dimension by using a low guard-wall as part of the composition.

dog catcher told Collins that he knew where to go to track down stray dogs, because they were so often found barking at her paintings of cats, she took this as a compliment.

For sheer size, the black cat of Shoreditch in the East End of London, by the street artist who uses the working name Sam3, is hard to beat. What it lacks in feline details and refinement, it makes up for in height, towering menacingly over the car parked beneath it. It is just one of many street paintings that have appeared in this district in recent years.

On the other side of the world, on the island of Penang, Malaysia, there is another giant cat, almost twice the height of the people who walk past it on the pavement. It is to be found on Armenian Street Ghaut and is one of many street murals that have appeared in the island's capital, George Town, in recent years. This painting and eleven other street art cat images in the town are part of the 101 Lost Kittens Project, which aims to create awareness of the need to protect pet animals and thereby reduce the population of stray

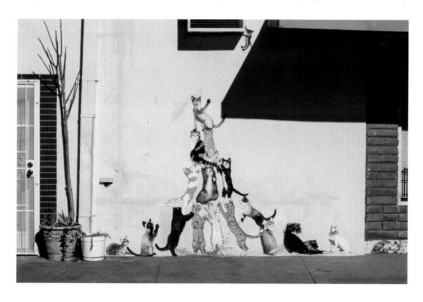

231

Marianne Collins, wall painting of cats attempting to rescue a kitten, 1993, in Miami, Arizona.

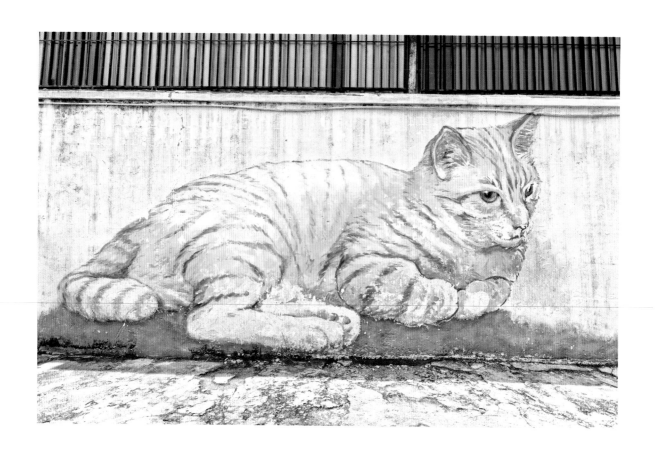

above: Giant cat on a wall in George Town, Penang.

opposite: Giant cat on a shop wall in Kingsland Road, Shoreditch, in the East End
of London. Painted by a street artist known as Sam3.

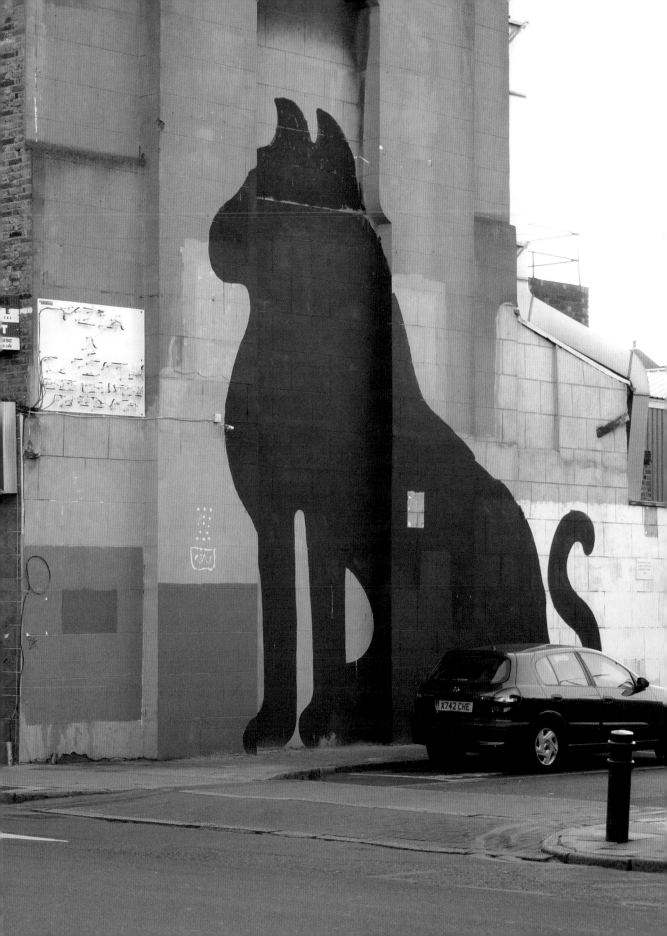

cats and dogs in the city. The work was created in 2013 using 'environmentally friendly' paint that would supposedly last for only two years, so that if the town tired of the image it would be easy to remove. The idea was that, if it was still wanted, it could easily be repainted and restored to its original condition. As this recent photograph shows, it was beginning to show signs of wear and tear, but restoration work has since been carried out. The giant cat painting – known to locals as 'Skippy' or 'Skippy Comes to Penang' – was the work of ASA (Artists for Stray Animals), a group of painters from Thailand and Malaysia.

STREET PAINTINGS OF this kind are growing in number and constitute the latest artistic genre in which people have chosen to celebrate the cat. As an image, the feline form seems to have a very special appeal, both to the artists and to those who enjoy looking at pictures.

For every artist portraying some other animal, there seem to be a hundred favouring the cat. During the research for this book, tracing examples of cat images from prehistoric rock art to the pages of medieval bestiaries, to the refined canvases of the old masters and the more daring portrayals of the modern avant-garde, there has always been a feast of alternatives from which to choose. For every work of art selected for inclusion on these pages, hundreds have had to be omitted.

I was once quoted as saying that 'artists like cats; soldiers like dogs.' This was, of course, an over-simplification, but embedded in this statement is a basic truth: there is a special bond between artists and cats that has straddled the centuries to give us countless enticing works of art that have provided endless pleasure for our eyes.

Select Bibliography

Alberghini, Marina, *Il Gatto Cosmico de Paul Klee* (Milan, 1993)

Altman, Robert, *The Quintessential Cat* (London, 1994)

Baillie-Grohman, W. A., and F. Baillie-Grohman, eds, *The Master of Game by Edward, Second Duke of York* (London, 1904)

Barber, Francis, *Bestiary* (London, 1992)

Bihalji-Merin, Oto, *Modern Primitives* (London, 1971)

—, and Nebojsa-Bato Tomasevic, *World Encyclopedia of Naïve Art* (London, 1984)

Brewer, Douglas J., Donald B. Redford and Susan Redford, *Domestic Plants and Animals: The Egyptian Origins* (Warminster, 1995)

Bryant, Mark, *The Artful Cat* (London, 1991)

Bugler, Caroline, *The Cat: 3500 Years of the Cat in Art* (London, 2011)

Cahill, James, *Chinese Painting* (Geneva, 1960)

Clair, Jean, *Balthus* (London, 2001)

Clutton-Brock, Juliet, *Domesticated Animals from Early Times* (London, 1981)

Cox, Neal, and Deborah Povey, *A Picasso Bestiary* (London, 1995)

Eliot, T. S., *Old Possum's Book of Practical Cats* (London, 1974)

Fireman, Judy, ed., *Cat Catalog: The Ultimate Cat Book* (New York, 1976)

Foucart-Walter, Elizabeth, and Pierre Rosenberg, *The Painted Cat*
 (New York, 1988)

Foujita and Michael Joseph, *A Book of Cats* (Southampton, 1987)

Fournier, Katou, and Jacques Lehmann, *All Our Cats* (New York, 1985)

Goepper, Roger, and Roderick Whitfield, *Treasures from Korea*
 (London, 1984)

Grilhé, Gillette, *The Cat and Man* (New York, 1974)

Haverstock, Mary Sayre, *An American Bestiary* (New York, 1979)

Holme, Bryan, *Creatures of Paradise: Animals in Art* (London, 1980)

Houlihan, Patrick, *The Animal World of the Pharaohs* (London, 1996)

Howard, Tom, *The Illustrated Cat* (London, 1994)

Howie, M. Oldfield, *The Cat in the Mysteries of Religion and Magic*
 (London, 1930)

Janssen, Jack, and Rosalind Janssen, *Egyptian Household Animals*
 (Aylesbury, 1989)

Johnson, Bruce, *American Cat-alogue: The Cat in American Folk Art*
 (New York, 1976)

Klingender, Francis, *Animals in Art and Thought to the End of the
 Middle Ages* (London, 1971)

Lang, J. Stephen, *1001 Things You Always Wanted to Know about Cats*
 (Hoboken, NJ, 2004)

Le Pichon, Yann, *The World of Henri Rousseau* (1982)

Lister, Eric, *Portal Painters* (New York, 1982)

——, and Sheldon Williams, *Naïve and Primitive Artists*
 (London, 1977)

Loxton, Howard, *The Noble Cat* (London, 1991)

Lydekker, Richard, *A Handbook to the Carnivora: Part 1* (London, 1896)

MacCurdy, Edward, *The Notebooks of Leonardo da Vinci* (London, 1956)

Mery, Fernand, *The Life, History and Magic of the Cat* (London, 1967)

Moncrif, François-Augustin de Paradis de, *Les Chats* (Paris, 1727)

Morris, Desmond, *Cat Lore* (London, 1987)

——, *Cat World: A Feline Encyclopaedia* (London, 1996)

Morris, Jan, *A Venetian Bestiary* (London, 1982)

Morris, Jason, 'The Cat in Ancient Egypt', BA thesis, University
 of Oxford (1990)

Nastasi, Alison, *Artists and their Cats* (San Francisco, CA, 2015)

O'Neill, John P., and Alvin Grossman, *Metropolitan Cats* (New York,
 1981)

Popham, A. E., *The Drawings of Leonardo da Vinci* (London, 1949)

Porter, J. R., and W.M.S. Russell, *Animals in Folklore* (Cambridge, 1978)

Ricci, Franco Maria, *Morris Hirshfield* (Paris, 1976)

Stephens, John Richard, *The Enchanted Cat* (Rocklin, CA, 1990)

Topsell, Edward, *The History of Four-footed Beasts and Serpents*
 (London, 1658)

Toynbee, J.M.C., *Animals in Roman Life and Art* (London, 1973)

Walker-Meikle, Kathleen, *Medieval Cats* (London, 2011)

——, *Medieval Pets* (Woodbridge, Suffolk, 2012)

Warhol, Andy, *25 Cats Name Sam and One Blue Pussy* (New York, 1954)

Webb, Peter, *Sphinx: The Life and Art of Leonor Fini* (New York, 2007)

White, T. H., *The Book of Beasts* (London, 1955)

Wilder, Jess, and Laura Gascoigne, *A Singular Vision: Fifty Years
 of Painting at the Portal Gallery* (Munich, 2009)

Zöllner, Frank, *Leonardo da Vinci* (Cologne, 2003)

Acknowledgements

This book could not have been written without the tireless research carried out by my wife, Ramona. Because so many cat books have been written in the past, the research for this one was unusually demanding, since we were determined to find new and exciting images that had not been published before. To this end, Ramona spent many hours searching for the perfect, little-known examples from all over the world, and I am especially grateful to her for this.

I would also like to thank Michael Leaman of Reaktion Books for suggesting that my double life as a zoologist and an artist meant that I was the right person to attempt this book. We began by looking at the subject of pets in art, but the field was so rich that we decided to narrow it down to just one pet, the cat. Even there I found myself confronted by countless thousands of feline images and had to make many difficult choices of omission.

I would also like to express my debt to Susannah Jayes, whose pains-taking copyright research for this book meant that we were able to include so many of the unusual examples of feline art that I had requested; and to Simon McFadden, for the excellent design of the book.

A number of people have kindly helped on specific points, in particular Paul Bahn on prehistoric cats, Kathleen Walker-Meikle on medieval cats and Sally Welchman on naive primitives. My sincere thanks to them all.

Photo Acknowledgements

AKG Images: pp. 82 (© ADAGP, Paris and DACS, London 2017), 126 (© ADAGP, Paris and DACS, London 2017), 176 (Jean-Louis Nou), 181 (Roland and Sabrina Michaud), 199 right; Alamy: p. 169 (The Art Archive); Ancient Art and Architecture Collection: p. 168 (Richard Ashworth); Art Institute of Chicago: p. 166; author's collection: pp. 11, 141, 163, 173 top and bottom, 214; painting © Balthus: pp. 112 (*The King of Cats*, 1935, oil on canvas, 71 x 48 cm, artist's collection), 113 (*Thérèse rêvant*, 1938, oil on canvas, 150, 5 x 130.2 cm, The Jacques & Nathasha Gelman collection, on deposit at the Metropolitan Museum of Art, New York); Bibliothèque nationale de France (BNF): p. 42; © The Trustees of the British Museum, London: pp. 20, 21, 54, 179; Bridgeman Images: pp. 13, 14 (Ashmolean Museum, University of Oxford, UK/Mrs Nina de Garis Davies), 63 (photo © Christie's Images), 74 (private collection), 91 (photo © Christie's Images), 125 (private collection/photo © Christie's Images/© 2017 The Andy Warhol Foundation for the Visual Arts, Inc./ Artists Rights Society (ARS), New York and DACS, London), 164 (Private Collection/Photo © Boltin Picture Library), 171 (The Art Institute of Chicago, IL, USA/Kate S. Buckingham Endowment), 185 (National Museum, Seoul, Korea), 191 left (private collection), 194 bottom (Freer Gallery of Art, Smithsonian Institution, USA/Gift of Charles Lang Freer), 201 (National Gallery of Australia/Purchased 1995), 202 (Museum

of Fine Arts, Houston, Texas, USA/Gift of Stephen and Stephanie Hamilton in memory of Leslie A. Hamilton), 206 (Freer Gallery of Art, Smithsonian Institution, USA/Robert O. Muller Collection); Brooklyn Museum: p. 17 (Gavin Ashworth); By kind permission of the Duke of Buccleuch & Queensberry KBE: p. 67; Courtesy of Leslie Caron: p. 153; © Constance Carmichael, www.foreignsanctuary.com: p. 228; www.ourberylcook.com/© John Cook 2017: p. 144; © Scott Dinel: p. 158 top and bottom; courtesy of the Leonor Fini Archives: pp. 116, 117, 118; Massimo Finizio: p. 29; Fotolibra: p. 8 (Martin Hendry); Fototeca Berenson: p. 55; © Fondation Foujita/ADAGP, Paris and DACS, London 2017: p. 208; Getty Images: pp. 9 (Amar Grover), 18, 19 (Werner Forman/ Universal Images Group), 25 (DEA/G. Nimatallah/De Agostini), 43 (Bettmann), 45 (Sander de Wilde/Corbis via Getty Images), 70 (photo by Fine Art Images/Heritage Images), 85 (Peter Harholdt), 226 (photo by Ashraf Amra/Anadolu Agency); © Melinda K. Hall: p. 156; © Marvin Hansen: p. 229; © Diane Hoeptner, www.dianehoeptner.com: p. 130; courtesy of Tokuhiro Kawai: pp. 210, 213; © Warren Kimble: p. 151; © Martin Leman: p. 149; Library of Congress, Washington, DC: p. 198; National Library of the Netherlands: p. 49; The Collection of the National Palace Museum, Taipei: pp. 187, 188; Mary Evans Picture Library: p. 46; © Natalie Mascall – SOFA/www.nataliearts.co.uk: p. 131; Photo: Archives H. Matisse/© Succession H. Matisse/DACS 2017: p. 98; © Julie McNamee: p. 231; Metropolitan Museum of Art, New York: pp. 34, 66; © Miroco Machiko: p. 162; photograph © 2017 Museum of Fine Arts, Boston: p. 191 right; Neanderthal Museum, Mettmann: p. 6; Marie-Lan Nguyen (2011): p. 30; Nicholson Museum, The University of Sydney: p. 27 (red-figure bell krater, 425–400 BC, made in Lucania, Italy. Attributed to the Cyclops Painter. NM48.2 Photographer: Rowan Conroy); The Pierpoint Morgan Library, New York: p. 51 (The Morgan

Library & Museum. MS M.282. Purchased by J. Pierpoint Morgan (1837–1913) in 1907); Rijksmuseum, Amsterdam: p. 47; Royal-Athena Galleries: p. 31; Saul Steinberg, *Untitled*, 1945–6, ink on paper, 36.8 × 58.4 cm, The Saul Steinberg Foundation, New York © The Saul Steinberg Foundation/Artists Rights Society (ARS), NY/DACS, London 2017: p. 225; © 2017. Photo Scala, Florence: pp. 110 (© Succession Picasso/DACS, London 2017), 139 (© 2017. Digital Image, The Museum of Modern Art, New York); Shutterstock: pp. 15 (Andre Nantel), 230 (gracethang2); © Successió Miró/ADAGP, Paris and DACS London 2017: pp. 120, 121; © Succession Picasso/DACS, London 2017: p. 106; University of California, Berkeley Art Museum and Pacific Film Archive (BAMFA): p. 189; courtesy Sally Welchman: p. 160; © Charles Wysocki – Artwork titled *Frederick the Literate*: p. 128.

Index

Page numbers in *italics* indicate illustrations